SCULPTURE IN MODERN AMERICA

SCULPTURE IN MODERN AMERICA

JACQUES SCHNIER

GREENWOOD PRESS, PUBLISHERS
WESTPORT, CONNECTICUT

The Library of Congress has catalogued this publication as follows:

Library of Congress Cataloging in Publication Data

Schnier, Jacques Preston, 1898–
 Sculpture in modern America.

 Bibliography: p.
 1. Sculpture, American. I. Title.
NB205.S35 1972 730'.973 70-163549
ISBN 0-8371-6213-0

Originally published in 1948
by the University of California Press, Berkeley and Los Angeles

Reprinted with the permission
of the University of California Press

Reprinted from an original copy in the collections
of the University of Illinois Library

First Greenwood Reprinting 1972

Library of Congress Catalogue Card Number 70-163549

ISBN 0-8371-6213-0

Printed in the United States of America

TO THE AMERICAN SCULPTORS
WHOSE WORK HAS BEEN THE
INSPIRATION FOR THIS BOOK

PREFACE

SCULPTURE *suffers for lack of treatises to explain or record it. Indeed, the literature of no other major art is marked by so great a dearth of books and essays. Artists, aestheticians, and the lay public interested in the accomplishments of contemporary American sculptors have until now been forced to rely on short chapters in books concerned mainly with the graphic arts, or laboriously consult the issues of art periodicals.*

The object of this book is to present a comprehensive survey of present-day American sculpture—to review the major schools or movements of contemporary sculpture, to describe the events leading to the establishment of these schools, and to show examples of the work of the leading exponents of the various movements. It is hoped that it may serve as a general reference book.

No amount of text alone can convey a clear conception of a work of sculpture. To be fully appreciated a statue or relief must be seen. In the absence of the actual object the best thing is a clear, sharply defined reproduction of it; hence this book.

In a work of this length it is only possible to touch upon the most salient features of modern American sculpture. Minor features, such as the adaptation of field stones, boulders, and driftwood as shaped by nature, to sculpture shapes, could have been discussed in the text. A consideration of the principles of sculptural design could have filled several chapters. But since the main purpose of the book is to present a survey, the text has been kept to a minimum, with major emphasis upon the reproduction of representative examples of work by present-day American sculptors. The text is to be considered no more than an introduction to the illustrations. The collection of plates should be thought of as comparable to an anthology of modern American poetry.

[vii]

The illustrations have been grouped by subject—heads, figures, animals, reliefs, and explorations in form. This has been done solely for purposes of convenience in reference. Other groupings based on media, i.e., stone, wood, or bronze, could have been used, but the system followed has been found to be of marked advantage for those who are interested in differences of treatment of the same subject matter.

Grateful acknowledgment is made to the National Sculpture Society, the Sculptors Gallery of the Clay Club, the Sculptors' Guild, and the many sculptors who generously supplied the photographs for this book; special thanks are due Carl L. Schmidt for his help in collecting the photographs. I am also indebted to Harold A. Small, August Frugé, and John Gildersleeve, all of the University of California Press, whose valuable suggestions and editorial assistance have aided me greatly in preparing the manuscript for publication.

J. S.

CONTENTS

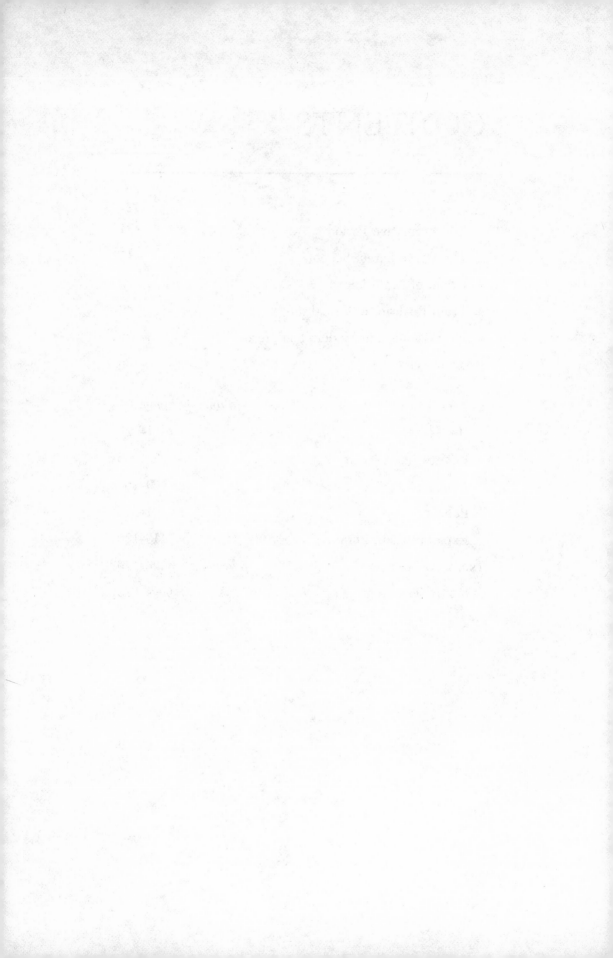

1, THE FORMATIVE PERIOD

THIRTY YEARS AGO the word sculpture brought to the minds of most Americans visions of classical Greek statues; carvings in marble of Apollo or Aphrodite, or the Hermes of Praxiteles. Modern sculpture, like modern architecture, was thought to be the collective whim of a handful of individuals eager for innovation. Now the scene has changed. We no longer feel bound to measure art according to the standards of Greek aesthetics. A modern sculpture has emerged, based on present-day economic, social, and aesthetic standards. Already this modern sculpture is being incorporated into our equally modern architecture and absorbed into our culture.

Modern American sculpture did not begin as a true primitive art, which evolved slowly through the stages that characterize the development of sculpture in other countries. It started in partial bloom; a provincial art that was an offshoot of an older civilization. Deep-rooted in foreign soil though its origins were, it now has a character which distinguishes it from that of other countries.

This character does not result from a homogeneity of style like that which characterized the sculpture of ancient Greece and Egypt. It is not always possible to distinguish examples of modern American sculpture from those created in England, France, or other European countries. However, when the sculpture created in the United States during the past three decades is studied as a whole there is clearly evident a tendency to synthesize the best features of earlier sculptural styles with the innovations of the modern experimentalists and to employ symbols, subject matter, and details characteristic of American life and thought. This tendency can be accounted for, in part, by a spirit of independent thinking that now pervades the creative arts in the United States; in part,

[1]

by adequate art schools which make it unnecessary for students to go abroad for training. The prestige and creativeness of contemporary American sculptors make their work a canon for younger men.

Prior to the first decade of the twentieth century, Europe was the fountainhead of American sculpture, as it was of painting and music. In the eyes of the American artist and aesthete, Europe was the source of all that was important in sculpture. It is true that the American sculptors John Quincy Adams Ward, Augustus Saint-Gaudens, and Daniel Chester French were well known and that their work was received with critical approval, but the two latter had studied abroad and all three worked in the European tradition. American sculptors, still feeling their way in artistic matters, looked to the Old World for their inspiration. Interested laymen, dealers, collectors, and museum directors considered it the chief source of purchasable works in bronze, stone, marble, and wood. Practically every American sculptor of note traveled to Europe to receive formal training. Some remained for an additional period to carry on creative work in the midst of a traditionally sympathetic environment, where all the crafts, trades, and skilled workmanship necessary for the translation of studio models into permanent castings or carvings were readily available.

In foreign art centers, widely publicized annual exhibitions afforded opportunities for displaying completed work which were not available in the United States. The fact that a statue had been shown in the Salon d'Automne in Paris enhanced its value in the eyes of American connoisseurs. Work sent back from Europe was shown in only a few of the larger cities, often in New York alone, and thus was brought to the attention of but a limited group. Hence there was little interest in America, during the late nineteenth century, in the development of adequate schools to train native sculptors or in the establishment of galleries for the display and sale of their work. This was the situation which had prevailed in the peripheral European countries in the seventeenth and eighteenth centuries. During this period art students were sent to Paris and to the French Academy in Rome for their training, and the culture and art of countries like Norway and Sweden became largely Gallicized. Many artists never returned to their native land, but practiced their profession in France.

A summary of the state of American sculpture prior to 1900 can be seen in the sculpture decorations for the Library of Congress in Washington. This great national undertaking brought together most of the well-known artists of the day. All of the recognized artistic effort that could be mobilized in our country was lavished on this building, which was completed in 1897. In the statues, reliefs, and massive doors in marble or bronze there can be clearly seen the European influence with its classic echoes, romantic interpretations of nature, and yearnings after the grand style.

<div align="center">II</div>

By 1900, European sculpture, which continued to establish the patterns which American sculpture followed, was beginning to break with the classical tradition. The influence of Auguste Rodin, whose work most clearly exemplifies this break, can hardly be overestimated; his domination of European and American sculpture continued to the time of his death in 1917. Both the desirable and the undesirable features of his work were slavishly copied by hundreds of sculptors, just as their predecessors had copied Greek sculpture of the classic period. In his concern to capture emotional feelings, Rodin displayed little interest in composition as a whole, in the integration of all elements into a self-contained, organized design. Like Michelangelo, he had a deep concern for the effects of light on sculptured surfaces. Distortion, irregularity of planes, exaggeration of contour and proportion, were some of the devices that Rodin emphasized. Most men who studied or worked in Paris at this time displayed in their work strong flavors of his style—informality of pose, forced gesture, and flickering surface—and those who actually studied with him show even stronger indications of his influence. Rodin, like Michelangelo, employed the technique of leaving the form half-submerged in the marble (i.e., leaving portions of the block unfinished) in order to concentrate attention on what, to him, was most significant. This treatment gave an enigmatic tone to his work. Others, less adept than Rodin, copied this treatment without the same effect.

Among the immediate pupils of Rodin were men who were themselves forging new principles. One of them, Antoine Bourdelle, was the first to find inspiration in archaic sculpture. He returned to an ordered structure, while keeping a rough, impressionistic surface. Within the architecture

of his designs he introduced moving shapes and decorative schemes of strong patterns and sharp contrasts in light and dark. His method of expressing the powerful emotions that inspirited his work was more violent and more arresting that Rodin's. This concern with archaic sculpture helped to revive an interest in the organizational and design features of sculpture. With this shift of interest to the factor of design there occurred a lessening of emphasis on the romantic and literary approach to sculpture. To produce a figure which was anatomically correct was not sufficient. Other values in addition to realism were being reëstablished. Sculpture elements, such as form, pattern, texture, repetition of rhythms, began to receive more and more attention.

Aristide Maillol was also a strong influence in the development of twentieth-century French sculpture. Many of those American sculptors who continued the tradition of seeking sculptural training and inspiration in Europe came under his influence. While Bourdelle was reëstablishing some of the basic features of plastic organization, Maillol set out to emphasize just one of those features—robust sculptural volumes. His emphasis on this sculptural element resulted in a voluptuousness and a generosity of form which prompted his admirers to discard from their work another canon of the romantic school—the canon of realistic proportion. Maillol's sculpture was conclusive evidence that a heavy-ankled, large-hipped, full-breasted, and generously rounded figure could be sculpturally successful and emotionally expressive; the essential requirement was that plastic values and design must determine the handling of the forms. The tactile appreciation of sculpture also received an impetus from Maillol's work. He declared that merely running one's fingers over the surface of his statues would produce a pleasurable aesthetic sensation.

Rodin and, to a lesser degree, Bourdelle, translated some of their statues into marble and stone. The traditional method at that time was for the sculptor to deliver the plaster cast of his statue to the stone carver who, by means of the pointing machine, reproduced or copied it in a glyptic material. Some sculptors have the ability to develop compositions in clay which are suitable for translation into marble, granite, or wood. Without working directly upon the material itself, these sculptors are able to visualize and to conceive in some temporary plastic medium,

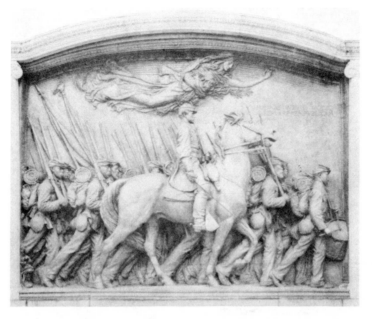

SAINT-GAUDENS: Shaw Memorial

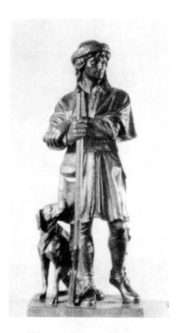

WARD: Simon Kenton

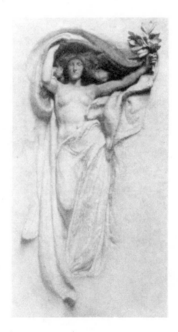

FRENCH: Mourning Victory

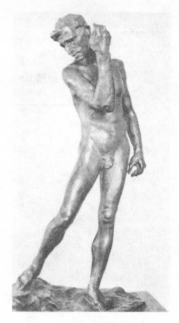
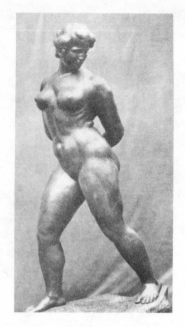

RODIN: Burgher of Calais MAILLOL: Action in Chains

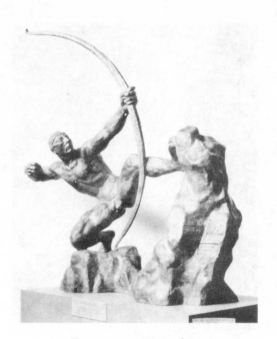

BOURDELLE: Hercules

such as clay or plaster, forms and designs that are indisputably appropriate when translated into a permanent hard material. Rodin and Bourdelle, however, were little concerned with the limiting sculptural possibilities of glyptic materials. Their appreciation of cast metal as a medium was well developed, and in some particulars—for example, the rippling surfaces of their bronze statues—they appear to have actually attempted to exploit new possibilities. Generally speaking, however, their interest was in emotional content and in exaggerated gesture. The statues of Rodin that were carved in marble could just as well have been cast in bronze, and many of them, like *The Kiss,* have been transposed into both materials.

In opposition to this tradition that did not respect the difference between modeling and carving, a new theory of sculpture developed. Sculpture, according to the proponents of this new viewpoint, was not just modeled form translated mechanically or by human machine into another material. For a carved statue to be true sculpture it had to be conceived directly in its final material and thus be instinct with the essential properties and qualities of this material. Advocates of the *taille directe* school asserted that direct carving by the sculptor resulted in a special quality—a freshness and a spontaneity—lacking in translated work.

Joseph Bernard, another Frenchman, was one of the earliest sculptors to practice the revived art of direct carving. Although at times he employed plaster studies as guides for carving his statues, he was also able to attack directly the block of marble. Unaided by drawings or models, he could work in the final material from the inception to the completion of a statue. For bas-reliefs and friezes Bernard relied solely on drawings made with charcoal on the faces of the marble slabs. This direct approach to his materials resulted in exceedingly simplified but truly glyptic configurations which seemed highly appropriate for the materials used. Simplified as they were, Bernard's conceptions always remained objective; the representational content was always self-evident.

The work of Mateo Hernández, a *taille directe* confrere of Bernard, was also objective. A naturalist, an *animalier,* and a real student of nature, Hernández's work was frequently inspired by animal models and carved directly from them. Sitting before a block of the most intractable

material, such as granite or diorite, in front of a cage containing a bird
or a quadruped, he tried to capture the characteristic shape, structure,
and movement of his model. The result of this practice was a series of
animal sculptures that equals the finest that were produced in ancient
Egypt.

Like Bernard and Hernández, Brancusi, another representative of the
taille directe school of Paris, gave up the modeling approach to sculpture
in favor of working directly in hard materials. Like them, he insisted that
a sculptor should do his own carving in wood, stone, or marble and not
rely upon a *formateur* or professional carver to translate his plaster con-
ception into some hard material.[1]

Unlike Bernard and Hernández, however, Brancusi steered a course
decisively away from natural representation. At the time he was working
in Paris, enthusiasm for Negro sculpture engulfed the world of modern
French painters and sculptors like a tidal wave. Sculptors imbued with
an enthusiasm for Negro sculpture saw in a cylindrical form a shape
sufficiently representative of a human torso; in an egg, a shape sufficient
for a human head. Brancusi became an enthusiast for this type of sculp-
ture and pursued it passionately.

<center>III</center>

Sculptural theorism and experimentation filled the artistic air of Paris
in the years just before and after World War I. European sculptors were
trying radical procedures, simplifications, exaggerations, and distortions
of all kinds in an effort to arrive at "significant form." Rebelling against
realism, against romantic attitudes and sentimental themes, they sought
to rediscover the basic elements of sculpture in order to erect a new set
of canons on logical foundations. But even within the ranks of the van-
guard the old dualism persisted, for where one group concerned itself
with form alone, the other dwelt on intuitive emotional values. The
American-born Epstein stressed emotional intensity by aggressively dis-
cordant forms and roughness of surface. Gaudier-Brzeska, a French
émigré in London, furthered the creed of "Vorticism." In the field of ex-
perimentation with pure form, Archipenko, a Russian, dissolved human

[1] Paul Morand, in his introduction to the catalogue of the Brancusi Exhibit at the Brummer
Gallery, 1926, wrote: "Brancusi is a born artisan. He knows nothing of pupils, assistants, stone-
pointers, polishers or cutters. He does everything for himself."

shapes into abstruse combinations of swellings, hollows, and open shapes with an ingratiating flow of line, in an attempt to approximate musical melodies and harmonies. Elie Nadelman, a Pole, smoothed the surfaces of his statues to fluent contours and adjusted forms to delicate proportions. The German, Lehmbruck, elongated his classic figures to pathetic expressiveness, although his fellow countrymen, most of whom were trained in Paris, were chiefly concerned with massive and powerful monumental and architectural sculpture.

Individual European artists, however, were not the only influences at work. The art horizon itself was spreading in time and space. Beatrice Gilman Proske[2] succinctly summarizes the effects of this ever-expanding horizon: Within the range of Greek art the uncovering of the Elgin Marbles directed artists' attention backward from the Hellenistic period and Praxitelean types of beauty to Phidias and fifth-century sculpture. Later the civilization of archaic Greece and Minoan Crete became known. Egypt continued to attract attention to the static monumental forms of its arts. Excavations during the late nineteenth century brought to light the art of Assyria and Babylon, and neighboring Persia. Japanese prints, on the admission of the French painters themselves, had a share in revolutionizing French painting, and Japanese decoration helped formulate *art nouveau*. Later, sculpture awoke to the aesthetic quality of Chinese, Indian, Cambodian, South Sea, and savage art. Pre-Columbian art in the Americas is the latest field to attract attention and to be added to the ever-expanding art horizon.

Because of the recognition enjoyed in Europe by the experimentalists Brancusi, Archipenko, Gaudier-Brzeska, and others, it was inevitable that their influence should be reflected in the work of those young Americans who, although trained at home, spent a summer or two in Europe. But it did not even require travel to Europe or study in the Paris ateliers to fall under the influence of these strong personalities. Newly founded American art magazines began to feature the work of these European sculptors, and leading American art galleries and museums to schedule comprehensive exhibitions of their work.

The Armory show at New York in 1913 brought to the startled attention of the American public most of the new European movements. Some

[2] Beatrice Proske, *Brookgreen Gardens, Sculpture* (Brookgreen, S.C., 1943), p. xxxii.

American artists almost immediately announced their adherence to these new art systems and became completely absorbed by their doctrines. Others used only certain elements as a veneer over familiar styles. The furor over the admission of Brancusi's *Bird in Space*—customs officials were at first unwilling to admit it as a work of art—focused the attention of even the lay public on abstract sculpture. From France came Gaston Lachaise to develop in America his individual aesthetic of bulky yet buoyant forms.[3] This treatment drew a certain following and reinforced the Maillol influence by substituting robust and generously proportioned shapes for slender, suave and sometimes seemingly expressionless relationships. Nadelman and Archipenko settled in New York. The latter founded a school which is still a formative influence on a number of younger sculptors. Meštrović, the Dalmatian, partly by way of the American exhibition of his work, and partly by way of commissions executed for America, added the emotional force and linear beauty of his Byzantine conventionalizations to the already numerous European influences.

IV

In the profusion of sculptural styles which were developing during the early twentieth century, one stands out preëminently. Solely on the basis of its widespread and powerful influence on American sculpture of the last two decades, its development can be thought of as representing a turning point in the evolution of sculpture in this country. This style, features of which still serve as foundation stones for our sculpture today, is primarily the conception of one artist. It is true that other sculptors experimented with or contributed to it in its early stages of development, but to Paul Manship belongs most credit for evolving it as a means for his own personal expression.

Manship's artistic style was formed at the American Academy in Rome, where he went as a holder of a fellowship from 1909 to 1912. Earlier recipients of this fellowship developed nothing new in their way of working, but Manship, appreciating the beauty of archaic Greek art, selected elements from it which he shaped into a distinctive style of his own. Other sculptors were attracted by his approach to design and his use of sound sculpture principles; they applied these principles, and

[3] *Gaston Lachaise, Retrospective Exhibition, 1935* (New York, Museum of Modern Art, 1935).

noting the effectiveness of the sculpture so created, were soon convinced of the value of this approach. Thus, the main features of Manship's style are dominant influences even today. His emphasis on design and his revival of integrated decorative elements operated to divert attention away from the romantic, impressionistic, and literary point of view, and resulted in a renewal of interest in the entire range of sculptural forms and devices and the concentration of attention on the organization of these forms into aesthetically satisfying compositions.

When he first exhibited his work in New York in 1913, Manship opened people's eyes to new shapes of beauty. The vague or irregular outlines of the impressionistic school were abandoned for precise, clear silhouettes. The modeling, though rich, was firm and smooth. Details were subjected to a schematic treatment which brought out all their decorative possibilities. From the archaic Greek he borrowed fishhook curls for the hair, flat parallel folds for the drapery, and scallops for the decorative border, but the playful spirit, the bold composition, and the appropriate use of studied detail counteracted any danger of mere imitativeness.

Through his remarkable perfection of technique there were made immediately popular the themes and ornamental treatment that he discovered in the art of older civilizations. Succeeding students at the American Academy in Rome fell in line with Manship, so that the archaizing style came to be associated with that institution. Other sculptors, even those who had been trained in the studios of the classicist Saint-Gaudens and the French impressionists, especially those working with architects, found that the simplification, conventionalization, and precise organization of design fitted in with the architectural style of the times and, therefore, often followed Manship's lead.

Notwithstanding his valuable contributions to design and the sound sculptural conception of his work, it is doubtful whether Manship's style would have exercised the strong influence which it did had he been an artist of less productivity. Manship is not only a gifted artist but a prolific one. Of course, like all outstanding and productive sculptors in Europe and elsewhere, he employs a large staff of assistants to help carry through his work. A chronological list of his important sculpture, published in 1927, included more works than any sculptor without assistance

could produce in a lifetime.[4] But it is to Manship's credit that he has trained these young sculptors to carry out his conceptions with no dilution in the quality of design. It is also to his credit that many of these men who obtained their early experience in his studio now rank among the leading sculptors of America.

Not long after his return from Rome, Manship was entrusted with the first of his many architectural commissions, the marble and bronze sculptures for the Western Union Building in New York. Concurrent with his work on his architectural commissions was his creation of studio pieces, most of which have found their way into museums and private collections. Much of his time and effort, however, was spent in designing garden sculpture and fountains. Here he had opportunity to allow his imagination free rein and to experiment with new sculptural principles. Fortunately for Manship, his sculpture attracted many art patrons with means and sufficient appreciation and interest to support his ambitious conceptions in this field, most of which were cast in bronze. The sculptures in the gardens of Mr. Herbert Pratt, Mr. William Mather, Mrs. Willard Straight, and Mr. Charles M. Schwab are a few examples of the many works of this kind which he created.

A consistently high quality of design and a continuously developing style are characteristic of Manship's work. Because of the masterful design of his statues, an objective analysis of the sculptural values in his work can readily be made. His *Atalanta*, a delicately modeled female figure in bronze, posed running against the wind, is a fine example of Manship's prowess as a sculptural designer. In this statue, the apparently moving figure is perfectly balanced on the thin support of one leg, and from its outstretched arms float the folds of a rhythmically flowing long drape. The design relationship between the flowing curves of the drape and the curvilinear quality of the figure is flawless. Even the shape and direction of the openings in the composition harmonize perfectly with the total conception. Representational though the figure is, and of so-called classic proportions, the shapes have been translated into pure sculptural masses which articulate successfully at the junction points.

In contrast to the delicate *Atalanta* bronze, the statue of *Europa and Jupiter*[5] is a compact sculptural mass, highly appropriate in conception

[4] Paul Vitry, *Paul Manship* (Paris, La Gazette des Beaux-Arts, 1927).
[5] *Ibid.*, plate 24.

and design for the marble in which it is carved. The composition is based on an opposition of curves—the long, taut curve of Europa's body opposed to the curve of Jupiter's turned neck and head. The projecting pointed horns are inserts of shaped and polished metal (a legitimate sculptural device). Europa's drapes, unlike those of the bronze Atalanta, are thick and heavy, thereby functioning as mass instead of line, and well suited to the characteristics of the material used for the statue. The rhythmical integration of the full-formed body of Europa with the massive form of the bull reaffirms not only Manship's mastery of design but also his appreciation of the sculptural properties of materials. Summarizing Manship's style, Proske writes: "He has the rare gift of historical imagination. He can project himself into another culture, extract its essence, and make it his own. What he took from archaic Greece was not so much the formal curls of hair and sharply folded garments as a way of seeing the human form; from Eastern art not so much certain postures as a sinuous grace, a concept of the body moving through space. These diverse elements are fused by the white heat of his imagination into something entirely his own."[6]

Later holders of the sculpture fellowship at the American Academy in Rome also contributed to the "design" movement initiated by Manship, and gave it additional impetus. Two of these were John Gregory, who held the fellowship from 1912 to 1915, and Paul Jennewein, fellowship holder from 1916 to 1919. Like Manship, both Gregory and Jennewein diverged from the late nineteenth and early twentieth century romantic style of sculpture to an approach more in harmony with the quality of design found in the archaic or early Greek statues. Gregory's style, in comparison with that of Manship, is less archaic, reminiscent of a later, more naturalistic phase of Greek sculpture. A purist and a classicist, attracted chiefly to garden figures and architectural sculpture, he consistently followed his special bent without seeking new and startling forms. His debt to classic art is more apparent in the total conception of his work than in any definite borrowing of detail. Striking design, clarity of execution, and all-pervading rhythm characterize his work. To Gregory's statue *Philomela,* a poetic little kneeling figure holding tiny wings, was given the medal of honor of the Architectural League in 1921. In this

[6] Proske, *op. cit.,* p. 308.

statue there can be seen the sure feeling for effective silhouette, rhythmic movement, and harmonious design that marks his other garden figures.

Jennewein was first captured by the rhythm and harmony of Greek ornamental carving, which is echoed in his earlier work—especially those compositions which he completed in Rome. Later, no longer dependent on classical models, he developed a style more truly his own, characterized by a mastery of linear rhythm and exquisitely designed decorative detail. Jennewein's pure design and precise modeling are well adapted to architectural sculpture, a field in which he has executed a number of important commissions, among them the gilt bronze figures on the entrance of the British Empire building, Rockefeller Center, New York, and the many reliefs and columnar figures for the Department of Justice building, Washington, D.C. His garden figures, less robust than either Manship's or Gregory's, are characterized by highly successful curvilinear design and delicate decorative treatment of detail. No portion of a Jennewein statue seems to have been slighted in its conception and execution. The design of a roll of curls in the hair is given the same careful attention as the modeling of the head itself. This is nowhere more clearly evident than in the exquisitely designed and modeled small portrait medallion *Jim*. Incorporated in another small medallion, a portrait of Theodore Shear, are all the subtle nuances of modeling that are characteristic of a young child's head. Such sensitive and superb modeling in small, intimate sculpture is achieved only as the outcome of an untiring observation of nature, a profound understanding of design, and a sure control of one's medium.

<div align="center">V</div>

During these early decades of the twentieth century, sculptors trained at the American Academy in Rome held no monopoly in the evolution of American sculpture. Men trained elsewhere in Europe or in America began to break away from the romantic, literary tradition of the late nineteenth century. In place of hazy, indefinite silhouettes, anatomical accuracy, and realistic tableau poses, they substituted clean-cut, rhythmical outlines and simplified forms which, though suggestive of the subject matter employed, were so shaped as to be aesthetically pleasing in themselves and sculpturally sound in design.

Another sculptor, whose skill in low-relief design has contributed

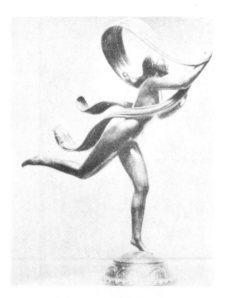
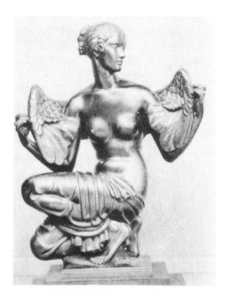

MANSHIP: Atalanta GREGORY: Philomela

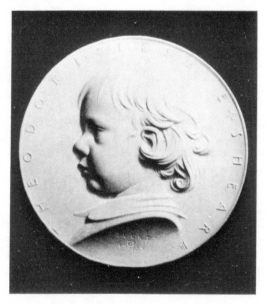

JENNEWEIN: Theodore Shear

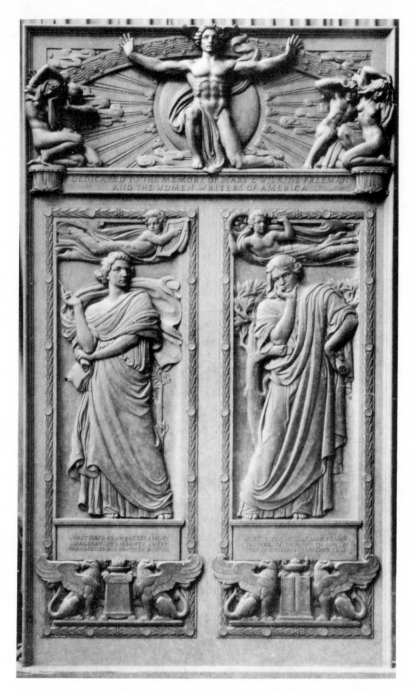

WEINMAN: Doors for the American Academy of Arts
and Letters Building

much to modern American sculpture, is Adolph Alexander Weinman. Without European study, Weinman has developed his talents so successfully that they have attracted as many important commissions to his studio as have been won by leading European-trained sculptors. Regarding the characteristics of Weinman's style, Proske states: "His early architectural sculpture, such as the panels for the Morgan Library and the façade of the Municipal Building, New York, is composed in the Classic-Renaissance manner, but the feeling for line and pattern and the masterly elaboration of decorative passages are already seen."[7] In his later work a stylizing tendency, with a greater emphasis on integrated design, becomes increasingly stronger; within the limits of assigned spaces he introduces a limitless variety of rhythmic movements and interplay of flowing line. Equally important is the success with which he creates, in his low-relief forms, the illusion of three-dimensional shapes. The Pegasus medallion used on the Saltus Award Medal of the American Numismatic Society[8] is an excellent example of Weinman's mastery of low relief within a small-scale area, and the bronze doors for the American Academy of Arts and Letters, New York, completed in 1938, present the widest array of his low-relief repertoire. The quality of three-dimensional relief and linear rhythm of the drapery in the large figures of the main door panels could well be used as a standard for these elements in this type of low-relief sculpture.

Modern American architecture, too, with its emphasis on design, function, and appropriate use of materials, has been a potent factor in the development of American sculpture. As in all ages, the field of architectural sculpture has provided sculptors the widest opportunity for the application of their talents. Few large buildings, even in times of greatest economy, are designed without some sculptural enrichment. Especially does this hold true for public buildings. To the average citizen, a permanent national, state, or civic edifice is inconceivable without sculpture either in the form of free-standing statues or bas-reliefs incorporated into the façade of the building. Because sculpture is thus used in connection with architecture, the prevailing style of architectural sculpture influences to a marked degree the entire sculptural style of a period. In

[7] Proske, *op. cit.*, p. 120.
[8] National Sculpture Society, *Contemporary American Sculpture* (New York, 1929), p. 328.

fact, during certain periods, for example the Gothic or the Romanesque, the style of architectural sculpture—the sculpture used on the churches and the cathedrals—is considered the style most characteristic of the era.

When architecture is derivative, when the forms and motifs of an earlier historical style are revived, the sculpture accompanying it is also invariably derivative. This is clearly seen in the revival of classical Greek and Roman architecture in the late nineteenth and early twentieth centuries. In the corresponding architectural sculpture of this period, not only were Greek mythological themes employed, but the sculptural treatment was confined to the narrow limits of Greek tradition. Hence, even much of the nonarchitectural sculpture of this period had a predominantly classical Greek flavor.

On the other hand, when architecture is nontraditional, nonderivative of historical styles, sculpture also tends to be nonderivative. When architectural forms result from a recognition of function, a respect for materials, the application of design principles, and a reflection of the politico-social system of the times, sculpture forms follow suit. It is under these circumstances that many of the outstanding sculptural styles of the past have evolved. It is also partly under the influence of similar circumstances prevailing in the field of present-day architecture that modern sculpture has evolved.

2 ˒ THE CARVE-DIRECT SCHOOL

RARELY DID a nineteenth-century American sculptor touch a chisel to the surface of marble, stone, or wood. Following the tradition of the period, he confined his creative efforts to designing his statues in a soft material such as clay. Upon completion, these designs were cast in plaster of Paris, and the plaster models became the patterns to which the professional stone carver referred when reproducing the sculptor's work in a permanently hard material. A few sculptors did follow their work through to completion, supervised the carvers, and even suggested minor changes in the final material. It was common practice, however, for sculptors to have no further contact with their designs once the plaster models left their studios for the carver's atelier. Even the carving of the sculptor's signature in the base of the finished statue was often entrusted to the craftsman.

The employment of professional stone carvers for translation of models into stone or marble is a practice still followed by many sculptors. A sculptor with numerous commissions would be able to complete within his lifetime only a fraction of the work entrusted to him were he to attempt carving all his work by himself. For this reason it is common for a busy sculptor to assign the carving of his work to artisans specializing in this craft, leaving the sculptor to devote his major efforts to the creative phase of his activities. In this he may be compared to an architect who confines his efforts to the design of structures on paper and, later, to the supervision of work during construction.

To facilitate the faithful reproduction of the sculptor's models into stone or marble the professional carver makes use of a mechanical device called a pointing machine, by means of which a point on the surface of

the sculptor's plaster model can be transferred to an exact point on the surface of the stone or marble. In principle the machine is a three-dimensional pantograph, a measuring device for recording, at one setting, the three dimensions necessary for locating a point in space. By locating a sufficient number of points on the stone, the carver assures himself of a close copy of the sculptor's original design. So adept and proficient are some of these carvers that their work may be considered facsimile reproductions of the original model.

When statues are cast in bronze, the sculptor also makes a clay model, following a procedure similar to that used when the statue is to be carved in stone. From the clay study he casts a plaster of Paris model which becomes the pattern for a mold into which molten bronze is poured. Upon removal of the mold there remains a rough-surfaced metal casting, a reproduction of the model in bronze. Chasing the rough bronze eliminates surface irregularities, sharpens details, and leaves a uniform finish ready for the oxidization or coloring process called patination. The method ensures that the finished casting is an exact duplication of the artist's work. There is little need for supervision by the sculptor once his plaster of Paris model is turned over to the foundry.

The practice of employing carvers to execute sculptor's models in stone, marble, or granite dates from the earliest Egyptian dynasties. Many of the masterpieces of Egyptian sculpture, for example the exquisite carvings of the Eighteenth Dynasty, were produced in this manner.[1] But at various periods in the history of sculpture, usually when a culture's art is on the decline, a gap occurs between the sculptor and the craftsman. More correctly speaking, a separation occurs between the sculptor and his materials; it is as if he divorced himself from his medium. As he becomes more and more engrossed in his expression in clay and less concerned with the medium in which the finished model is to be reproduced, his tendency is to create forms and designs ill suited to the final material. The models of such a sculptor, when reproduced in marble, often look as soft as the clay in which they were conceived. The marble lacks an appearance of solidity.

[1] See the illustrations of sculptor's stone models in *The Art of Ancient Egypt* (Vienna, Phaidon, 1936), p. 241, 242. When a new pharaoh mounted the throne, countless statues of him, in granite or stone, carved on a monumental scale, were erected at temple sites up and down the Nile Valley. They were all carved from the same model or models made by the master sculptor. It would have been impossible for one sculptor to have carved a fraction of these.

Designs in the submissive clay also permit of such inappropriate elements as flying draperies, unsupported outstretched arms, or body masses so distributed that they lack accord with the simplest laws of mechanics and will break when their marble or stone version is subjected to any unusual blow or vibration. In such sculpture there is little relationship between the forms and the sculptural properties of the material in which the completed composition is carved.

The character of form in the outstanding sculpture of all periods is intimately connected with the materials of which it is made. Steatite and onyx, for example, are not suitable for carving of great fineness and precision, because of their plane structure and because of abrupt changes in hardness or brittleness. Because they are easily broken they are carved with difficulty, and to the sculptor they suggest forms different from those suggested by the uniformly hard marbles and stones. Granite's hard and crystalline structure presents difficulties to the carver of minutiae which are not readily overcome; its consistency and coarseness of grain demand a broad treatment not necessary in other materials. Nuances of surface are also difficult to obtain in this material, and for this reason it is not an ideal medium for portraiture. Marbles, on the other hand, are generally close-grained, compact stones. They lend themselves to the carving of fine detail and are capable of taking a high, smooth polish. It is this latter characteristic that has given them their name, which is derived from the Greek μάρμαρος, meaning "shining stone."

Stone varies from the dull, completely opaque sandstone to the translucent, brilliantly high-lighted obsidian. In color it ranges from the pure milk white of Carrara marble to the shiny coal black of jet. Some stones are mottled, striped, or veined, but those that are uniformly colored throughout the block are preferable for sculpture. The size of crystals, grains, or units composing the stone, and the arrangement or compactness of these units, determine the stone's texture.

The principle of relation between form and material applies equally well to wood. There is a definite limit to the intricacy of detail appropriate for open-grained woods such as oak and teak, whereas in close-grained woods fine detail can be emphasized for enrichment and variety.

As much care has been given by some sculptors of the past to the proper relationship of shape and material in a statue as is given by

present-day diamond cutters to the most effective faceting for a rough diamond; not just any type of cutting will do for a given rough gem. In the Canova Collection in the Piazza San Marco at Venice there is a plaster model for a marble statue by Canova on which the points, which are few in number, are marked by metal pins projecting about 1/16 inch from the surface of the plaster instead of being marked on the surface with a pencil. According to the English sculptor Francis Sargant, the pins were so placed by Canova so that he would have a substantial "skin" of material to deal with when he should take over the finishing of his marble statue from the *formatore*. They also indicate Canova's recognition that marble, having a certain degree of translucency, requires a slightly greater volume than plaster for expressing a given mass.[2]

It is true that some sculptors are fully capable of creating in easily workable materials—temporary mediums—designs appropriate for translation into permanent mediums such as stone, granite, wood, or glass. They are able to conceive in plastic materials, like clay or plaster, compositions that are sculpturally successful when transposed into a hard material. Although approaching the carved statue by way of modeling in clay, they are able to keep in mind the peculiarities of the eventual material. They give due consideration to the translucency and fragility of marble and alabaster, the grain and texture of wood, the coarseness and stubbornness of granite, and the stability, play of color, and surface finish of bronze. They are like skilled designers in architectural and allied fields who with pencil and paper are able to create designs which are structurally sound and aesthetically satisfying when executed by craftsmen in the concrete, steel, glass, wood, or other material for which they were conceived.

But toward the end of the nineteenth and at the beginning of the twentieth century, artists who concerned themselves with the limiting sculptural possibilities of glyptic materials were few. During this period, the majority of the statues carved in stone, marble, and granite could more effectively have been reproduced in bronze. Little attention was given to the structural aspects of the carved material. Little appreciation was held for the aesthetic relationship between form and material—a relationship that causes a shape that appears appropriate in dense gran-

[2] Kineton Parkes, *The Art of Carved Sculpture* (London, Chapman and Hall, 1931), Vol. II, p. 14.

ite to seem ineffectual when translated into a medium with a semitrans-
lucent surface, like marble, or when cast in bronze.[3]

On this subject of the relationship between form and medium Jules
Campos writes: "Each material possesses characteristics which the
sculptor has to discover. They are the pre-sculptural dispositions such as
the shape of the block, the grain, the texture, the colour, the degree of
hardness, et cetera. It is the sculptor's task to harmonize his conception
with these pre-sculptural dispositions of the material."[4] In his harmonious
collaboration with his material the sculptor preserves the natural propor-
tions of the block—he conserves its volume.

It was almost inevitable that the complete disregard for materials of
sculpture, which characterized this period, should lead to an artistic
revolution. The first reverberations of this reaction were heard in the
United States at the time of the famous Armory Show in New York in
1913. Examples of the French *taille directe* school of sculpture were
seen for the first time in America at this exhibition. They aroused intense
interest among artists in general and stimulated younger sculptors to
experimentation along similar lines. Moreover, artists returning from
study abroad began to preach the new doctrine of carving direct. But
probably no single factor contributed more to the revival among sculp-
tors of an interest in working directly in glyptic materials than the influx
of European sculptors who migrated to America after World War I.
These men brought with them a knowledge of the latest developments in
European sculpture and a lively enthusiasm for them. Among these de-
velopments was the return to direct carving as practiced by Bernard,
Brancusi, Hernández, Zadkine, Meštrović, and Eric Gill. Starting with
the rough block of marble or granite, they frequently completed, unaided
by assistants, every phase of the work from the blocking out of the main
masses with the "point" (roughing-out chisel) to the laborious process of
polishing the surfaces by means of abrasive blocks and powders. Sculp-

[3] In the *Enciclopedia Italiana* one reads: "A plastic idea can only be born already conceived
in a given material, and not as an idea which can be expressed at will in bronze, marble, or wax,
et cetera. The statues of Michelangelo Buonarotti for Medicis' tombs, translated into bronze
(as they can be seen in Florence in the Piazzale Michelangelo) and subjected to a chiaroscuro
and to lights which are not appropriate for marble, are as absurd as certain famous oil paintings
translated into mosaics." Quoted by Jules Campos, *José de Creeft* (New York, E. S. Herrmann,
1945), p. 27.

[4] Campos, *José de Creeft*, p. 23.

ture to these artists, as to their predecessors of the Romanesque and early Gothic periods, meant loving the material, knowing its secrets, and being able to unveil them. It also meant that they must possess enough skill to impose their will on the block. As though bound by a religious prohibition, they refused to model, in clay, statues that would be submitted for actual carving to the craftsman, the *metteur aux points.*

The completed work of these sculptors, although surprisingly different from the conventional statues in museums and art galleries, was enthusiastically received by young artists and those who seriously concerned themselves with contemporary art. Wherever examples of the new sculpture could be seen—in museums, art dealers' galleries, fairs, or as illustrations in publications—new adherents to the idea of carving direct were enlisted. Some artists, trained in accordance with the prevailing rigid academic standards, were able, by means of the shift to this method, to liberate their individuality from the dead weight of conventions. Because of the absence of any formal standards except a strongly emphasized "respect for the material," an opportunity for free interpretation of subject matter and, thereby, an accentuation of personal expression was encouraged. In addition, the act of working in a hard material encouraged a subordination of realistic treatment to the development of types of conventional but highly expressive forms dictated by the nature of the material itself.

Cutting away rather than building up forced these sculptors to consider their carvings primarily in terms of mass. It forced them to see their compositions essentially as combinations of a few large, simple, geometric shapes. In carving direct, only the basic and essential shape can first be established. This method therefore encouraged sculptors to establish the relationships of these masses not on the basis of realism but on the basis of the abstract principles of design.

So far as most of these sculptors are concerned, there has never been a question of carving versus modeling—that is, modeling for bronze, terra cotta, glass, or other cast materials. Outstanding sculptors have both carved and modeled. Eric Gill, the English sculptor, wrote that modeling "is no less creative than carving; good modeling is every bit as good as good carving."[5] Certain subjects are unsuited to the solid, massive treat-

[5] Quoted by Jack C. Rich, *The Materials and Methods of Sculpture* (New York, Oxford University Press, 1947), p. 223.

ment of carving and are better adapted to terra cotta or bronze. In the past, masterpieces have been produced by both methods of sculpture. The charming and delicately modeled pottery tomb figurines of the Tang Dynasty, the elongated, graceful, bronze Siamese Buddhas of the Thai period, and the exquisitely sculptured Egyptian mummy coffins shaped from sheets of gold are examples of successful sculpture in modeled or built-up mediums. The beautifully designed and carved reliefs on the temple of Ankor Vat in Cambodia, the richly carved high reliefs on the terraces of the stupa at Borobudur in Java, and the elongated figures on the west portal of Chartres Cathedral are examples of what may be achieved by direct carving.

II

The feverish emigration from Europe following World War I brought to America the sculptors Heinz Warneke, Henry Kreis, Carl Schmitz, José de Creeft, Alexander Archipenko, and others of equal versatility. Some of these sculptors, like Warneke, Kreis, and de Creeft, devoted the major part of their creative efforts to carving direct. The others, although experienced in this approach, are better known by their works produced by other methods. Outstanding among the native American sculptors who carve direct are Robert Laurent, William Zorach, Ahron Ben-Shmuel, Richard Davis, Chaim Gross, and the Westerners, Ralph Stackpole, Donal Hord, and Robert Howard.

Robert Laurent.—One of the first modern American sculptors to use the direct-carving method was Robert Laurent. He was guided in his early training by Hamilton Easter Fields and Maurice Sterns, and absorbed some of their interest in the basic sculptural qualities of Negro, primitive, and Oriental carving. The imprint of this sound influence is seen throughout his work.

Laurent's first carvings were decorative panels. He later adapted flower and plant shapes to three-dimensional carvings in wood, in which he achieved a variety of highly effective curving, flamelike compositions, harmonious with the grained character of wood. One of these compositions, *Water Plant*, was awarded the Logan Purchase Prize in Applied Arts at the Chicago Art Institute Exhibition in 1924, by which time the carve-direct method had already met with "official" approval. Later, his emphasis on flower and plant designs in wood gave way to the carving

of bird and animal forms and then to a strong interest in the human figure as subject matter.

Laurent experiments in many mediums. It is in alabaster, however, that he is most prolific and successful as a carve-direct sculptor. In this semitranslucent medium he achieves a voluptuous and voluminous quality of rounded forms well suited to its particular character. These forms he composes into compact masses with no extraneous protrusions, undercuts, or delicate detail to destroy or distract from the compactness of the whole.

William Zorach.—It was after years of training and experience as a painter that William Zorach, another exponent of the carve-direct school, became interested in sculpture. This interest developed by way of a casual experiment in carving a butternut panel from an old bureau. He discovered from this experiment that, as compared with his early adventures in art, "sculpture, direct carving, was an expanding universe, a liberation and a natural form of expression."[6] Later experiments led to carving figures in tree stumps, large compositions in mahogany timbers, and eventually, statues in marble, stone, and granite. Zorach's greatest adventure in sculpture, however, is his *Mother and Child* which he carved out of a three-ton block of marble with chisels and hammer, unaided by power-driven tools or assistants.

Examples of his carving talents, from the very earliest to the latest, are characterized by a representational type of form and a free type of composition. Unlike those sculptors who rigidly adhere to the original shape of the block, the result being a monolithic type of composition, Zorach uses a looser organization of form. Even in some of his earliest work he makes use of openings through the mass which add interest and variety to the total effect. Carved in York Fossils (a close-grained stone), his statue called *Affection* (plate 93), showing a young girl embracing a dog, exemplifies the artist's appreciation of the relationship between material and sculptural volumes as well as the formal aspects of design.

Heinz Warneke.—Warneke's background is a thorough and "strictly academic" training in the German tradition. But fortunately it has also included vacation periods given over to the practical application of formal studies. This practical work consisted of carving in stone or wood

[6] *Painters and Sculptors in Modern America* (New York, Crowell, 1942), p. 128.

in a sculptor's studio or shop where actual commissions were in process of execution. When at the end of his formal classroom studies he was assigned a master's studio at the Berlin Kunstgewerbe Museum, he carved in both wood and brass as mediums in which to search for an individual style.

Sculpture created by Warneke since his arrival in America in 1923 attests to his continued interest in carving. Most of his statues have been carved in wood, marble, granite, brick, or even brass. For the brass carvings the composition is cast in a rough general shape and is then cut or chiseled away to a depth of at least a quarter inch to uncover his final conception. Some of his small pieces are carved directly out of a solid block of metal.

Much of his subject matter he selects from the animal world, by which he is greatly attracted, but he also uses the human figure singly and in groups. His compositions are characterized by strong emphasis on large, simple masses, knowingly integrated one with the other by flowing transitional surfaces that appear unerringly correct. Rarely are abrupt changes employed at the junctions of these masses. The all-over composition is delineated with rhythmically flowing and clearly defined outlines. These characteristic features of his work can be seen in his *Deer Startled*, in carved brass, *Rearing Stallion*, in ebony, *Mother Cat and Kittens*, in Belgian granite, and *Cat*, in marble (plate 87).

Henry Kreis.—Like Warneke, Henry Kreis arrived in America with a thorough background in carving. He obtained his experience from four early years of apprenticeship to a tombstone carver and later from art-school vacation periods during which he carved figures in the studio of a leading German sculptor. The art school which he attended was conducted by the government and thus had every conceivable type of sculpturing equipment. There was practically no limit to materials; even ton-sized blocks of marble were available for those students who the instructors believed were ready for them.

Tombstone cutting, and then carving statues for other sculptors were Kreis' first undertakings in America. When Joseph Urban, the architect, commissioned him to do eight heroic figures for the International Magazine Building in New York, his experience with glyptic material and

[7] Illustrations of all three works are shown in *Painters and Sculptors in Modern America*, pp. 116–117.

appreciation for it were fully realized. Five years as assistant to Paul Jennewein and Paul Manship completed the formative period of his career. This was a period of thorough training, application of knowledge, and rich variety of experience.

Viewed subjectively, Kreis' work is quietly persuasive rather than dramatically insistent. As formal design it is a successful translation of subject into sculptured masses and an integration of these masses into coherent, well-organized compositions. The forms are highly simplified, at times approaching cubic treatment. The transitional movements from form to form are frequently angular. His *Eagle,* in blue stone (plate 81), and *Figure,* in Georgia marble (plate 11), are examples that display these characteristic features.

José de Creeft.—In the shop of a Barcelona *imagier* which he entered as an apprentice at the age of 13, José de Creeft observed for the first time the process of carving. He watched and admired his artist-craftsman employer carve with devotion and skill his saints and madonnas. He was thus inspired to express himself by carving directly in wood and stone. Later, while studying sculpture in Paris, in order to obtain practice in reproducing his models in stone he sought employment with Maison Greber, famous *metteurs aux points.* In this stone carvers' workshop he had his first real experience with blocks of wood and stone, the raw materials of sculpture.

Three years of reproducing in stone the designs which other sculptors had modeled in clay gave him a sound appreciation of materials. He set up his own sculpture studio in Paris, shortly after World War I, and moved to the United States in 1928. In the beginning he followed the traditional method of the *metteur aux points* for executing his work— modeling in clay, casting the composition in plaster of Paris, and then, with the aid of the pointing machine, translating the model into stone. He soon found that he had constantly to fight against the constraint imposed by the model, which denied expression to thoughts suggested by the stone as he worked on it. Therefore, he tried next the classical method of Michelangelo. This method makes use of a small *maquette* (a rough sketch model in modeling wax or plaster) as a guide for arriving at the main lines and masses; but the *maquette,* like the full-sized model, also proved an encumbrance. As the carving progressed the changing

shape of the block suggested new conceptions which were improvements over certain elements in the original sketch. This finally led de Creeft to work directly on the block, unconfined by any previous preparation. Creation and execution became simultaneous acts.

All of de Creeft's carved statues give evidence of his conscious adherence to the original shape of the block—an adherence which makes for a compact organization of forms, like that found in his *Maya,* carved in Belgian granite (plate 3) and *Suzanna,* carved in ebony.[8] The forms themselves are characteristically full, bulging, and at times richly voluptuous. Now and then, surfaces of otherwise bulging forms are flattened, creating in part of the shapes a cubic effect. A flowing, rhythmical line silhouettes the majority of his compositions.

Ahron Ben-Shmuel.—As a way of earning a living in his youth, Ahron Ben-Shmuel chose working in a stoneyard. During a three year's apprenticeship as a monument carver he learned much about carving and the properties of stone. In the intervals between routine jobs at the yards he did a great deal of work for other sculptors—reproducing their models in stone. This work in resistant material compelled him to consider the mechanical as well as the purely expressive or representational consequences of each move. In his first try at sculpture in wood, the long taper of the fox's nose he was carving taught him how to work with the grain of his material, and the varying texture of the wood forced him to cut carefully at details—the eyes and the ears. His statue *Wrestlers,* in Quincy granite, shows his power of design as well as his versatility in carving such obdurate material.

Richard Davis.—Richard Davis obtained his stone-carving experience from Ben-Shmuel, whom he describes as "an artist of sincerity and integrity, a good teacher, and a superb craftsman." From this experience, Davis found that "the very hardness of stone and the relative slowness of carving permits and even forces the carver to concentrate on shape rather than meaning or idea. And the greatest carvings are those which have the most perfect marriage of the idea and the form, the now perfect relationship between subject and material."[9] Perhaps no single piece of his shows better this "perfect marriage of idea and form," as well as of form and material, than his portrait of Maimé Tse, carved in alabaster (plate 1).

[8] Campos, *op. cit.,* plate 20. [9] *Painters and Sculptors in Modern America,* p. 146.

Chaim Gross.—If several different materials—a dark wood, a light wood with colorful grain, a piece of marble, and a block of granite—were given to Chaim Gross with an order to make a figure from each, the results would not be the same. According to him: "In each case I would be concerned not only with synthesizing in a pleasing manner the forms of the figure, but also with the character of the material—its texture, grain, color and hardness."[10] Form and material to Gross are like two opposing forces in mechanics. It is through the synthesis of the two forces that his statues are produced.[11]

Stackpole, Hord, and Howard.—Each of the three Western sculptors, Ralph Stackpole, Donal Hord, and Robert Howard, has his own definite preference with respect to the kind and hardness of stone or wood in which he carves and the particular manner or style in which he works. Stackpole has a strong penchant for massive monolithic monuments in granite. Hord works in both stone and wood, but only in the hardest varieties of each. Obsidian, the material in which he carved *La Cubana* (plate 6), is one of the hardest and most difficult-to-work stones known to sculptors. Howard is the leading experimenter of the group. His carvings in wood display much inventiveness and a spirit of exploration.

III

The belief of de Creeft and other sculptors, that one should work directly on the block unconfined by any previous preparations, is not shared by all exponents of direct carving. Many sculptors qualify the doctrine of the carve-direct school. They concede that even if the sculptor makes a model, large or small, for the translation into stone, but does his own cutting, he is bound to avoid a plastic effect in the finished work. By carving direct he becomes aware of the properties of his material and, in turn, consciously or subconsciously imparts a glyptic quality to the finished work.

Other sculptors use a model or sketch as the purpose, size, and material of the projected statue may require. Charles Rudy, whose sculpture is received with acclaim in exhibitions and by collectors, does much of his work, like de Creeft, without preliminary sketches. For one of his

[10] *Ibid*, p. 142.

[11] The set of illustrations in Rich, *op. cit.*, pp. 50–51, dramatically portray the evolution of a Gross carving from the preliminary drawing to the completed work.

carvings, *The Sisters,* he simply began with the idea of doing two chil-
dren. As he carved, "the composition seemed to come naturally into the
discipline of the stone—the form and feeling with it."[12] But he often makes
small rough sketches of an idea, then adapts them to a larger size and to
the final material; and with some commissions and architectural sculp-
tures he feels that a detailed sketch is imperative. For the former, he
sketches out the size and scale in rather exact detail for use as a guide,
and then begins working directly in the material, checking a few points
and measurements, changing here and there when it seems necessary.
For the latter, he uses carefully studied scale models from which he faith-
fully points up the full-size statue. Whatever changes he makes on the
full-scale work he does within the limits of certain main points.

Richard Davis also advocates the use of sketches for carved sculpture.
For him, it is "sometimes necessary first to work out a great many sketches
on paper or in clay," to determine the basic composition and to provide
opportunity for studying the anatomy and character of the natural forms
to be used, before he carves into the block. "Once these facts are well in
mind, carving in the stone will establish the dialect and the idea will be
translated into the idioms of the particular stone."[13]

The sketch occupies a definite and important place in Kreis' method
of design. He resorts to small sketches in soft material to solve many of
his problems. In experimenting with ideas for future use he makes small
terra-cotta figures, seldom more than five inches tall, and never, except
for architectural work, a carefully studied plaster model for pointing up
a carving. For him, a small sketch is a sufficient guide, enabling him
readily to make changes suggested by the roughed-out stone as carving
progresses.

It is known that many sculptors of the past made use of small studies
in wax before they began to carve in the stone block. The purpose of a
sketch was to clarify in the sculptor's mind the three-dimensional aspect
of his composition and to assist him in achieving it in his material. Some
of the preliminary wax sketches that Michelangelo made for his stone
carvings are still extant and can be seen in European museums. He used
these studies as working guides for his large-scale statues. Before carving
the statue of David, he made several three-dimensional wax sketches,

[12] *Painters and Sculptors in Modern America,* p. 104.
[13] *Ibid,* p. 144.

which were about a tenth the size of the marble block and were carefully worked out in detail. Several wax fragments of limbs for the *David* are in the Victoria and Albert Museum at South Kensington. Benvenuto Cellini, like most sculptors of the Renaissance, advocated working out compositions in a soft material before beginning carving on the block of stone. His description of this method, as given in his treatises, is quite detailed.[14]

Whether sketches are or are not used in direct carving, this school has strongly influenced the development of sculpture in modern America. The more emphasis placed on the stone, marble, granite, or wood of which a statue is made, the less emphasis on the storytelling and solely representational character of the work. The result of this approach is a trend in sculpture which, similar to that in modern architecture, is away from romantic, traditional standards and the mere copying of historical styles. It encourages a subordination of realistic treatment, the development of stylized but expressive forms, and a greater freedom in the interpretation of subject matter.

[14] "To succeed with a figure in marble the art requires a good craftsman first to set up a little model about two palms high, and in this model he carefully thinks out the pose, making his figure draped or nude as the case may be. After this he makes a second model of the size his marble is to be; and if he wants it to be particularly good he must finish the large model much more carefully than the small one. If, however, he be pressed for time, or if it be the will of his patron who needs the work in a hurry, it will suffice if he complete his big model in the manner of a good sketch, for this may be quickly done, whereas the working out in marble takes a long time. True it is that many strong men have gone straight for the marble with all the fury of the chisel, preferring to work merely from a small and well designed model, but, notwithstanding, they have been less satisfied with their final piece than they would have been in working from a full size model. This was noticeable in case of our Donatello, who was a very great man, and even with the wondrous Michelangelo, who worked in both ways. But it is perfectly well known that when his fine genius felt the insufficiency of small models, he set to work with the humbleness to make models of the size of his marble; and this we have seen with our own eyes in the Sacristy of St. Lorenzo." Benvenuto Cellini, *The Treatises . . . on Goldsmithing and Sculpture,* trans. by C. R. Ashbee (London, Edward Arnold, 1898), pp. 135–136.

3 , CREDO
OF MATERIALS

I N TWENTIETH-CENTURY SCULPTURE the return to direct
carving is not an isolated phenomenon; it is part of a
much larger movement that deals with the effective aes-
thetic use of all sculptural materials and the proper methods of working
in them. The gap which at the beginning of the twentieth century sepa-
rated the sculptor from his carving materials—his marble, granite, stone,
and wood—also separated him from full aesthetic mastery of the other
traditional materials. The nineteenth-century sculptor's concentration
on his designs in clay and his exaggerated emphasis on virtuosity of mod-
eling resulted in failure to exploit fully the sculptural possibilities of
bronze, iron, terra cotta, glass—in fact, all of the cast, wrought, fired, and
pressed mediums. This disregard for materials is clearly exemplified in
the work of Rodin. Not only were his marble statues merely records of his
studies in clay, but so were his bronzes. Rodin's translation of his models
interchangeably, without revisions, into carved or cast materials clearly
evidences his lack of regard for the inherent sculptural properties of the
respective mediums.

This disregard for materials, which characterized nineteenth-century
sculpture, engulfed all the plastic arts. In architecture, it manifested
itself by the way in which designers used cast iron when its properties
as a building material were first discovered. The first structural iron
forms were cast to simulate carved stone, faithful even to the joints in
the masonry and the Corinthian capitals on fluted columns.[1] In pottery,
the same disregard is seen in those examples of Wedgewood that were
meant to be "works of art" instead of useful wares—the copies of Greek
pottery prototypes or their adaptations to modern uses which Wedge-

[1] Walter Teague, *Design This Day* (New York, Harcourt, Brace, 1940), p. 72.

wood instituted in an attempt to raise the art of the potter to the position it enjoyed during the Grecian period. As the shapes of the Greek vases—the kylix, pyxis, lekythos, of the best period—were copies from or intended to emulate metal-work, they lacked true ceramic quality.[2] Moreover, the painted decorations, although created by the skillfully wielded brushes of artists, and notwithstanding their exquisite draftsmanship, exhibited slight sympathy for the plastic qualities of the clay. On the other hand, Wedgewood's useful wares, the shapes of which evolved naturally from the clay materials and the methods of production, have survived as the archetypes of the best wares being made by his firm today.

The separation of the artist from his medium and the inappropriateness of the resulting forms are attributed by some writers to the coming of the machine age, in which the machine, as an instrument of reproduction and mass production, replaced the hand tool directly guided by the skilled artisan. "In a sense every tool is a machine—the hammer, the axe, and the chisel. And every machine is a tool."[3] The real distinction here, however, lies in the attitude of the artist toward his tools; whether he takes them and his materials into his confidence as he creates individual objects or designs for reproduction, or whether he slights them and is unconcerned about the materials and methods by which his work is to be executed. It is because sculptors of the nineteenth century had the latter attitude that their activities in the plastic arts are thought of as an outcome of the machine age.

Before the machine age, craftsmen had the advantage of working directly with their materials. In the slow-moving conditions of their era there was time to get the feel of materials and to master them, to try out all their possibilities and to perfect the techniques of their use. There was opportunity to discover what could be done with the substance at hand and to weed out all inappropriate or impractical applications of it. The problem of fitness of form to materials, as of form to function, worked itself out naturally, without hurry, but with a good deal of certainty.

Toward the end of the last century, however, many designers and craftsmen were preoccupied with the transition from manual to machine production. Instead of pressing forward to attack the new problems of

[2] Gisela Richter, *Attic Red-Figured Vases* (New Haven, Yale University Press, 1947).
[3] Herbert Read, *Art and Industry* (London, Faber and Faber, 1934), p. 38.

design postulated by this unprecedented transformation, some crafts-men remained content to borrow their styles from antiquity and to per-petuate historical prototypes in decoration.

Even in his use of traditional cast bronze the nineteenth-century sculp-tor was ordinarily divorced from his material and from his "machine" for reproduction. It is true that, unlike carvings in stone reproduced from a model by a *metteur aux points,* a bronze casting can be a faithful fac-simile of the sculptor's model.[4] By means of a mold made directly from the model the finest details can be reproduced with uncanny precision; hence there was a tendency during past centuries for sculptors to con-cern themselves but little with the mechanical aspects of reproduction and the finishing of castings after they were removed from the molds. Under such circumstances almost no incentive was aroused for the ex-ploitation of the intrinsic physical and aesthetic qualities of cast metal, its degree of ductility or malleability, its range of natural color, its in-herent brightness, its susceptibility to polish or applied coloration by means of acids or enamels. The obvious high tensile strength and high weather-resisting properties of bronze were recognized by almost all sculptors. Experience had proved that attenuated forms, thin projecting elements, flying drapery, and an open distribution of masses could be safely achieved in this traditional metal, and its properties which allowed these achievements were accordingly put to use; but almost all its other properties were left unused or were improperly used. In the typical American art academy of the period little if any distinction was made in the designing of bronze statues to be cast by the lost-wax process or in a sand mold.[5]

In Europe, especially in Germany, during the first two decades of the twentieth century some of the ambitious student sculptors escaped the pitfalls of the typical art courses by supplementing their training with work in a master sculptor's studio. Here they had opportunities to be-come acquainted with materials by working on actual commissions in the process of execution. It was in this way that sculptors like Warneke, Kreis, and Schmidt obtained experience in working directly with mate-rials, thus bridging the gap between design and execution.

[4] For a detailed description of the casting process see Jack C. Rich, *The Methods and Materials of Sculpture* (New York, Oxford University Press, 1947), pp. 135–141.
[5] For explanations of these two processes see Rich, *ibid.,* pp. 141–156.

Kreis' description of one of these master sculptor's studios, that of his instructor, Professor Wackerle, which was in the same building as the Art Academy, is revealing. Fortunately, even in Wackerle's regular class the "credo of materials" was fostered. According to Kreis' description of this sculpture class: "He had it so arranged that everyone was working on something individual. I did mainly woodcarving—a chest, a door. Someone else built up a fountain in plaster to be cast in iron later, others carved medals or coins in the negative cut technique, someone was stone carving, another had a commission for a building or carved a candlestick or built up figures directly in terra cotta. There was a bronze caster in the school, a class to hammer metal, a kiln . . ." in short, experience in every medium was available. "Concerning the use of materials, I heard the opinion of a man of taste and ability, and noticed how a design was changed and why. He had only fifteen students or so, but he picked mainly those who had learned something before in one field or the other. So it came about that he was only the guide, while each student was the other's teacher. This type of school where the workshop idea is of primary importance seems to me the ideal art school."[6]

One of the first sculptors to concern himself with the inherent sculptural properties and possibilities of each of his mediums was Brancusi. After a short period of highly academic expression, his virtuosity in handling material gave way to the barest simplicity and directness of form. He employed the orthodox materials of sculpture—metal, wood, and stone—in such a way as to display their individual properties and not to simulate those of other materials. He exploited the lightness and apparent unsubstantiality of a polished metal surface to suggest a bird in flight or the shimmer of a fish. He carved a timber in accordance with its structure, grain, and tensile strength. He polished the surface of an egg-shaped mass of marble to accentuate the rich fullness of the form, the translucency of the surface, and the intriguing crystalline structure of the material itself.

II

After World War I, a respect for materials began to manifest itself slowly in American fields of art design, and to understand it, it is necessary to examine further the changes that were taking place there at this time in

[6] *Painters and Sculptors in Modern America* (New York, Crowell, 1942), p. 148.

the training for the plastic arts. The initial impetus for this interest in materials came from Europe.

The outstanding organized attempt to indoctrinate art students with an appreciation of the materials of design was instituted at the German Bauhaus. The backbone of the Bauhaus system was the preliminary course, the foundations of which were laid by Johannes Itten. He was the first collaborator that Gropius, the founder of the school, invited to join the staff. Itten's teachings stressed, among other things, representation and experimentation with actual materials, and plastic composition with various media. In part this supplied a phase of training which was present in earlier centuries when there was no academic instruction in the arts or crafts and students were taught independently by a master who was a craftsman as well as an artist.

Unprecedented as they were, the Bauhaus doctrines were taken up by other European art institutions and then spread to America. According to the Bauhaus system, "to experiment is at first more valuable than to produce."' Therefore the artist does not begin with a theoretical introduction, but starts working directly with the materials. The basic workshop in which this work is done is an important factor in his development. The student artist experiments with tools and machines, and with different kinds of material such as wood, metal, rubber, glass, textiles, paper, or plastics, unhampered by conventions. No copying of any kind is employed in this workshop, nor is the student artist asked to deliver premature practical results. By working with the different materials he discovers step by step their typical possibilities and acquires thorough knowledge of their appearance, structure, texture, and surface treatment. He also becomes conscious of volume and space—fundamentals in three-dimensional design. In this way his ability to construct inventively and to learn through observation is developed—at least in the beginning—by undisturbed, uninfluenced, and unprejudiced experiment; by the free handling of materials, without practical aims. In order to make certain that firsthand manual knowledge of the materials is acquired, the student's use of tools is restricted; typical treatments and combinations of materials are analyzed. To gain further knowledge about wood, for example, he visits workshops, where different character-

' Herbert Bayer, ed., *Bauhaus [1919–] 1928* (New York, Museum of Modern Art, 1938), p. 116.

istics of flat grain and quarter-sawed grain, bent and laminated wood, and the methods of joining, gluing, nailing, pegging, and screwing are actually observed.

In Bauhaus training, the most familiar methods of using materials are summarized and their use is, for the time being, forbidden. The study of paper offers an instructive example of the way this approach is applied. In handicraft and industry this material is generally used lying flat; the edge is rarely utilized. For this reason paper is experimented with standing upright, or even as a building material; it is reinforced by complicated folding; the edge is emphasized. Paper is usually pasted, so instead of following this procedure the student ties, pins, sews or rivets it; fastens it in a multitude of ways. At the same time, he learns its properties of flexibility and rigidity and its potentialities in tension and compression, and finally, after he has tried all other methods of fastening, he pastes it.

Training based on "respect for material" also stresses the inherent surface properties of a medium and distinguishes these characteristics one from another. "Structure" refers to those qualities of surface which reveal how the raw material grows or is formed, for example the grain of a wood or the crystalline structure of a granite. "Facture" refers to the qualities of surface which reveal how the raw material has been treated technically—as the hammered or polished surface of a metal or the wavy surface of corrugated iron show how they have been worked upon. "Texture" is a general term which refers to both structure and facture when both are present. The texture of a polished wood reveals both the structure (grain) and the facture (polishing), but the surface of a freshly broken piece of marble shows only the structure (crystals). Surface qualities can usually be perceived by sight and often by both sight and touch. The structure of highly polished wood, for example, can be perceived by eye but not by touch; the facture of the low relief on a coin can be perceived by sensitive fingertips, but far more easily by the eyes. The texture of a roughly hewn boulder carving can be readily perceived by both hand and eye.

No two materials have exactly similar texture. By grouping specimens of surfaces of different materials in scales and series a device may be obtained on which one can learn to detect tactilely the minutest differ-

ences and subtlest transitions in surface quality—hard to soft, smooth to rough, warm to cold, straight-edged to shapeless, and polished to mat. A similar device can be made to show visual qualities of surface—transparent to opaque, unpatterned to grained, clear to cloudy, and fine-tooled to coarse-tooled.

<div align="center">III</div>

In order to be independent of the traditional use of media some sculptors create original compositions, using a great variety of materials in completely unorthodox ways. Out of such apparently outlandish substances as corrugated metal and wire netting, plywood and bent plastics, matchboxes, phonograph needles and razor blades, they fashion compositions unlike anything ever seen before in traditional sculpture. This approach to sculpture has given rise to a distinct movement called "constructivism," and the resulting works are called "constructions."

Constructivism is said to have originated in Europe as an extension of cubism as used in painting by Picasso and Braque. By pasting fragments of newspapers, tickets, and other odd bits of paper on a background and completing the design with paint or pencil, the cubist painter formed a composition which he called a *collage*. The *collage* not only provided interesting new surfaces but also proved the artist's emancipation from the exclusive use of traditional methods and media.

In 1913, Picasso carried this *collage* technique further by pasting on cardboard various solid objects—pieces of glass, wooden spools, sections of lath, and other odds and ends—and framing the whole as a kind of relief. About the same time, other European artists began to produce similar reliefs, utilizing a far bolder variety of materials and a more abstract conception of design. Some of these constructions were in glass, metal, and wood on plaster, with depth not unlike that of relief sculpture, and were entirely free from the trivial surface treatment of cubist *collage*. These constructions led to three-dimensional compositions and later to arrangements that could be suspended by wires, eliminating not merely the framed background but also the solid base or pedestal of conventional free-standing sculpture. Added significance was given to these constructions by eliminating traditional media such as bronze, marble, and wood and composing with the new industrial materials, glass, wire, sheet metal, celluloid, plastics, or concrete.

The American sculptor whose style is most closely linked with that of the European constructivists is Alexander Calder. His interest in open composition, stressing the nontraditional use of materials—the direct antithesis of the compressed unity of traditional material which is characteristic of the work of Brancusi,—is the same as theirs. Starting as a representational primitive, Calder has now arrived at complete abstraction. Although he uses a wide variety of material (wood, wire, sheet metal, pipe, and plywood), his characteristic medium is metal, especially in flat form. He has always avoided modeling in favor of direct handling—cutting, shaping with a hammer, or assembling piece by piece. This approach has fostered a simplicity of form and a clarity of contour in his work and has allied him with those other explorers into the realm of three-dimensional plastic form—Hans Arp, Henry Moore, and Giacometti.[8] Calder's repertoire is quite varied and includes stabiles (nonmovable, base-supported compositions), mobiles (movable, suspended, or supported compositions), and motorized mobiles (movable compositions operated manually or by motor power).

To the person who thinks of sculptural form only in terms of stone with its massiveness and weight, the light, flat, or attenuated metal forms in the mobiles or stabiles of Calder and other sculptors working in the same idiom will seem unstable, thin, restless, and dangerous. Actually, metals in general have structural, factural, and textural properties quite distinct from those of stone, and it is only when the properties of a metal are exploited to the fullest that a sculptor achieves the most effective expression of his ideas. Metal can be used sculpturally in several ways. Its use as a positive material for casting purposes, for example, cast bronze, has already been referred to. It may also be employed directly as a quasiplastic repoussé medium and beaten or hammered into a desired shape—usually in thin sheet form. Metal may also be wrought; that is, the mass of metal may be heated and hammered into form on an anvil while the mass is hot and plastic; and many metals can be ground to a sharp edge, producing crispness of detail not practical in stone.

In recent years, the use of sheet metal for sculpture has received a strong impetus from the rich and full-formed hammered sheet-lead sculpture of José de Creeft and the ingenious sheet-copper reliefs of Saul

[8] James J. Sweeney, *Alexander Calder* (New York, Museum of Modern Art, 1943).

Raizerman. In developing his sheet-lead sculpture, de Creeft first hammers out the basic shapes of his composition from the back of the sheet with a broad-headed wooden mallet. The initial design drawn on the face of the sheet before work begins requires frequent revisions at this stage of the work. After the large masses have been hammered out from the back, they are given more definite shape by working on them from the front. Final shape and details are achieved with small fiber mallets and punches. To prevent twisting and warping of the completed sculpture, the hollow metal shell is reinforced with cross members inserted through the opening in the back. De Creeft's hammered-lead heads, *Himalaya*, in the Whitney Museum of American Art, and *Rachmaninoff*, awarded the First Sculpture Prize at the Pennsylvania Academy of Art, 1945, are superb examples of his work in this medium.

IV

For thousands of years the list of available sculptural materials remained unchanged. There were few materials used by sculptors at the end of the nineteenth century that were not known in Rome during Augustus' reign. A sculptor was dependent on the resources which nature had put in his way; he was limited to the materials that were found ready at hand—stones, woods, metal, plastic earths and waxes, ivory, bone, and horn.

But today, countless new and improved materials for modern sculpture have been made available, the results of research by chemists, physicists, and metallurgists. From the investigations of these men come the materials most characteristic of our time—new materials for which the progressive sculptor finds appropriate forms and effective application. It is to the scientists that sculptors owe light-weight metals, for example aluminum and magnesia alloys, and noncorrosive metals such as stainless steel, chrome and cadmium plate, and anodized aluminum. There are also the many plastics derived from cotton and wood fibers, resin, soy beans, milk, and many other surprising sources. These plastics can be molded into almost any form, pressed or laminated into sheets, and extruded as rods and tubes.

A plastic substance is any material that can be softened and cast, molded, or pressed into a desired shape. In modern technology, how-

ever, this term has taken on a new meaning and refers specifically to the large group of recently discovered synthetic materials having these properties. Among the most important characteristics of synthetic plastics are lightness of weight, ease of shaping by modern machine methods, permeability to dye of virtually any color, and the varying degrees of transparency or translucency in which they can be produced—from crystal-clear Plexiglas and Lucite to completely opaque phenolic resin. When employed for casting purposes, plastics are generally more economical than metal and less fragile and more permanent than plaster of Paris. Gelatine, plaster of Paris, and, more commonly, latex rubber are the materials used for the molds into which the plastic in liquid form is cast. For small objects solid casting is employed, but for large sculpture masses the most efficient method is slush casting or slush molding, which produces a hollow cast.

Plastics and other recently discovered materials such as magnesium, aluminum, and stainless steel may materially revolutionize the sculpture of our era. An example of how a new material can decidedly influence an entire art is seen in the French cathedral architecture of the eleventh and twelfth centuries. France of this period saw a remarkable advance in the making of colored glass and stained-glass windows. The Gothic builders, eager to use this glass in larger and larger areas, designed and constructed higher and wider palaces for Our Lady. As they developed ribbed vaulting and the flying buttress, they contracted the masonry walls and enlarged their openings. In the end they succeeded in building great structures which are mere skeletons of masonry, framing huge screens of glass. Gothic glass, therefore, is thought by some art historians to have been the cause, and not the result, of the most striking characteristic of Gothic building—the attenuated skeletal structure.

The true nature of a new substance must often be revealed by stripping away the disguise in which it comes to the sculptor. Reactionary prejudices cause a surprising number of valuable achievements of scientific research to be presented as cheap substitutes for familiar but more expensive materials. Most plastics, now indispensable aids to modern fabrication, were originally promoted as imitations of other materials—and never deceived the knowing. These attempts at imitation have only confused the potential user and obscured, for a time, the special qualities

of these modern materials not possessed by wood, ivory, marble, or any of the other older materials. But intelligent sculptors and designers are freeing plastics from pretense and giving them true aesthetic status. "There is no need to apologize for a material that can be moulded in the most difficult forms, is hard, durable, colorful, light, pleasant to the touch and relatively inexpensive."[9] The sculptor's problem is only to understand the nature of plastics and to use them intelligently. He must know where the slightest inevitable tendency of molded plastics to shrink and warp can be tolerated and where it cannot. Chiefly, he must know how to create forms that will bring out a plastic's sparkle and color and which, when they are touched, will arouse pleasant tactile sensations.

The sculptor who has experimented most extensively with plastics is Leo Amino. Although he is primarily concerned with the emotional and human qualities of his work, the type of form he achieves in plastics displays his keen interest in exploiting the medium's possibilities for sculpture. Some of his plastic compositions have the quality of heat-shaped and drawn glass figures; others, that of large masses of amber in which have been embedded linear designs in thread and wire. All his compositions in plastics show an exceedingly high degree of imagination and invention.

A major step in the creation of any piece of sculpture is the sculptor's selection of the material most suitable for his specific need. He must release this material from any masquerades in which it may come to him and study it so that he may obtain the maximum effect from its individual qualities, and then shape it into forms that are appropriate to its sculptural properties. This is just as true of the materials which have been used for countless centuries as it is of the latest manufactured materials. For a sculpture to reach its acme of effectiveness, it must show, among other things, high quality of design, successful exploitation of material, and efficient and full use of the processes and tools by which it has been fabricated.

[9] Teague, *op. cit.*, p. 18.

4, FROM REALISM TO SURREALISM

PRIOR TO THE ADVENT of the modern movement in sculpture with its strong emphasis on design and basic form, and its recognition of the relation between form and material, sculpture in America, like that in Europe, was characterized by pronounced realism. The term "realism" as applied to sculpture refers to images that are capable of instantaneous identification—images that are reproductions of nature in accordance with visual perception and scientific knowledge. In certain extreme examples of realistic sculpture even material surfaces such as drapery, skin, hair, and the bark of wood are so simulated as to deceive eyes and mind into believing in the reality of what is rendered.

"Realism" as a qualitative term in sculpture is to be distinguished from the term "representation." In a realistic composition the forms appear to be copies of real forms in nature. There is an apparent striving after complete duplication or imitation of all casual variations and details in the object. "Representation," on the other hand, is a broad term and applies to any form in which there is resemblance to objects in nature, however slight or incomplete this resemblance may be. It is, therefore, applied to all sculptured forms which show any degree of resemblance to natural forms, from the highly realistic shapes which are more or less copies of nature to shapes which approach the nonrepresentational or abstract. A nonrepresentational form, of course, is one in which there is no trace, however slight, of any resemblance to an object. Used interchangeably with the terms "representational" and "nonrepresentational" are the terms "objective" and "nonobjective."

Realism can be a desirable and enriching feature in sculpture. When every minor detail is integrated into the major masses and these in turn

are arranged into a harmoniously organized whole, the resulting composition may be aesthetically highly successful and rich in human experience. But the chief drawback of the realistic approach in sculpture—or, in fact, in any art—is the tendency to copy slavishly or to imitate nature at the expense of such aesthetic qualities as form and integrated design, without which no man-created shapes can be thought of as works of art.

Among outstanding historical examples of realistic sculpture are the statues of the later Greeks, the portraits of the Etruscans and Romans, and the figures of the master sculptors of the Renaissance. Although they conventionalized the faces of their statues, the Greeks depicted with exacting care each elevation and depression of a back and each prominence on the surface of a knee. The bodies of their statues were so packed with detail that our eyes alone cannot discover them all—only an exploring finger can do so. The Etruscans, and later the Romans, ventured even closer to nature. The precision of their portraits in respect to chance detail can only be explained by supposing them to have been elaborated from death masks or modified from casts taken from nature.

After the Roman period, European sculpture passed through a primitive, an archaic, and then a stylizing period. In the Renaissance, it returned again to a realistic treatment of subject matter, in part because of the growing interest in the sculptures of antiquity—newly unearthed from Roman temple sites in Italy. Giovanni Pisano, whose father, Niccola, is considered the first sculptor of the Renaissance, deliberately reproduced the plastic reliefs of Roman imperial days when completing the pulpit of the cathedral at Siena. Sculpture executed under this influence of antiquity aimed at the representation of external reality, anatomical accuracy, and corporeal substantiality. Donatello, whose early work is said to have been copied by as outstanding a sculptor as Michelangelo, fervidly embraced the realism of the Greeks and Romans. The resulting naturalism in his nude statues was unrivaled, and his bronze *David* was anatomically so perfect that contemporaries considered it to have been cast from life. It is the work of Michelangelo, however, that epitomizes the realistic character of Renaissance sculpture. Throughout the entire scope of his work one finds a painstaking rendering of anatomical detail and surface minutiae such as the veins on the back of the hands, and the wrinkles and skin creases at knuckles and joints of fingers and toes.

The nineteenth-century European master of realism in sculpture was Rodin. Inspired by the works of Donatello and Michelangelo while on a study tour in Italy, he explored even further than they the realm of realistic rendition of the human figure. His detailed knowledge of the human body was obtained through constant observation of the figure in action. Like the Greek and Renaissance masters he learned to read and to represent the expression of feeling in all parts of the body. Rodin's deep concern with realism is attested by the number of nude models, men and women, he had in his studio. In movement or in repose, they supplied him with a continuously changing picture of nudity in various attitudes and action. He was always an interested spectator before the spectacle of muscles in movement.

In America, realism in sculpture reached its zenith at the beginning of the twentieth century in the work of Augustus Saint-Gaudens. Like most American sculptors of his time, he obtained his training in Europe, first in Paris and later in Rome. The latter city was also the scene of his first professional work, and while he was working there he became inspired with a love of Renaissance. From the sculpture of the Renaissance he took his skill in delicate modulation of surface, the design and shaping of exquisite detail, and the airiness of fluttering drapery.

Saint-Gaudens is credited by some writers with the distinction of being the first American sculptor to evolve a personal style free from strong European influences. In doing so, it is claimed, he "was in a very real sense the father of American sculpture, for his influence and example were dominant through the fertile years of his own generation and the next, which saw the rise of a national school."[1] However, it is Manship who is thought by other writers to represent the beginning of the American school, because of his reëstablishment of sound design principles, reemphasis on basic sculptural form, and revival of integrated minor and decorative elements in sculpture.

Whether the national style was ushered in by Saint-Gaudens or Manship, there is no question that it was Manship who first severed the ties which bound American sculpture to the realism of its early period. It is true that no work by Manship lacks representational quality. Every figure, animal, plant, or flower form is readily recognizable. The rippling

[1] Beatrice Proske, *Brookgreen Gardens, Sculpture* (Brookgreen, S.C., 1943), p. 11.

muscles and visible bone processes on the surface of his nude figures are defined with anatomical truthfulness. The fleshy forms of his female figures are rendered with characteristic voluptuousness. Even accessory forms such as drapery, garments, or architectural details may be instantly identified. But notwithstanding this pronounced adherence to nature and the inclusion of particularizing detail, none of Manship's sculptures can be thought of as realistic in the sense of being slavish copies of nature. All of his work, from the earliest to the latest, is characterized by a masterful translation of natural shapes into effective sculptural forms. Muscle masses, visible sinews, and bone processes appear to have been transposed and defined according to their most effective positions in a carefully designed plan. In none of his work is a natural form exactly duplicated or arbitrarily placed in the composition.

Even in his most true-to-life portrait, that of John D. Rockefeller,[2] Manship achieves a great deal of representational quality without resorting to an exact imitation of nature. All the wrinkles on the forehead and at the corners of the mouth, and the drooping creases of the sagging jowls, although rendered with lifelike quality, fit into a consciously organized pattern of minor forms which produces a decorative effect that is clearly the result of the definite design approach of the sculptor.

Manship's approach to the translation of nature rapidly won new adherents in spite of the fact that a number of his contemporaries continued to work in the realistic manner of Rodin and other European sculptors. Rebelling against the realism of nineteenth-century European and American sculpture, against romantic attitude and sentimental pose, the sculptors who followed Manship's lead sought out the basic sculptural shapes in nature's myriad forms and integrated them in their compositions on the basis of sound aesthetic principles. The human figures and other natural forms in the representational sculpture of John Gregory, Paul Jennewein, Gaetano Cecere, Allen Clark, and Edmond Amateis all show this approach. Works of the more recently active sculptors, Richard Davis, Donal Hord, Donald De Lue, Adlai Hardin, Charles Rudy, Jacques Schnier, Theodore Barbarossa, Joseph Kiselewski, Carl L. Schmidt, Henry Kreis, Sidney Waugh, Benjamin Hawkins, and Wheeler Williams also fall in this category.

[2] Paul Vitry, *Paul Manship* (Paris, La Gazette des Beaux-Arts, 1927), plates 64 and 65.

No discussion of representational content in twentieth-century American sculpture would be complete without mention of the work of Carl Milles, who since 1931 has lived and worked in the United States. Born in Sweden, he received his training in the ateliers of Paris. During the early years of his career, Milles, like many other European sculptors of his generation, worked as an assistant to Rodin in his studio near Paris. Some of his early work shows strong traces of a hazy impressionistic mannerism reminiscent of Rodin's style, but it was not long after his return to Stockholm that he succeeded in achieving a personal manner of sculptural expression that was free from the influences of his French masters and the neo-classicism of his homeland tradition.

An examination of Milles' work reveals a closely knit rhythm of line and mass. In the majority of his compositions all traces of impressionism have disappeared. The shaping of each part is carefully considered in its rhythmic relationship to the design as a whole. Furthermore, most of Milles' work, like that of Manship, is characterized by a superb translation of natural forms into their sculptural counterparts. Representational though these forms are, they have been distorted and reworked in their translation and infused with a high degree of fantasy and humor. One of Milles' major American works is the monumental fountain *Meeting of the Waters,* in St. Louis, Missouri. In this group of more than a dozen heroic-size bronze figures, Milles presents a large cross section of his rich repertoire of sculptural design.

In reviewing the development of American sculpture, it can be said that by the beginning of the twentieth century the pictorial conquest of the external visual world had been completed and refined. The more adventurous and original sculptors were growing bored with copying nature. Driven by a powerful impulse that appears to have manifested itself in all the arts, these sculptors abandoned imitation of natural appearance in favor of aesthetic translation.

In most art schools and academies, instructors imbued with the non-realistic approach to sculpture were called upon to take over positions made vacant by retiring sculptors trained in the school of realism. Now that there was no longer any encouragement or incentive to copy nature, the creative energy of younger men was directed more and more toward the use of sculptural form in a purely plastic manner. Human inquisitive-

ness and inventiveness stimulated further investigation and exploration in the realm of sculptural form and design. This resulted in the formulation of new aesthetic principles or the revival of old ones as applied to sculptured compositions, and attempts to evaluate sculptural form entirely apart from representational content. As an analogy, reference was made to music, in which rhythmic repetition, pitch, intensity, harmony, and counterpoint are composed without reference to natural sounds; but it is not only music that emphasizes the aesthetic quality of its component parts apart from representational content. In architecture, in dancing, and in poetry we can detect a similarity of approach. The themes may be sound relations of words, posture progressions of the body, or combinations of columns and wall surfaces in a building, and all these may be repeated, varied, contrasted, and woven into an integral whole.

The modern sculptor is deeply interested in the qualities of his medium and in the themes and combinations that can be made of them. The obviously distinguishing feature of sculptural forms is their *actual three-dimensional volume*—they exist in blocks or masses, the aspects of which change with the point of view of the spectator. Various surfaces, planes, projections, and hollows meet the eye; each is differently shadowed; each is bounded by contours; and each may be decorated with surface lines in the shape of grooves or ridges and may even be colored. These are the means at the disposal of the sculptor. Apparently less subtle and delicate than those of other media, they can be combined into a wealth of simple and powerful designs.

Whereas the sculptor of the realistic school relied upon the appeal of the associative quality of the subject represented, the modern sculptor concentrates on unrestrained variety and directness of presentation in three-dimensional forms. The difference between the associative quality of a work of art and its aesthetic quality can readily be seen in the effect a European cathedral may have on a traveler. The traveler who responds on the basis of associated ideas may turn in his thoughts to his own memories or dreams; to the pageantry of medieval history or ideals of Christian purpose; to questions of architectural style or authorship: the associated idea replaces the intrinsic aesthetic appeal based on the formal arrangement of the component parts of the cathedral.

Those sculptors who have broken with realism show that sculptural forms can be regarded, not as imitations of nature, to be judged by their fidelity to the model, but as creations in themselves—elements in a design in which the natural object is a theme to be utilized rather than imitated. The modern sculptor strives to interest less by subject matter, intrinsic nobility, sentiment, morality, or picturesqueness than by plastic form; by an original and satisfying arrangement of forms in terms of their lines and curves, and by a balancing of masses. Adjoining forms are frequently distinguished and marked off by sharp lines of intersection; at other times they are joined one to another with rhythmically flowing surfaces. Each part is molded into a variation of some chosen theme—a columnar cylinder, a polished ovoid, a sharp slender projection, or a smooth bulbous swelling,—no variation exactly the same as its neighbors, never too far from nature.

Examples of natural forms translated into sculpture on the basis of formal arrangement can be seen in the stylized animal bronzes of the Scythians. In these representations there is no attempt to conform with the exact but casual appearances of animals, no desire to evolve an ideal type of animal. Rather, from an intense awareness of the nature of the animal, its movements and its habits, the artist selects just those features which best denote its vitality. By exaggerating these and distorting them until they cohere in some significant rhythm and shape, he produces a representation which conveys to us the very essence of the animal.

An appreciation of the nonrealistic sculptor's approach to translating nature can be obtained by a study of the spontaneous art efforts of children, savages, and untaught artists. Their efforts are not directed toward exact representation, but toward simplification, generalization, and abstraction; toward rhythm and contrast of themes. They do not attempt, of their own accord, to copy exactly all the visible details of an object; that comes with tedious observation and painful technical preparation. The thought that such a thing would be worth trying appears not to occur to them at first. What is immediately pleasurable is the relatively easy task of drawing or shaping from imagination a rough simplified sketch of some object, or type of object, that has attracted persistent interest: a horse, a tree, or a man. Such a statue is more or less automatically constructed in the imagination from the many memories of the object as

seen on different occasions. The forms are inevitably distorted by the exaggeration of aspects which have attracted special attention and by the omission or minimizing of others. The compositions usually tend to become rhythmic in accordance with an innate human tendency to repetition; and when repeated stimuli become tedious, a natural craving for contrast gains ascendency and results in variations of forms.

Work so produced is not always art. Children and savages usually begin and end with mere random scrawlings or disorganized jumbles of blurred shapes. From these to the sophisticated, well-integrated organizations of the modern sculptor is a long way. It would be illusory to hope that merely by recapturing the naïveté and freedom of childhood or the savage state one could produce work as excellent in quality as that of recognized contemporary sculptors, but there is an essential continuity between the spontaneous art of a native artist or gifted child and that of a modern, nonrealistic sculptor. By contrast with the artist who aims at literal representation, both the native and the nonrealistic sculptor are working along similar lines: the selection of significant visible qualities, their recombination into a generalized nonrealistic though not necessarily nonrepresentational form, and the generation of the aesthetic pleasure that accompanies such a process.

Of all native art, that of the Negroes of Africa is most frequently cited in support of the nonrealistic approach to sculpture. Their almost diagrammatic statues, conceived as compositions of highly rudimentary forms, were first brought to the attention of artists by the French painters Vlaminck and Picasso. It was about 1905 that these artists began to recognize in the tradition of Negro sculpture the sound sculptural characteristics, the qualities and distinctions, to which their predecessors had been totally blind. Today, that tradition has become an accepted art tradition, like those of the Mayas, the Chaldeans, and the Chinese.

Negro sculpture's plastic quality, vitality of form, simplification without impoverishment, unerring emphasis on essentials, and consistent three-dimensional organization of structural planes are the characteristics that most forcefully attract the modern sculptor. From a representational point of view such native statues are apt to be meaningless or even disagreeable to civilized people, but in the shapes of their volumes and the design of lines, planes, and masses they achieve a variety of striking

effects that are equaled in few, if any, other kinds of sculpture. These effects are usually impossible in sculptural representations of the human figure in which natural proportions are strictly adhered to; for example, a realistic figure such as the Greek or Renaissance artists produced. They can be obtained only by abandoning considerations of lifelike proportions and detail and by freely distorting the natural shape of the body into arbitrary forms, emphasizing here, diminishing there, rounding, flattening, or elongating at will.[3]

By some writers, modern nonrealistic sculpture is thought to have had its beginnings in the "discovery" of Negro sculpture by modern French painters.[4] According to them, it is the influence of native statues that is reflected in the simplicity of such modern sculpture. But far from being the cause of this simplicity, primitive art is only a kind of stimulus to modern artists in the formulation of their own aims with respect to the basic plastic qualities of sculptural form. Behind all this, however, is a sociological factor. At various times in cultural evolution, intricate and complicated externals, whether social, cultural, artistic, psychological, or physical, are deemed undesirable. This leads in art to a revival of simple, fundamental concepts, akin to those present in primitive art, which are found to be emotionally more satisfying and compelling than the prevailing ones. This renewal of the essentials of art by a return to fundamental formal relations is referred to as "primitivism." It is an attempt to infuse new life into art by breaking away from current and accepted formulas which seem to have exhausted themselves and by reinstating the basic principles of an earlier, unsophisticated art.

In their interpretation of sculptural forms, some modern artists are inspired to emphasize forcefully the shapes, planes, lines, and edges of these forms. In so doing they sometimes completely dissociate them from natural objects and resolve them into purely geometrical or amorphous shapes. Creations of this kind—works in which there is no intentional resemblance to objects in the real world—are commonly referred to as "pure abstractions" or "abstract art." Artists working in the abstract idiom justify their approach on the basis that any work of art is worth looking

[3] Paul Guillaume and Thomas Munro, *Primitive Negro Sculpture* (New York, Harcourt, Brace, 1926), p. 32.

[4] *Cubism and Abstract Art* (New York, Museum of Modern Art, 1936), p. 103. Here it is stated that Picasso's first cubist sculpture was "dependent to some extent on Negro sculpture of the Congo and Cameroon."

at primarily because it presents a satisfying composition or organization of shapes, lines, curves, and surfaces. "Resemblance to natural objects, while it does not necessarily destroy these aesthetic values, may easily adulterate their purity. Therefore, since resemblance to nature is at best superfluous and at worst distracting, it might as well be eliminated."[5] The abstract artist therefore tends to create works which are aesthetically significant exclusively in relationships of form and in qualities of material and texture. "He is a purist, and makes no kind of compromise with any world outside of the ideal world of subjective creation; he merely gives outer and solid form to conceptions that are as abstract as any conceived by the mathematician."[6]

Closely related to the abstract artist is the sculptor of semiabstract forms. He combines formal relations "with a reflection or representation of qualities typical of living things or at least qualities due to natural processes . . . He links his formal conception with the vital rhythms everywhere present in natural forms."[7] The majority of so-called abstract artists combine features of pure abstraction and semiabstraction in their work.

The various abstract currents alive in Germany after World War I were united with similar influences from Holland and Russia in the famous Bauhaus. From the very day of its inception, Bauhaus training in sculpture followed the trend of the abstractionists. The Bauhaus credo for sculpture, as expressed by Moholy-Nagy, placed major emphasis on volume; every other characteristic of a statue—weight, structure, representational idea, likeness, expression, proportion, rhythm, consistency, and color—was of secondary importance.[8] It was argued by Bauhaus adherents that this method of conceiving form prevailed everywhere among people in the early stages of art development, but that in the course of cultural evolution it had been superseded by the intellectual conception of the likeness of works of art to objects in the external world; now, it was necessary to revive the basic concept of the preëminence of volume. In all phases of sculptural training, from the elementary exercises in carving or shaping simple masses to the arrangement of complex constructions, Bauhaus teaching stressed this aspect of form.

[5] *Cubism and Abstract Art*, p. 13.

[6] Herbert Read, *Henry Moore, Sculptor, an Appreciation* (London, A. Zwemmer, 1934), p. 10.

[7] *Ibid*, p. 11.

[8] László Moholy-Nagy, *The New Vision*, 3d rev. ed. (New York, Wittenborn, 1946), p. 42.

Among the first European artists to experiment with three-dimensional abstract forms were Picasso, Brancusi, Tatlin, Pavsner, and the brothers Gabo. Brancusi, the only sculptor of the group, naturally carried his experiments the furthest. With him form became simplified into pure geometric volumes such as ovoids, cylinders, and cubes. His polished marble egg-shaped mass called *The Beginning of the World*, and his thin, bulging, bronze column entitled *The Golden Bird*, have already become well known as examples of the earliest abstract sculpture.

Alexander Archipenko, Jacques Lipchitz, and Henry Moore are other European sculptors who have explored the realm of abstract form. Archipenko began his investigations of abstract shapes and the planned use of holes and concavities in statues as early as 1912. Although much of his work contains representational elements, his tie to natural forms has always been a very loose one, and frequently is completely severed. Disregarding anatomical reality, he at times replaces abdominal volumes with holes bored entirely through the statue and reverses convex surfaces into concavities (plate 132). Since his arrival in America his work has become less abstract, but the freedom of design gained from earlier experimentation with abstractions still prevails.

Lipchitz, who lived in the United States during World War II, was influenced early in his career by the concepts of cubist painters, and as a result of this influence his first compositions show a preference for cubic volumes.[9] Later, he expanded his range of forms to include curved surfaces and convex forms in his designs. His recent sculptures contain a preponderance of rounded forms.

One of the most prolific contemporary sculptors working in the abstract idiom is the Englishman, Henry Moore. Profiting by the experiments of the earlier abstractionists, Moore has applied their inventions to his own work and, at the same time, explored even further the sculptural possibilities inherent in pure shapes. The outstanding characteristics of his sculpture are a rich variety of forms and a novel use of holes and concavities in his compositions. Like Archipenko, Moore frequently employs representational forms, but wherever these are used they are so highly simplified that they are barely recognizable as such. According to Herbert Read, Moore looks upon most of the forms of natural growth as

[9] *Cubism and Abstract Art*, plates 100 and 102.

being evolved from soft materials—flesh, blood, tender wood, and sap—
which cannot be translated directly into hard or brittle materials like
stone and metal. "He has therefore sought among the forms of nature for
harder and slower types of growth, realizing that in these he would find
forms *natural* to his carving materials. He has gone beneath the flesh to
the hard structure of bone; he has studied pebbles and rock formations.
Pebbles and rocks show nature's way of treating stone—smooth sea-worn
pebbles reveal the contours inherent in stone, contours determined by
variations in the structural cohesion of stone. Stone is not an even mass,
and symmetry is foreign to its nature; worn pebbles show the principles
of its asymmetrical structure."[10] More significant still are the forms built
up out of hard materials, the actual growth in nature of crystals, shells,
and bones. Crystals are a key to geometrical proportions assumed natu-
rally by minerals, and shells are nature's way of evolving hard hollow
forms—exact epitomes of harmony and proportion.

In America, interest in abstract sculpture has been stimulated by the
work of Alexander Calder and Isamu Noguchi, as well as by the work of
the European abstractionists. Calder's stabiles and mobiles in wood,
wire, sheet metal, and pipe have had a wide appeal in recent years. Un-
like most other abstractionists, Calder rarely, if ever, uses representa-
tional themes. Like the constructivists, who were his forerunners, he
depends entirely on the carefully studied interrelation of suspended or
supported forms variously shaped and composed.

Noguchi has discarded one by one all the representational features of
his early sculpture and has finally arrived at pure abstraction, although
many traces of one of the outstanding characteristics of his early work—
his strong interest in form—still prevail. His abstraction, *Capital,* in the
Museum of Modern Art, clearly exemplifies this characteristic of full
form. Other abstractions, such as his constructions built up of pierced
marble slabs (plate 128), while possessing much less volume, still empha-
size this quality to a greater degree than any of Calder's abstract mobiles
or stabiles.

The value of composing in the manner of the abstractionists lies in the
great freedom it permits in the development of aesthetically successful
designs. Unhampered by any need to copy or even to represent forms in

[10] Read, *op. cit.,* p. 15.

nature, the abstract sculptor evolves shapes that are intrinsically inter-
esting and organizes them solely on the basis of aesthetic principles;
freed from copying proportions in nature, he willfully distorts in order to
achieve more intense or startling effect. By the unadulterated and un-
compromising use of form, line, rhythm, contrast, repetition, opposition,
and balance he makes maximum use of the design possibilities of his
medium.

<center>II</center>

In certain examples of modern sculpture, representational quality is
clearly discernible in the component parts; but the total combination of
these forms results in sheer fantastic, unreal, dream images, true fig-
ments of the artist's imagination. This kind of modern sculpture, in which
recognizable elements are present, but in which these elements have
been arranged in a completely unreal and bizarre manner, like that seen
in the phantom images of dreams, or have been combined with abstract
forms, is referred to as "surrealism" or surrealistic sculpture—sculpture
that is above reality.

Surrealism, which manifests itself in literature as well as art, was
launched as a movement in Paris in 1924 by the poet, André Breton. He
defines it as "pure psychic automatisms, . . . thought's dictation in the
absence of all control exercised by the reason and outside all aesthetic or
moral preoccupation."[11] Breton declares: ". . . the chief discovery of
Surrealism is, that without any preconceived intention, the pen that flows
in writing and the pencil that runs in drawing spin an infinitely precious
substance, which, though perhaps not all convertible, nonetheless ap-
pears charged with all the ardor stored within the poet and painter at a
given moment."[12] The emphasis in surrealism is on the aesthetic utiliza-
tion of the artist's entire psychophysical field, of which consciousness is
only a small fraction. "In these *unfathomable* depths there prevails, ac-
cording to Freud, a total absence of contradiction, a release from the
emotional fetters caused by repression, a lack of temporality and the
substitution of external reality by psychic reality obedient to the pleasure
principle and no other."[13]

[11] *Painting and Sculpture in the Museum of Modern Art* (New York, 1942), p. 18.

[12] Marguerite Guggenheim, ed., *Art of This Century* (New York, Art-aid Corporation, 1942),
p. 20.

[13] *Ibid.,* p. 21.

The fantastic images of surrealist painting and sculpture are revolting to some spectators: figures floating through space; watches hanging limp like wet clothes; bodies with holes through their abdominal or chest region, or walking around headless with their heads in their hands. These and other unreal combinations of human features with trees, architecture, or animal forms have caused many spectators to wonder if these works of art were not the expression of mad men and women. Yet these same spectators unquestioningly accept in art such equally fantastic and impossible images as mermaids, angels, or representations of the devil with horns and tail. These images were conceived by artists hundreds of years ago and have been handed down from generation to generation, becoming part of our artistic heritage. They are taken for granted, and no one seems to question their use, yet it is no more possible to find their prototypes in reality than it is to find a living body with a hole entirely through its abdominal region, like those in Archipenko's *Composition* of 1912 or in many of Henry Moore's figures.

Each nation or race has its own series of acceptable unreal or surrealistic images. In Indian temples one can see statues of Kali, the terrible demon goddess of Hindu mythology. In one of her many manifestations she is shown with an emaciated body clad in a tiger-skin, with a garland of human skulls hanging from her neck; her abdominal region is a hollow, concave form, exposing her backbone—a form that recalls the concavities so characteristic of the surrealist sculpture of Ossip Zadkine and Henry Moore. Another god commonly depicted in Hindu sculpture is Vishnu, with two, four, six, or more pairs of arms. In Japan, the statue of Senju Kwannon—apparently a Japanese version of the many-armed Hindu Vishnu,—called the Thousand-Armed Kwannon, may have as many as forty or fifty pairs of arms. The dragon is, perhaps, the most universally depicted creature of man's artistic imagination. Scattered all over the world are to be found examples of this monster, fierce, fantastic, sharp-toothed, and combining other features of a number of animals. In different localities its components are different, but its main form usually incorporates certain common elements.[14]

Surrealism, then, does not represent a new kind of artistic expression. Because of the widespread use of fantastic and unreal art motifs and

[14] Jacques Schnier, "Dragon Lady," *American Imago*, Vol. 4, Pt. 3 (July, 1947), p. 78.

the frequent appearance of such motifs throughout art history, the present-day surrealist artists cannot claim sole ownership of this style; it goes back to the origin of man's imagination. Its chief characteristic is the emphasis on the unreal and fantastic in combinations and positions that defy all reason and, sometimes, even the law of gravity.

The pioneers of surrealistic sculpture in America were Lipchitz and Archipenko, both of whom, even today, are among the most prolific workers in this field. Recent experimenters are Leo Amino, Herbert Ferber, and Theodore Roszak. In Amino's sculpture there is always a pronounced quality of formal design, but he is "primarily concerned with the emotional and human qualities of his work."[15] The shapes and arrangement in his sculpture seem to result from the dictates of feeling, both conscious and unconscious. It is the preëminence of this emotional tone that makes Amino's surrealistic sculpture so effective.

An examination of the development of American sculpture since its break with realism in the early years of the twentieth century reveals three major trends in the treatment of representational content. In one, exemplified in modern architectural sculpture and followed by the majority of American sculptors, easily recognizable subject matter is integrated into effective designs, but with no attempt at realistic interpretation. In the second, that of the pure abstractionists, exemplified by the work of Calder, Noguchi, and the more recent work of Claire Falkenstein, forms have been completely divorced from representational content, and the entire emphasis is placed on formal arrangement. In the third, recognizable elements are arranged in a completely unreal and bizarre manner or combined with abstract forms. These last-mentioned works, which are devoid of arrangements seen in external reality, seem to reflect the fantasy visions of our dream life and are frequently referred to as surrealist art.

[15] Sahl Swarz, *Catalog of the Amino Exhibition* (New York, Sculptors Gallery, Clay Club, 1946), p. 6.

5 · EXPRESSIONISM IN MODERN SCULPTURE

EVEN AFTER the formal and technical aspects of master-pieces of sculpture have been studied, these works still present unsolved riddles to our understanding. We admire them, we are overawed by them, we feel haunted by them; but we are unable to say why they affect us as they do.[1]

When our emotions are aroused by a statue, and this applies to works in other art mediums as well, we are concerned with something more than a sensory impression. It is not uncommon to hear said of a statue or other work of art; "It has feeling; it moves me." So intense may the effect be that the spectator is drawn to the statue time after time. It is like the feeling we derive from a play or book that compels us more than once, perhaps many times, to return to it.

From a spectator's point of view it is this power to move him emotionally that constitutes the most important contribution of any art. It is this power that has placed art so high among the achievements of mankind, and caused vast museums to be founded to house it, art patrons to expend fortunes to collect it, and rulers to divert large portions of their nations' revenues to foster it. The greatness of dynasties and nations in world history has been in large part measured on the basis of their artistic achievement.

To be successful a sculptor's work must be an embodiment of his imagination. Such work is referred to as being expressive or imaginative. If a statue is not expressive or imaginative and leaves us emotionally cold, it is said to be thin, shallow, and mediocre. If it is expressive and we are irresistibly drawn to it, we say it is deep, moving, and inspiring.

[1] Sigmund Freud, "The Moses of Michelangelo" (1914), *Collected Papers*, Vol. IV (London. Hogarth Press, 1934), p. 251.

So important is this quality of expressiveness that during the past few decades there has been, in all fields of art, a marked upsurge of interest in it. The qualitative term "expressionism" is not limited to the work of those few artists who are associated with the definite art movement called "Expressionism" which was formally organized in Munich in 1911. "In its broadest sense the term 'expressionist' has been used to describe the work of almost all modern artists who reject the imitation of the outer world of reality for the expression of an inner world of feeling and imagination."[2]

Instead of copying nature as he sees it, the expressionistic sculptor portrays nature as he feels it; he uses nature as a medium or as subject matter to portray his inner self. When so used, a natural object becomes a vehicle or symbol for conveying human feelings or emotions. The use of a human figure, a tree, or an animal in a composition then becomes a means to an end and not the end itself.[3]

The expressionistic sculptor does not aim at a literal translation of his model, but uses shapes and forms inspired by nature just as his feelings prompt him. To convey the feeling of strength in a statue, the hands may be made twice their natural size. If purple suggests itself as the color for painting the statue of a cow, the cow is painted purple. Proportions as they exist in nature are not duplicated in expressionistic sculpture. Eyes may be made larger or smaller than they actually are, a face may be made longer or broader, and a body may be drawn out and attenuated until it is as thin as a pole. A figure may be made squat, heavy, and earthy in contrast to tall, thin, ethereal figures; either way, it would be impossible to find anything in nature of exactly corresponding proportions. In his use of natural forms the expressionistic sculptor on the one hand exaggerates, emphasizes, or willfully distorts, and on the other subdues, slights, or completely eliminates details.

Occasionally the expressionistic sculptor resorts to primitivism, a style of art like that of savages and children. This anomalous feature appearing in the work of twentieth-century artists is a source of much confusion in the minds of many spectators, who wonder why sculptors resort to such crude shapes and representations. But strains of discordant music,

[2] *Painting and Sculpture in the Museum of Modern Art* (Museum of Modern Art, New York, 1942), p. 15.

[3] Oskar Pfister, *Expressionism in Art* (London, Kegan Paul, Trench, Trubner & Co., 1922), p. 15.

peasant art with its crudities, any juxtaposition of violently contrasting colors, and roughly carved primitive statues are capable of arousing strong feelings which at times are far more pleasurable than those produced by the conventional, realistic, sophisticated, and meticulously finished art forms based on our immediate artistic heritage.

From the definition of surrealism given in Chapter IV it is clear that surrealistic art is highly expressionistic in the sense that it is not concerned with reality but with the expression of the unconscious thoughts of artists. The surrealists speak of their art works as automatisms the structure of which is determined entirely by the dictates of the inner mind, wholly free from reason or morals. Even squares and circles (that is, even the nonrepresentational or abstract forms which appear in some examples of their work) have symbolic significance, according to the surrealists.[4]

The expressionistic sculptor, then, uses every possible device appropriate to his medium to convey his ideas and to provoke a similar, sympathetic response in the spectator. But none of these devices are innovations unique with the modern expressionistic sculptor. There is probably not one single device or feature used in modern sculpture that cannot be found in some sculpture of the past. Abstraction, fantasy, primitivism, simplification, and disregard of proportions all have been used at one time or another in the sculpture of earlier periods. The technique of distortion, for example, is not new to modern sculpture. In the Romanesque sculpture created in Europe during the tenth to twelfth centuries, distortion and disregard of naturalistic proportions were the outstanding characteristics. The sculpture on the French cathedrals of Autun and Vézelay shows strikingly how the Romanesque sculptors made use of exaggeration to heighten the emotional appeal of their art. Similar exaggeration of form is found in the attenuated bronze figures of the Etruscans, the highly stylized animal forms used in Scythian art, and the carvings of prehistoric man of the Aurignacian and Solutrian periods, discovered in mound and cave sites in Europe.

Reference has already been made to the widespread use of surrealistic elements—that is, elements of fantasy—in the sculpture of the past. In addition to the examples mentioned in Chapter IV there are the human-

[4] *Cubism and Abstract Art* (New York, Museum of Modern Art, 1936), p. 15.

headed winged bulls from the ancient Assyrian palace of Sargon II, the animal-headed humans in the Mayan sculpture from Piedras Negras in Guatemala, and the phoenix, garuda, unicorn, and many other equally fantastic animals. The centaurs, satyrs, dryads, nymphs, nats (Oriental demons), winged creatures, and serpent-bodied humans used so frequently in the sculpture of all epochs also fall in this category. Abstract forms were occasionally used for symbolic or expressionistic purposes in ancient sculpture, and are also found in the art of present-day savages. If we study the flat, long, oval objects (*tjurungas*) carved from wood by the Central Australian aborigines, we find that the outstanding characteristic of these ceremonial objects is the pattern of concentric circles with which the surface is decorated. According to Australian native belief, this concentric circle motif indicates a place, usually the place where an ancestor emerged from the earth, or where he finally "goes in" and becomes a *tjurunga*. When the concentric circle is used to decorate other objects, it is said by the Australian to mean "womb inside," "in the womb," or "right inside the womb"; or it may be referred to by the aboriginal Australian word for navel—a euphemism for vagina.[5] This abstract concentric circle design, therefore, expresses a definite meaning for the natives; it has symbolic content.

<p style="text-align:center">II</p>

In strong contrast to the pronounced realistic interpretation of nature that marked American sculpture prior to the twentieth century, today's sculpture has a definite expressionistic quality. In order to achieve this quality it was necessary for sculptors to forego reproduction of nature in accordance with visual perception and the factual dictates of scientific knowledge. It was necessary to forego striving after exact duplication or imitation of all casual variations and details in the object. In proportion as effort is directed toward copying the outer world of reality, the expressive quality in sculpture decreases. In proportion as attention is directed towards objectifying the subjective—portraying the inner world of feeling,—expressionism increases.

It should be made clear that, although the expressionistic sculptor is interested in portraying man's inner self and not the external world, it

[5] Geza Roheim, "The Concentric Circle and the Fertility Rites," in his *The Eternal Ones of the Dream* (New York, International Universities Press, 1945), p. 102.

does not follow that his work need be completely divorced from shapes and forms as they appear in nature. On the contrary, expressionistic sculpture may run the whole gamut from objectivity to subjectivity. At one extreme, it can be highly objective or representational; a hand, an arm, a head or any other naturalistic shape used by the sculptor can readily be recognized. At the other extreme, it can be completely subjective; natural shapes are abstracted or highly distorted and have meaning not readily understood by the uninitiated spectator. Since forms constitute the language of sculpture, the more objective—that is, the more recognizable—the forms are, the more certain he is of what they contain for him; the more subjective—that is, the more abstract—they are, so much the more mysterious and unfathomable they seem.[6]

Among present-day American sculptors whose work, though highly representational, is nevertheless noticeably expressive, are George Aarons, Adlai Hardin, Anna Hyatt Huntington, Donald De Lue, Joseph Pollia, Helene Sardeau, Carl Schmitz, and Sidney Waugh. Some of them, like De Lue, occasionally explore the realm of less representational expression, but generally speaking, subject matter in the work of these artists, though certainly not literal, departs little from impressions made on our eyes by the shapes in nature. De Lue's sculpture, irrespective of its degree of representation, always possesses emotional quality, achieved through the use of effective pose, strong accents in details, and pronounced distortion of forms. His fierce, powerful *Cosmic Head* (plate 2), his agitated *Pegasus* (plate 70), and his aroused *Triton* (plate 24) carved on a monumental marble urn for the Federal Reserve Bank in Philadelphia, are characteristic of this phase of his work.

Emotional quality is also reflected in the masterfully designed sculpture of Sidney Waugh. Never distorted or exaggerated, never departing too far from nature, it appeals through its refinement, its lyricism, and its richness of detail. His monument to the Polish hero Casimir Pulaski (plate 45), besides possessing these characteristics, breathes a feeling of courage, dauntlessness, and determination.

Mental anguish and distress, rather than fierceness and force, are reflected in much of Helene Sardeau's sculpture. In her *Negro Lament* (plate 15) it is clear that much thought has been given to sculptural form

[6] Jacques Schnier, "Expressionism in Sculpture," *Bulletin, San Francisco Art Association*, Vol. 2 (September, 1935), p. 1.

and design, especially to the design of the exquisitely modeled hands; there is also a strong emphasis on the brooding, introspective pose that indicates concern with deep inner feeling.

At the other extreme, far removed from the work of the group of sculptors mentioned above, is the fantastic, enigmatic, and provocative sculpture of such artists as Leo Amino, Claire Falkenstein, Isamu Noguchi, and Theodore Roszak. Their work is almost always devoid of objectivity. Some of their compositions, such as Falkenstein's *Organic Form* (plate 123) and Roszak's *Scavenger* (plate 139), appear to be adventures in pure abstract form, but the shapes and their arrangement result from the dictates of feeling and thus are expressive. This is especially true of Amino's work, which, although abstract, has deep emotional and human qualities.

III

In attempting to learn more about the workings of the artist's unconscious mind and the inner meaning of modern sculpture, "one observes a peculiarly strong repudiation of the possibility that true aesthetic feeling is concerned with anything more than form."[7] There are even extreme purists who maintain that any content of meaning which modern sculpture may have is simply a concession to the unsensitive spectator, an inducement for him to take an interest in the aesthetic quality of art. Just as any moral purpose is held by some to vitiate a play or novel, so is any ideational theme regarded as a blemish on the purity of a sculptured composition. But no one except an extreme purist would maintain that the formal elements of sculpture—volume, balance, contour, rhythm, repetition, and opposition,—indispensable as they are, could ever constitute the whole of sculpture. There must be ideas as well. And much of the aesthetic pleasure derived from sculpture results from the presence of these ideas, albeit this pleasure is dependent, in large measure, on the sense of order and relationship with which the ideas are presented.

Psychological studies, by Freud and others, emphasize that aesthetic capacity and the artistic impulse proceed from the unconscious mind.[8]

[7] Ernest Jones, *Psychoanalysis* (London, Ernest Benn, 1928), p. 68.

[8] For example: Sigmund Freud, *Delusion and Dream* (New York, Moffat, Yard, 1917); "The Relation of the Poet to Day-dreaming," in his *Collected Papers*, Vol. IV, pp. 173–183. George Walther Groddeck, *Exploring the Unconscious* (London, C. W. Daniel, 1933); *The World of Man, as Reflected in Art, in Words and Disease* (London, C. W. Daniel, 1934). Margaret Naumberg, *Studies of the "Free" Art Expression of Behavior Problem Children and Adolescents as a Means*

It is not uncommon for artists to admit that their ideas came to them in dreams, which had their origin in the unconscious. Some artists scribble on paper, dabble with clay, or even go off on a trip while waiting for an idea or inspiration to well up from their unconscious mind. In fact, creative workers in all the arts have long recognized their dependence upon the inner mind and in every age ascribed their inspiration to some power not resident in their conscious selves. Even the humblest writer has known times when the words pour out almost by themselves. The sculptor's endeavor, then, is to transmute in his particular medium the ideas and emotions arising from the inner, unconscious mind, and to express them in a pure aesthetic arrangement.

It is evident that ideas originating in the unconscious mind which are expressed in sculpture qualify as art only after being objectified in a formal arrangement in some permanent or semipermanent material. Hence we may describe the creative act of making a statue as having two phases: the first, that in which something within the sculptor causes the ideas to appear, and the second, that in which these ideas are worked out. The former, whatever it be called by artists or laymen—inspiration, intuition, the gift of God, or repressed instinctual drives,—moves the artist to act and seems independent of his volition. The second phase is work, often hard work, in forming and developing the ideas. This activity is under the voluntary control of the sculptor. Success, however, presupposes certain basic training without which no idea, however novel, meaningful, or inspired, can be transmuted in sculpture. The basic requirements are: experience with materials, observation of nature for accumulating a vocabulary of forms, knowledge of design and aesthetic principles, and technical skill; a deep understanding, either intuitive or conscious, of human nature is also necessary, particularly for the production of sculpture that is meant to have a wide popular appeal.[9]

Since the sculptor has no voluntary control over the primary creative act, he is rarely able to explain it. He may attempt a description of the conditions under which he was surprised by his inspiration: how it appeared in a dream, in a fantasy, or as a revelation. Writers, better

of *Diagnosis and Therapy* (New York, Nervous and Mental Disease Monographs, 1947). Hanns Sachs, *The Creative Unconscious: Studies in the Psychoanalysis of Art* (Cambridge, Mass., Sci-Art publishers, 1942).

[9] Edmund Bergler, "Psychoanalysis of Writers," *Psychoanalysis and the Social Sciences* (New York, International Universities Press, 1947), Vol. I, p. 248.

equipped for verbal description than sculptors are, have more fre-
quently attempted to elucidate this phase of creativity. Nietzsche, in
Ecce Homo, describes the act of artistic creation as follows: ". . . some-
thing which profoundly convulses and upsets one becomes suddenly
visible and audible with indescribable certainty and accuracy . . . A
thought flashes up like lightning, it comes with necessity, without fal-
tering . . . There is an ecstasy so great that the immense strain of it is
sometimes relaxed by a flood of tears, during which one's steps now
involuntarily rush and anon involuntarily lag. There is a feeling one is
utterly out of hand, with the very distinct consciousness of an endless
number of fine thrills and titillations descending to one's very toes. There
is a depth of happiness in which the most painful and gloomy parts do
not act as antitheses to the rest, but are produced and required as neces-
sary shades of color in such an overflow of light. There is an instinct for
rhythmic relation which embraces a whole world of forms . . . Every-
thing happens quite involuntarily, as if in a tempestuous outburst of
freedom and absoluteness, of power, and divinity."[10] But such descrip-
tions of conscious mental processes offer no satisfactory explanation of
the inner metal processes at work in creative activity.

In recent years, with the increasing interest in the workings of the
creative mind, some sculptors, in spite of the difficulties of verbal de-
scription, have attempted to explain the initial phase of their creative
work. Seymore Lipton, an American sculptor, writes as follows: "Inven-
tiveness of sculptural concepts interests me not merely as a striving for
newness or novelty, but as the realization of a total personality, a reach-
ing down into introspective levels and a by-product of fulfillment . . . To
communicate successfully such tensions of inner and outer reality, the
imaginative construction must evoke experiences beneath the visual
surface. My plastic strivings always seem to build themselves around a
core of evolutionary reality. They are never self-conscious platonic
essences, that is, universal analogies of form trying to parallel prehistoric
sculpture, primitive sculpture, or other modern plastic idea. They find
their birth in the subconscious, the instinctive, the mental, the moral, the
sensory."[11]

[10] Quoted by Bergler, *ibid.*, p. 250.
[11] Seymore Lipton, "Some Notes on My Work," *Magazine of Art*, Vol. 40 (November, 1947),
p. 264.

Much of our knowledge about the inner mental processes relating to expressionistic art has come from those students of the mind who have studied unconscious thinking. They are now in general agreement that the forms and ideas which appear in expressionistic sculpture and which stem from the artist's fantasies, from his unconscious thinking, are symbols or signs which when properly translated have logical, understandable meaning. Even the weird forms and shapes in abstract sculpture which originate in the unconscious mind of the artist have just as much meaning, at least for the artist, as the natural, rational forms in objective or representational art. The forms or symbols, whether representational or abstract, and the fantasies, ideas, or themes of expressionistic sculpture are referred to as the "manifest" or surface content and the meaning that lies behind the manifest expression is called the "latent" content. The latent content of expressionistic sculpture deals with unconscious themes, with the deep emotional life of man and woman, with longing, aspiration, love, procreation, the family—mother, father, and siblings,— as well as the origin and meaning of life itself. It also deals with those other, not readily acceptable themes, which nonetheless play a vital role in our emotional life—such as fear, aggression, passivity; tragedy and heartbreak; and death.

It is of course not only the artist who has unconscious thoughts. Everyone has both day dreams and night dreams, and no doubt most of these dreams are weird enough to "write a book about." Dreams can range from the most gentle to the most violently passionate; they may be amusing or tragic. At one extreme they may deal with tender love and at the other with jealousy, rage, and despair. Feelings not usually sanctioned by society here find an outlet: thirst for vengeance, sadistic and masochistic tendencies, and the urge to murder. But it is only rarely that the true meaning of the fantasies in dreams is apparent. Almost always the latent content is so unacceptable to the dreamer's conscience that it can find an outlet only when disguised or presented in a symbolic form that is beyond his recognition. The daydreamer is ordinarily ashamed of his fantasies and conceals them from other persons; "he cherishes them as his most intimate possessions and as a rule would rather confess all his misdeeds than tell his daydreams."[12] He believes that he is the only person

[12] Freud, "The Relation of the Poet to Day-dreaming," *Collected Papers*, Vol. IV, p. 175.

who daydreams in this way and has no idea that everyone else weaves fantasies of the same sort for himself.

The selfsame life of fantasy and dream that is the source of others' daydreams and fantasies is also the fountainhead of the expressionistic artist's imaginative work. But if the others were to communicate to us their intimate, personal fantasies, it would give us no pleasure. In fact, when they are disclosed to us they repel us, or at most leave us cold. However, when a person of artistic talent and skill transforms his fantasies into a statue, he makes them impersonal and socially acceptable. In the presence of such a transformation, our feeling of repulsion is overcome and we experience instead a feeling of elation.

How does the expressionistic sculptor make the transformation? First of all, he understands how to elaborate or abstract his fantasies or daydreams, so that they lose that personal note which repels most spectators. By means of symbols and disguises suitable to his material he replaces the decidedly personal elements in his fantasies with completely impersonal ones. Then he remolds and welds this material until it faithfully expresses his original fantasy. Finally, making use of the principles of formal design and of aesthetics, he translates his material into a work of art. So far as he has been capable of extracting and expressing the universal content of his fantasy, the quality which allies it to the unconscious dreams of all humanity, his sculpture may be said to be successful.

These spontaneously generated productions which spring from the unconscious mind of the artist do not constitute the whole of expressionistic sculpture. There are also works based on ready-made themes taken from folklore, mythology, allegory, or history. These themes, which come from the racial treasure house of myths, legends, and fairy tales, often represent the fantasies of an entire race or nation, and present, in a disguised form, the same range of emotions that appears in the dream life of present-day individuals. They are the "age-long dreams of a young humanity," and when the competent sculptor gives them expression they may move us as much as the expression of his own spontaneous personal fantasies. Even within the bounds set by his choice of subject the sculptor retains a certain amount of independence, which can express itself in his choice of material and in the changes which he makes in the traditional version of the theme employed.

BIBLIOGRAPHY

African Negro Art. Ed. by James J. Sweeney (New York, Museum of Modern Art, 1935).

Agard, Walter R. *The New Architectural Sculpture* (New York, Oxford, 1935).

American Painting and Sculpture, 1862–1932 (New York, Museum of Modern Art, 1932).

The Art of Ancient Egypt (Vienna, Phaidon, 1936).

Bayer, Herbert, ed. *Bauhaus [1919]–1928* (New York, Museum of Modern Art, 1938).

Bergler, Edmund. "Psychoanalysis of Writers," *Psychoanalysis and the Social Sciences* (New York, International Universities Press, 1947), Vol. I, p. 248.

Blossfeldt, Karl. *Urformen der Kunst* (Berlin, Wasmuth, 1928).

Campos, Jules. *José de Creeft* (New York, E. S. Herrmann, 1945).

Casson, Stanley. *Sculpture of Today* (New York, Studio, 1939).

Cellini, Benvenuto. *The Treatises of Benvenuto Cellini on Goldsmithing and Sculpture.* Tr. by C. R. Ashbee (London, Edward Arnold, 1898).

Cladel, Judith. *Aristide Maillol* (Paris, Grasset, 1937).

Clarke, Carl D. *Molding and Casting* (Baltimore, Lucas, 1938).

Cubism and Abstract Art (New York, Museum of Modern Art, 1936).

Ede, H. S. *Savage Messiah* (New York, Knopf, 1931).

Freud, Sigmund. *Delusion and Dream* (New York, Moffat, Yard, 1917).

———. *The Interpretation of Dreams.* Authorized Translation of the 3d ed., with an Introduction by A. A. Brill (New York, Macmillan, 1923).

———. *Introductory Lectures on Psychoanalysis* (London, Allen & Unwin, 1922).

———. "The Moses of Michelangelo" (1914), in his *Collected Papers* (London, Hogarth Press, 1934), Vol. IV, p. 251.

———. "The Relation of the Poet to Day-dreaming," in his *Collected Papers* (London, Hogarth Press, 1934), Vol. IV, p. 175.

Gaston Lachaise, Retrospective Exhibition, 1935 (New York, Museum of Modern Art, 1935).

Giedion-Welcker, Carola. *Modern Plastic Art* (Zurich, H. Girsberger, 1937).

Goldscheider, Ludwig. *Donatello* (New York, Oxford University Press, 1940).

Goldscheider, Ludwig. *Roman Portraits* (New York, Oxford University Press, 1941).

Goldwater, Robert J. *Primitivism in Modern Painting* (New York, Harper, 1938).

Groddeck, Georg W. *Exploring the Unconscious: Further Exercise in Applied Analytical Psychology* (London, C. W. Daniel, 1933).

———. *The World of Man as Reflected in Art, in Words and Disease* (London, C. W. Daniel, 1934).

Gropius, Walter. *The New Architecture and the Bauhaus* (New York, Museum of Modern Art, 1937).

Guggenheim, Marguerite, ed. *Art of This Century* (New York, Art-aid Corporation, 1942).

Guillaume, Paul, and Munro, Thomas. *Primitive Negro Sculpture* (New York, Harcourt, Brace, 1926).

Hoffman, Malvina. *Sculpture Inside and Out* (New York, Norton, 1939).

Jones, Ernest. *Psychoanalysis* (London, Benn, 1929).

Lawrie, Lee. *Sculpture* (Cleveland, Jansen, 1936).

Lipton, Seymore. "Some Notes on My Work," *Magazine of Art,* Vol. XL (Nov., 1947), p. 264.

Moholy-Nagy, László. *New Vision,* 3d rev. ed. And, *Abstract of an Artist* (New York, Wittenborn, 1946).

National Sculpture Society. *Contemporary American Sculpture. The California Palace of the Legion of Honor, Lincoln Park, San Francisco, April to October, 1929* (New York, 1929).

———. *Sculpture Exhibit. Whitney Museum of American Art, 1940* (New York, 1940).

Naumberg, Margaret. *Studies of the "Free" Art Expression of Behavior Problem Children and Adolescents as a Means of Diagnosis and Therapy* (Nervous and Mental Disease Monographs, no. 71) (New York, Nervous and Mental Disease Monographs, 1947).

Painters and Sculptors in Modern America. Introduction by Monroe Wheeler (New York, Crowell, 1942).

Painting and Sculpture in the Museum of Modern Art. Ed. by Alfred Barr, Jr. (New York, Museum of Modern Art, 1942).

Parkes, Kineton. *The Art of Carved Sculpture* (London, Chapman and Hall, 1931).

Pfister, Oskar R. *Expression in Art, Its Psychological and Biological Basis* (London, Paul, Trench, Trubner, 1922).

Pound, Ezra. *Gaudier-Brzeska* (New York, John Lane, 1916).

Proske, Beatrice. *Brookgreen Gardens, Sculpture* (Brookgreen, S.C., 1943).

Putnam, Brenda. *Sculptor's Way* (New York, Farrar and Rinehart, 1939).

Read, Herbert. *Art and Industry: The Principles of Industrial Design* (London, Faber & Faber, 1934).

———. *Henry Moore, Sculptor, an Appreciation* (London, A. Zwemmer, 1934).

Rewald, John. *Maillol* (New York, Hyperion, 1939).

Rich, Jack C. *The Materials and Methods of Sculpture* (New York, Oxford University Press, 1947).

Richter, Gisela. *Attic Red-Figured Vases* (Yale University Press, 1946).

Rindge, Agnes. *Sculpture* (New York, Payson and Clarke, 1929).

Rogers, Meyric R. *Carl Milles* (Yale University Press, 1940).

Roheim, Geza. "The Concentric Circle and Fertility Rites," in his *The Eternal Ones of the Dream* (New York, International Universities Press, 1945).

Sachs, Hanns. *The Creative Unconscious: Studies in the Psychoanalysis of Art* (Cambridge, Mass., Sci-Art Publishers, 1942).

Schnier, Jacques. "Dragon Lady," *American Imago,* Vol. IV (July, 1947), p. 78.

———. "Expressionism in Sculpture," *San Francisco Art Association Bulletin,* Vol. II (Sept., 1935), p. 1.

The Sculpture of Ivan Meštrović (Syracuse University Press, 1948).

Story, Sommerville. *Auguste Rodin* (New York, Oxford University Press, 1939).

Swarz, Sahl. *Catalog of the Amino Exhibition* (New York, Sculptors Gallery, Clay Club, 1946).

Sweeney, James J. *Alexander Calder* (New York, Museum of Modern Art, 1943).

Taft, Lorado. *The History of American Sculpture* (New York, Macmillan, 1903).

Teague, Walter D. *Design This Day* (New York, Harcourt, Brace, 1940).

Vitry, Paul. *Paul Manship* (Paris, La Gazette des Beaux-Arts, 1927).

Zigrosser, Carl. "Heinz Warneke: Sculptor," *Creative Art*, Vol. II (April, 1928), p. xxxv.

Zorach, William. *Zorach Explains Sculpture* (New York, American Artists Group, 1947).

PLATES

ACKNOWLEDGMENTS

EXCEPT as noted below, the photographs from which the plates were made were supplied by the sculptors of the works pictured. Only if it was specifically asked that the name of the photographer be shown is that information given here. The location of the finished work is indicated only when it was noted by the sculptor.

Plate 5. Detail from Ellen Phillips Samuel Memorial, Fremont Park, Philadelphia.

Plate 8. In the collection of the Chicago Art Institute.

Plate 9. In the collection of Rose Pauson, San Francisco; photo by Romaine.

Plate 10. In the collection of Marian Willard, New York; photo by Salem Rice.

Plate 12. Photo courtesy of Sculptors Gallery, Clay Club.

Plate 15. Photo by Imandt.

Plate 16. Photo by Stetson.

Plate 24. In the Federal Reserve Bank, Philadelphia.

Plate 26. Photo courtesy of Sculptors Gallery, Clay Club.

Plate 27. Photo courtesy of Sculptors Gallery, Clay Club.

Plate 28. Photo by Walter J. Russell.

Plate 29. In the collection of R. E. Langer.

Plate 31. Photo by Schiff.

Plate 33. In the Pennsylvania Academy of Fine Arts.

Plate 35. In the Whitney Museum, New York.

Plate 39. In the Springfield Museum of Art, Springfield, Missouri.

Plate 42. Photo by Carl Klein.

Plate 46. Photo by Dana.

Plate 49. In the collection of Frederic L. Ballard, Philadelphia.

Plate 52. Photo courtesy of Sculptors Gallery, Clay Club.

Plate 56. At the Golden Gate International Exposition, 1939–1940.

Plate 64. Photo by Hedrich-Blessing.

Plate 68. Photo courtesy of the San Francisco Museum of Art.

Plate 72. In the Memorial Building, St. Louis, Missouri.

Plate 73. For Stark Park, Manchester, Massachusetts.

Plate 76. In the collection of International Business Machines Corporation.

Plate 77. In the Court of the Hispanic Society, New York.

Plate 78. At the Federal Building, New York World's Fair, 1939.

Plate 83. Photo courtesy of Sculptors Gallery, Clay Club.

Plate 89. In Brookgreen Gardens, South Carolina.

Plate 91. Photo by Romaine.

Plate 92. In the collection of Phillip Chapman, Philadelphia. Photo by Lew Tyrrell.

Plate 93. In the collection of the Munson-William Proctor Institute, Utica, New York.

Plate 94. In Brookgreen Gardens, South Carolina.

Plate 98. At the Sunnydale Housing Project.

Plate 101. At the Groton School, Groton, Massachusetts.

Plate 102. Photo by Romaine.

Plate 103. In the Garfield Restaurant, Brooklyn.

Plate 104. At the Missouri Historical Society, St. Louis.

Plate 105. In the Federal Courthouse, Philadelphia.

Plate 106. In the Post Office, Oakville, Connecticut.

Plate 108. In the Post Office, Penn's Grove, New York.

Plate 109. In the Buffalo Historical Society, Buffalo, New York.

Plate 112. In the Post Office, Carthage, Mississippi.

Plate 114. Photo courtesy of Sculptors Gallery, Clay Club.

Plate 117. Photos courtesy of Medallic Art Company.

Plate 120. Photo courtesy of the San Francisco Museum of Art.

Plate 123. Photo courtesy of the San Francisco Museum of Art.

Plate 125. Photo courtesy of the San Francisco Museum of Art.

Plate 126. Photo courtesy of Sculptors Gallery, Clay Club.

Plate 127. Photo courtesy of the Arts Club of Chicago.

Plate 128. Photo by Burkhardt.

Plate 133. Photo courtesy of Sculptors Gallery, Clay Club.

Plate 134. Photo courtesy of Sculptors Gallery, Clay Club.

HEADS

MISS MAIMÉ·TSE (*Alabaster*) Richard Davis

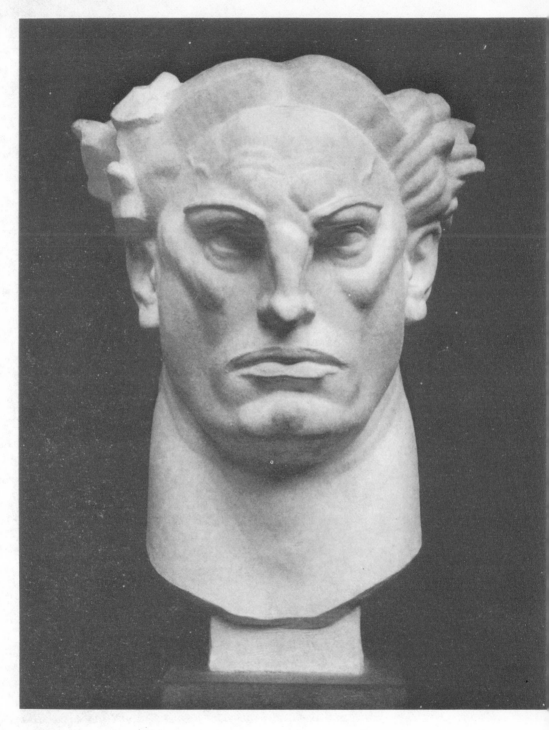

Cosmic Head *(For granite)* Donald De Lue

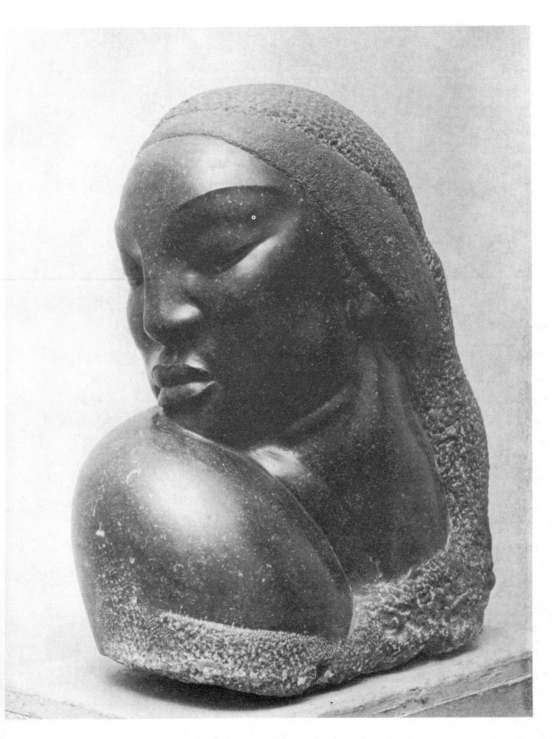

MAYA *(Black Belgian granite)* José de Creeft

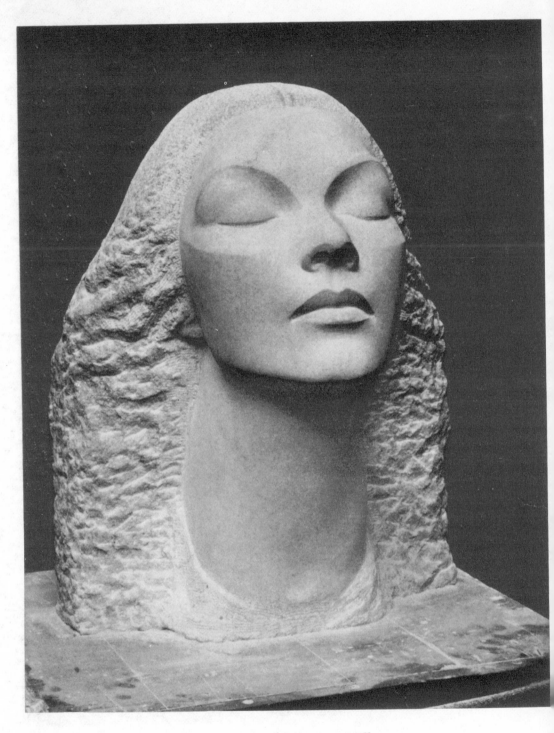

WOMAN (*Marble*) Burr Miller

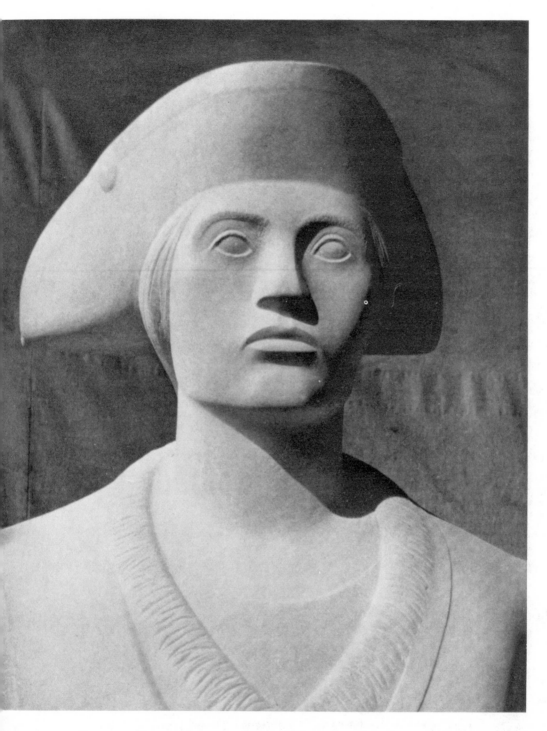

REVOLUTIONARY SOLDIER: DETAIL *(Limestone)* Erwin Fry

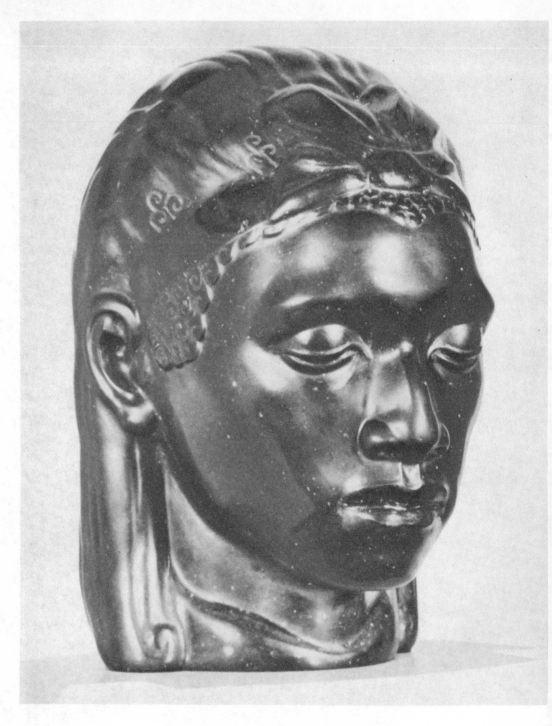

La Cubana *(Obsidian)* Donal Hord

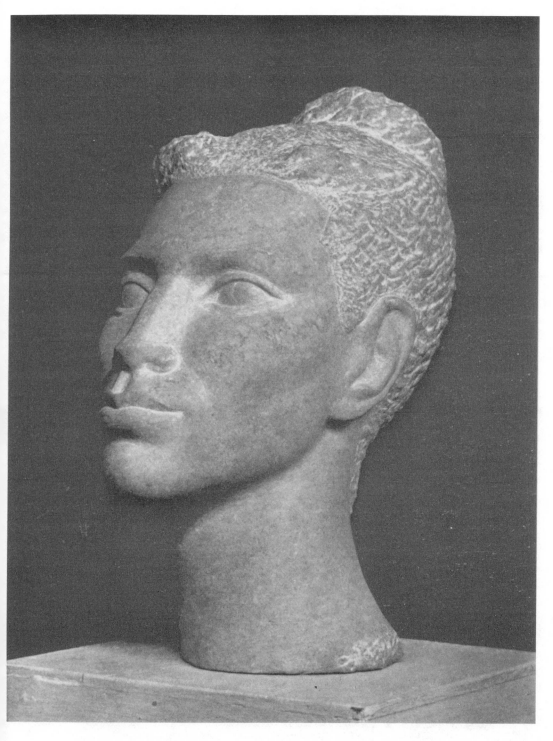

Miss Benjamin of Jamaica *(Tennessee marble)* Ruth Nickerson

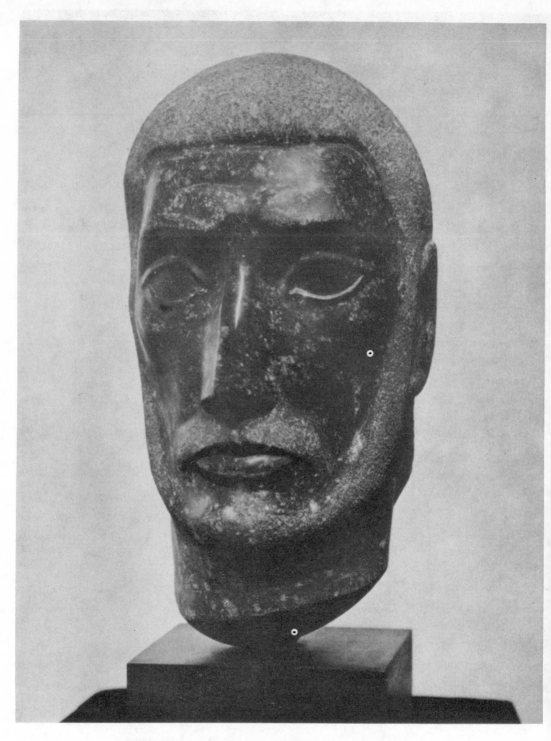

THE PROPHET *(Black granite)* William Zorach

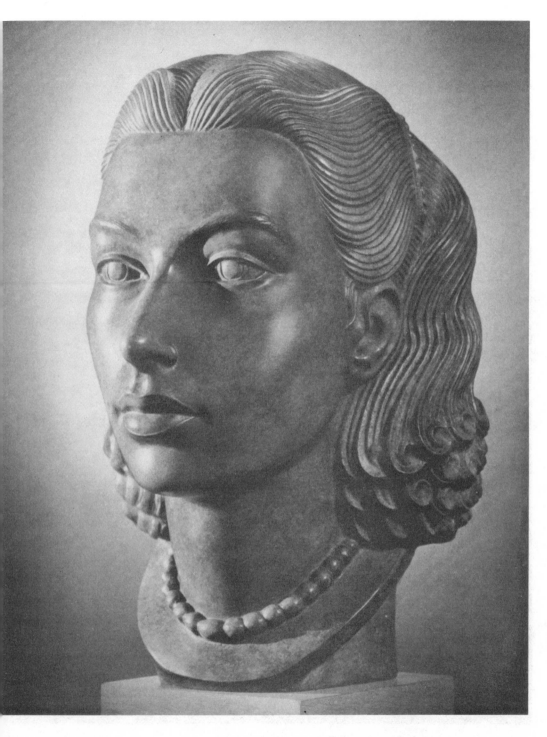

JEAN HABER GREEN, M.D. *(Bronze)* Jacques Schnier

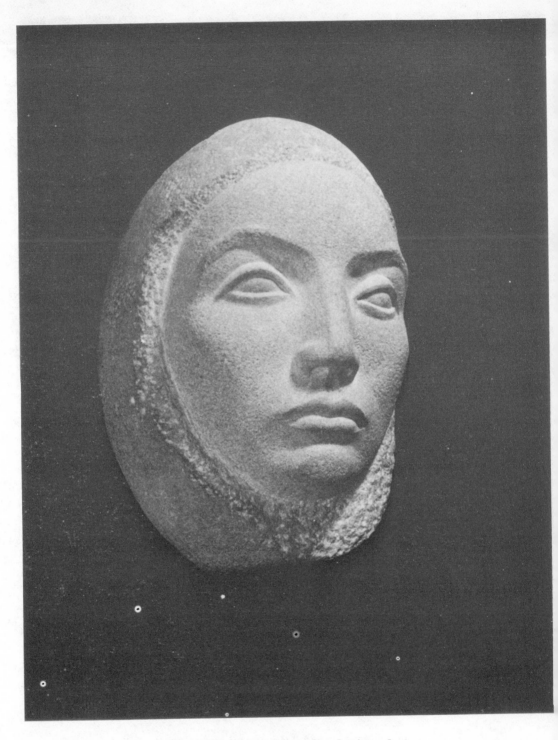

Head *(Quartzite)* Richard O'Hanlon

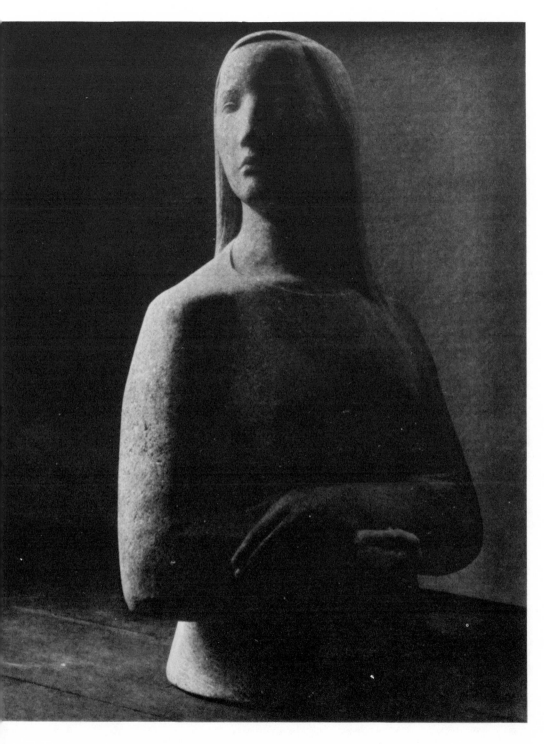

FIGURE *(Pink Georgia marble)* Henry Kreis

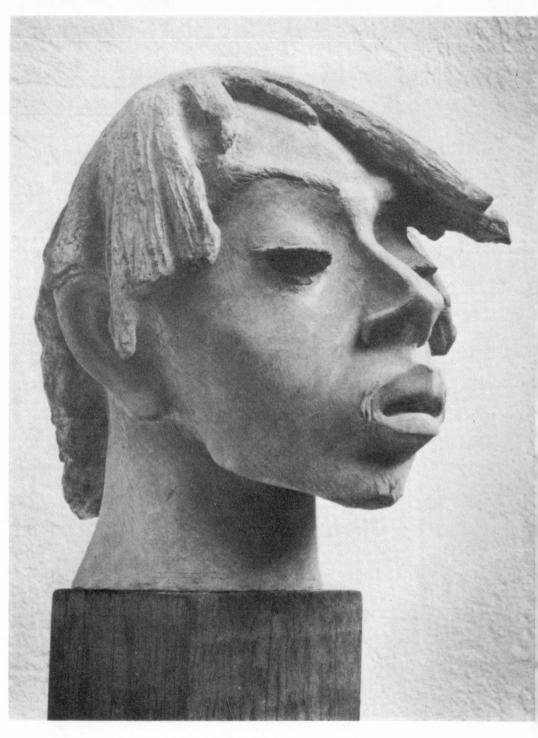

JUAN DE DIOS *(Plaster)* Lu Duble

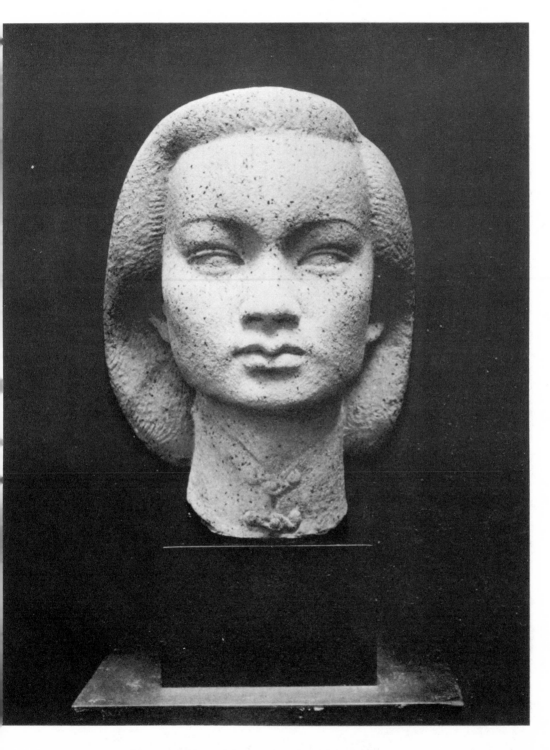

CHINESE GIRL *(Terra cotta)* Clara Fasano

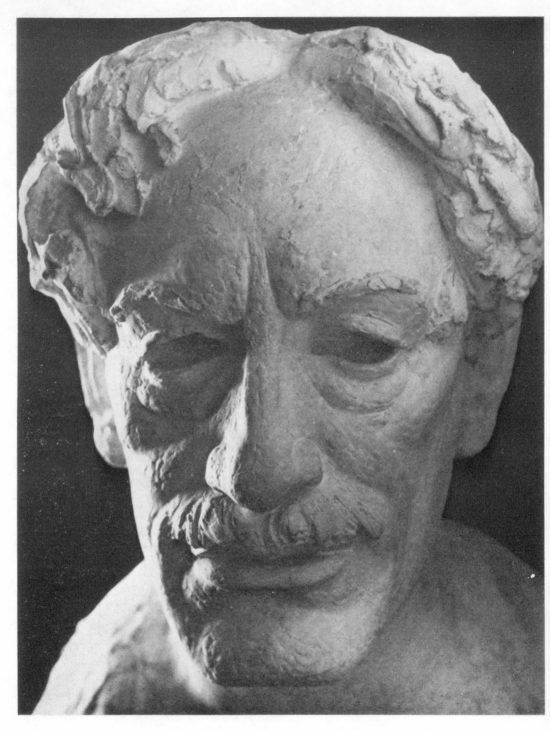

BARBUSSE *(Plaster)* George Aarons

14

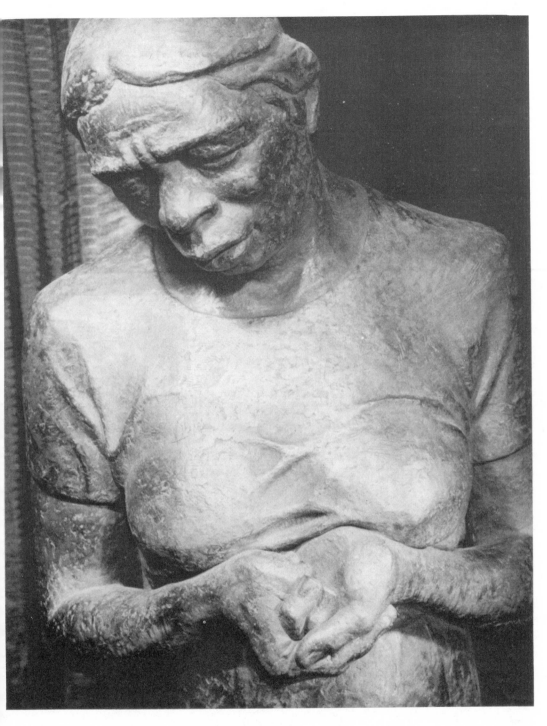

Negro Lament *(Terra cotta)* Helene Sardeau

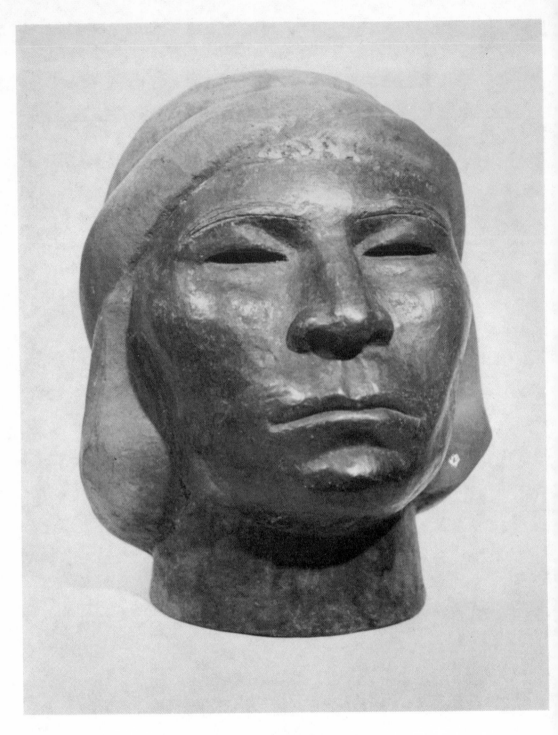

HOPI *(Terra cotta)* Margo Allen

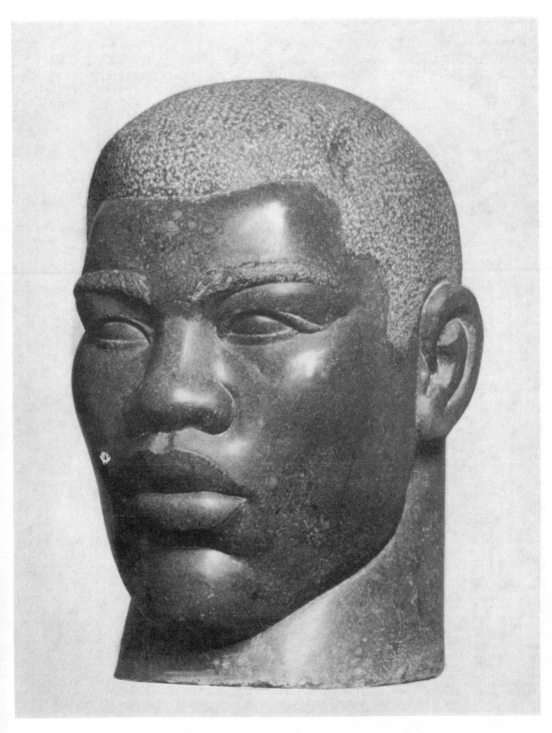

JOE LOUIS *(Gray Vermont marble)* Ruth Yates

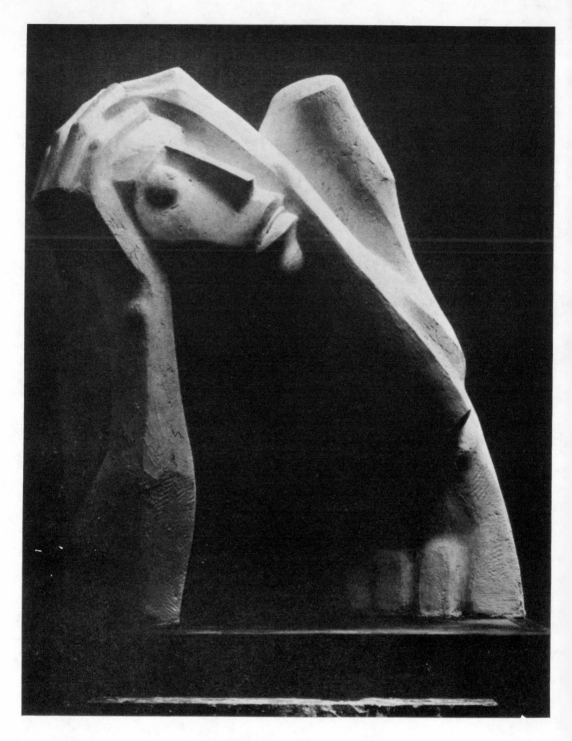

FEAR *(Plaster)* Albert Stewart

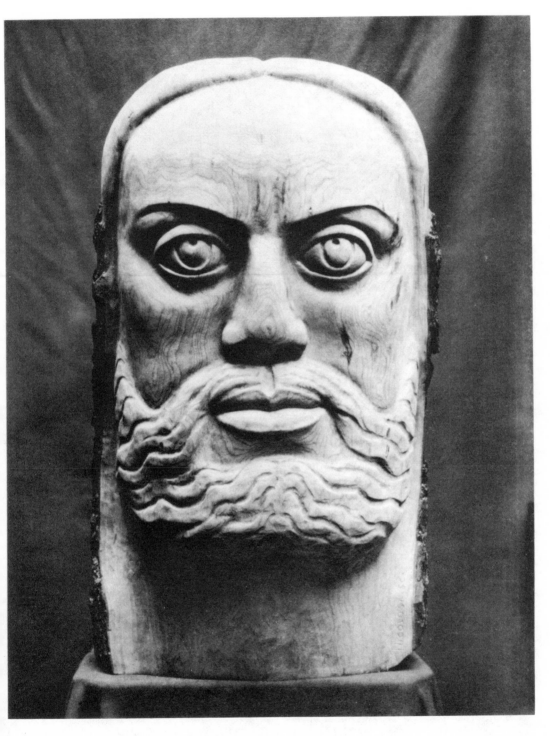

PROPHET *(Wood)* Joseph Nicolosi

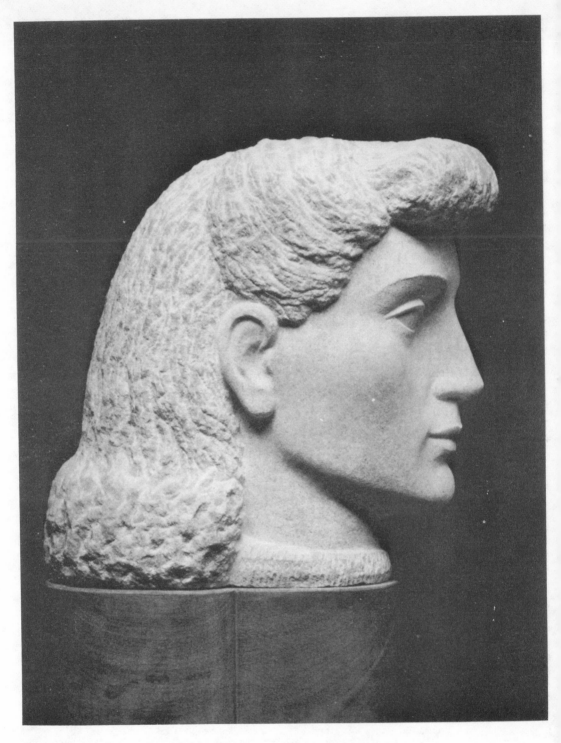

HEAD (*Marble*) Bruno Mankowski

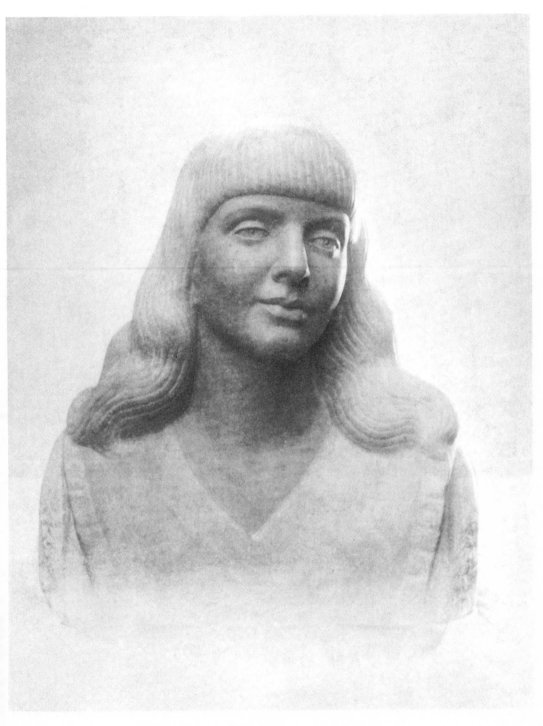

GUILA BUSTABO *(Marble)* Pietro Montana

21

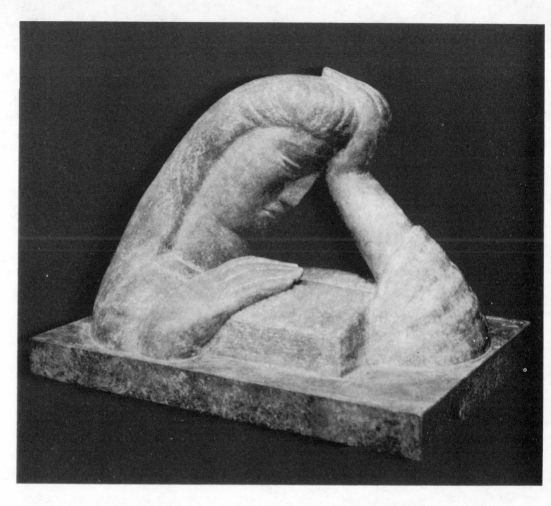

THE BOOK OF LIFE *(For stone)* Lucy Christopher

FIGURES

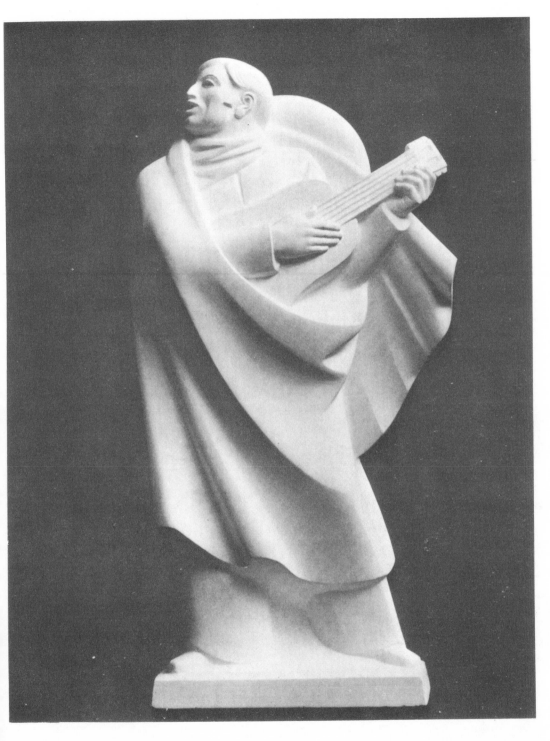

SOUTHERN TROUBADOUR *(Plaster)* Carl Schmitz

23

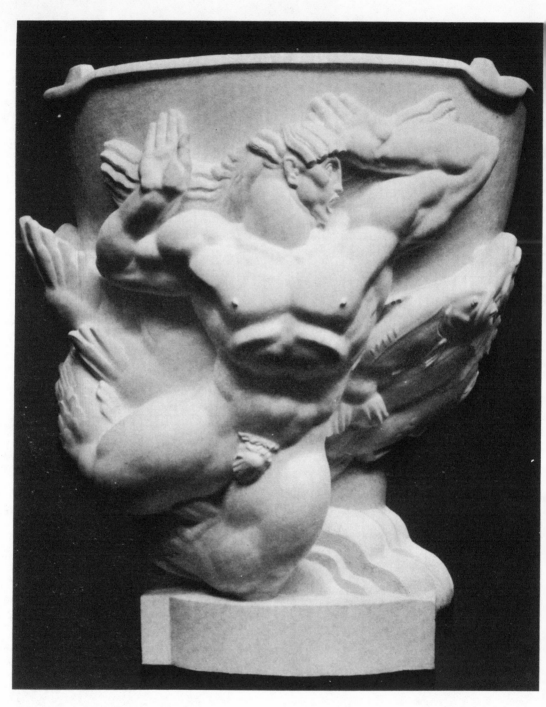

TRITON *(For marble)*　Donald De Lue

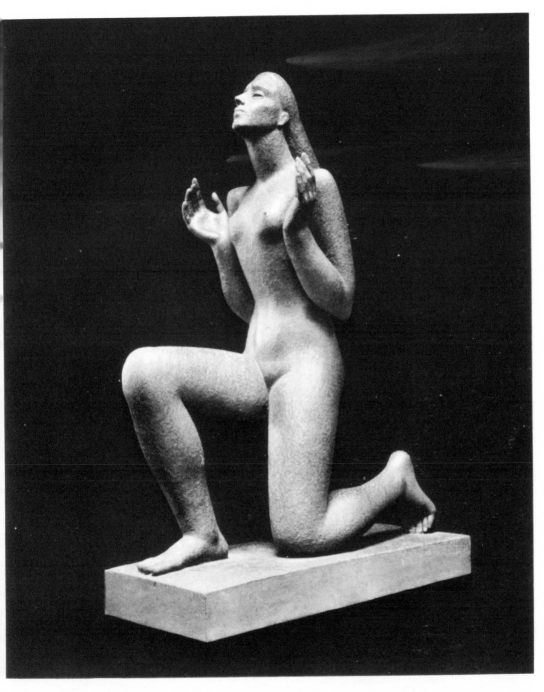

Sᴜɴ Wᴏʀsʜɪᴘ *(Patined plaster for bronze)* Clara Fasano

25

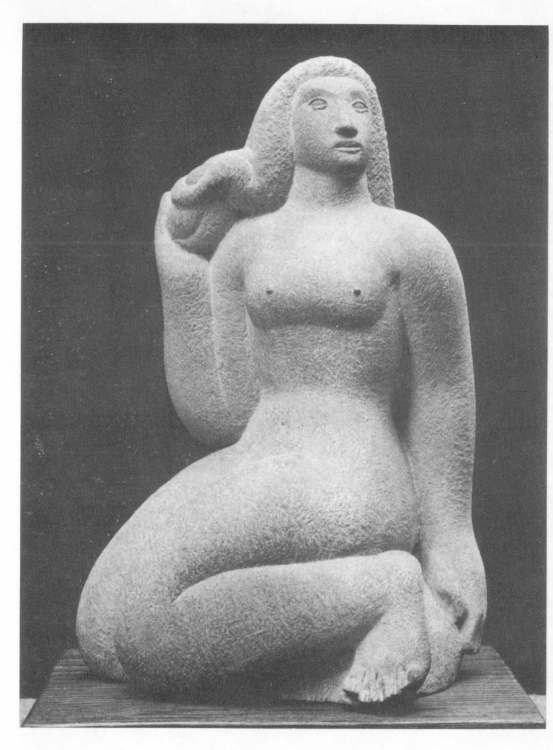

Eve (*Limestone*) Jean de Marco

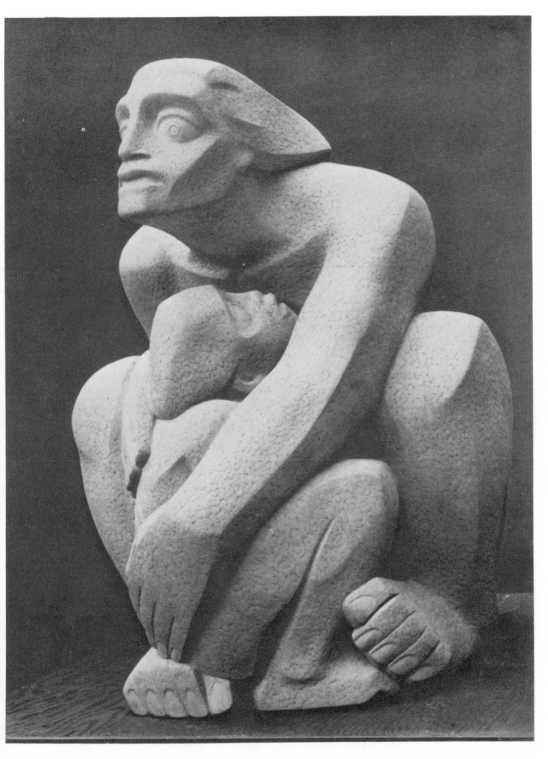

SHELTER *(Terra cotta)* Nina Winkel

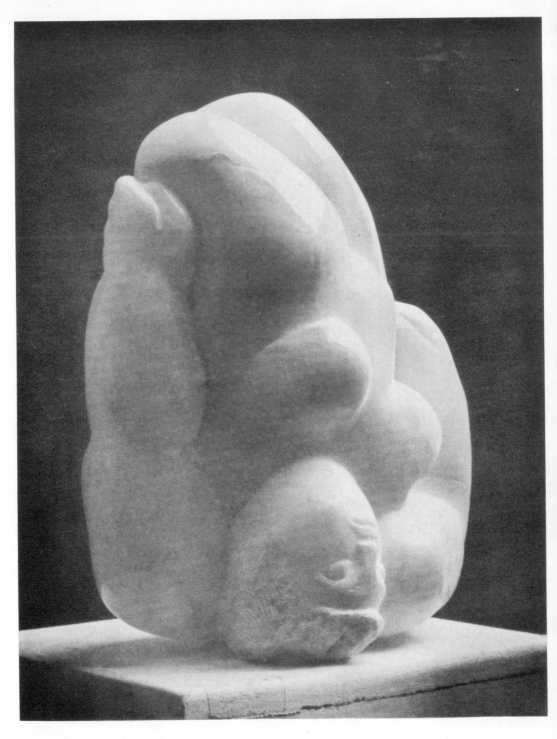

Metamorphosis *(Alabaster)* Burr Miller

28

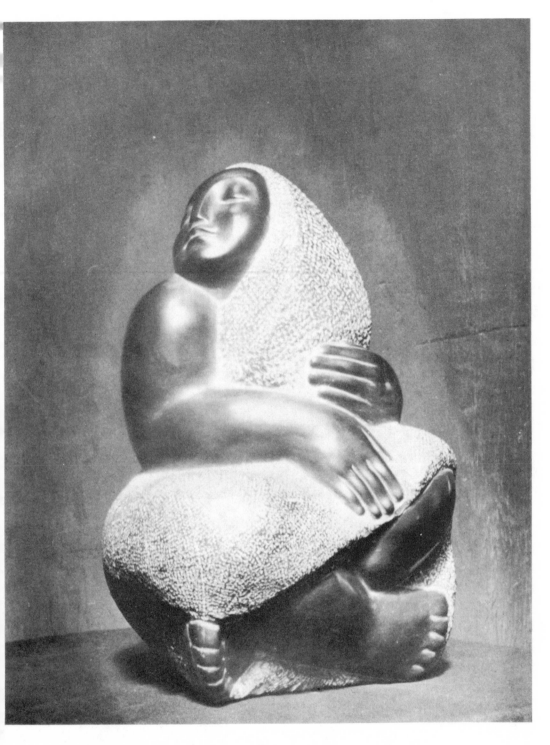

INDIAN WOMAN *(Black Belgian marble)* Cleo Hartwig

29

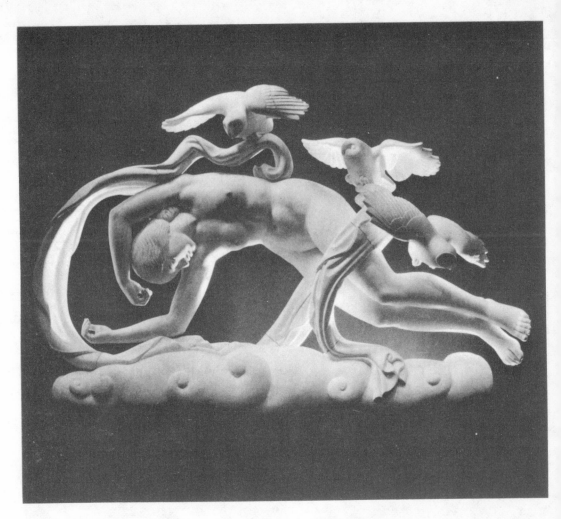

EVENING *(For bronze)* Paul Manship

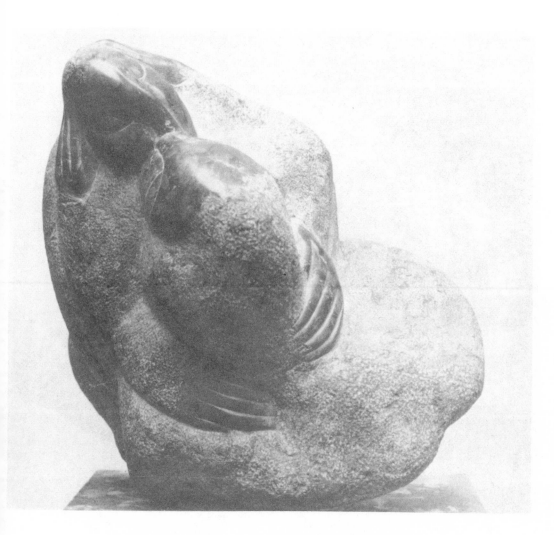

THE KISS *(Mallorcan marble)* José de Creeft

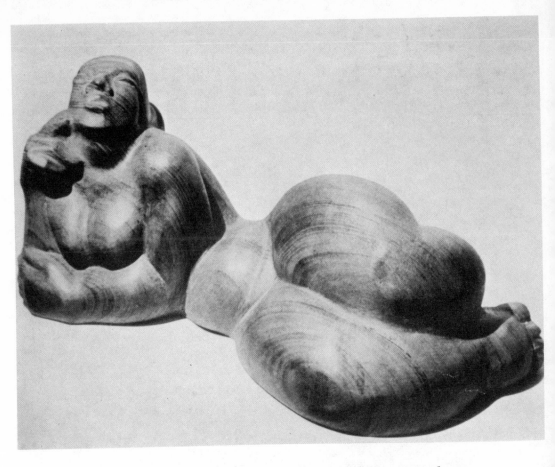

RECLINING NUDE (*Honduras mahogany*) Ellen Key-Oberg

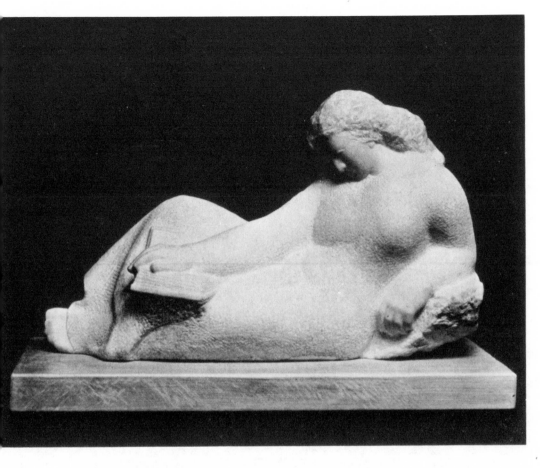

RECLINING GIRL *(Marble)* Charles Rudy

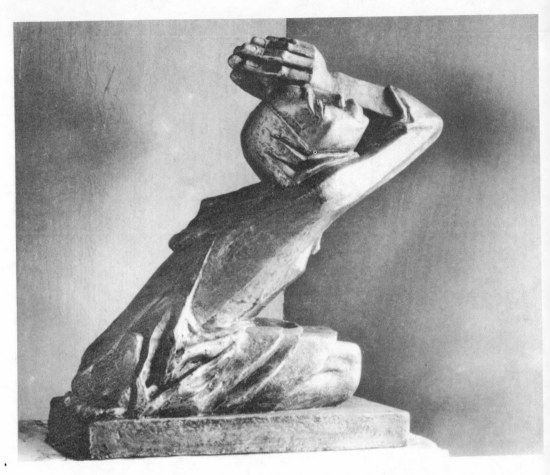

PRAYER TO THE DEAD *(For bronze)* Lu Duble

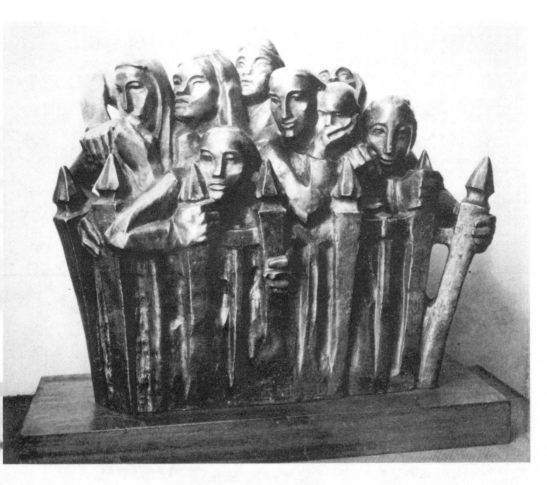

MINE DISASTER *(Bronze)* Berta Margoulies

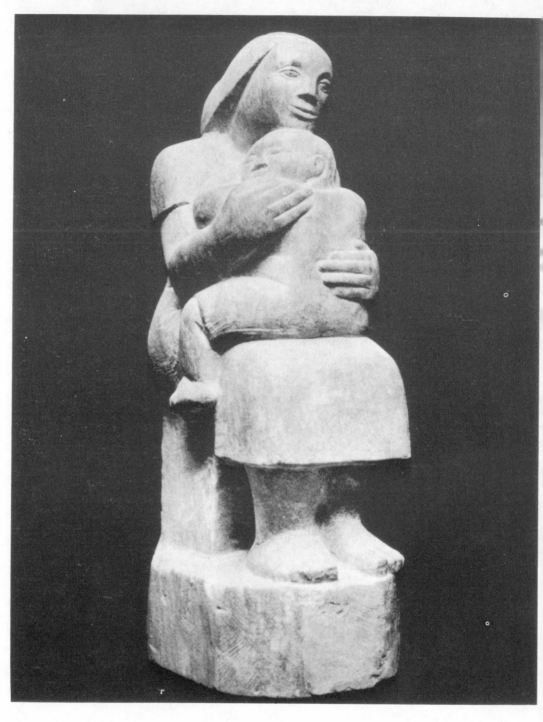

MOTHER AND CHILD *(Marble)* Cesare Stea

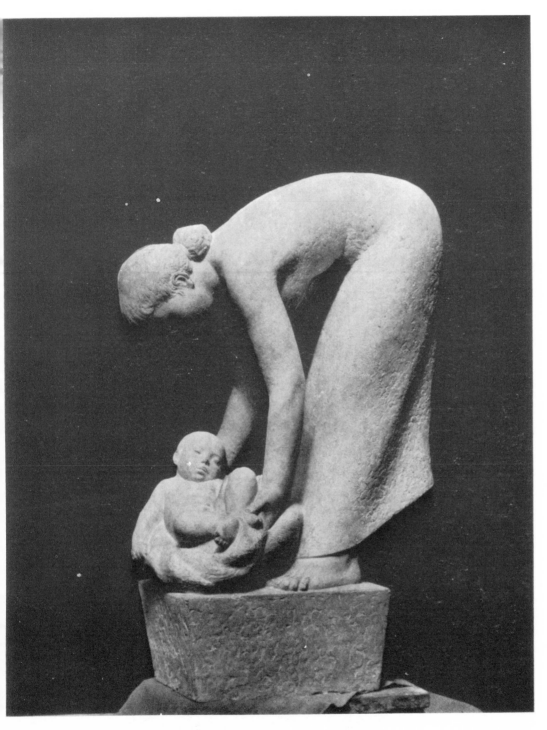

MOSES *(For bronze)* Peter Dalton

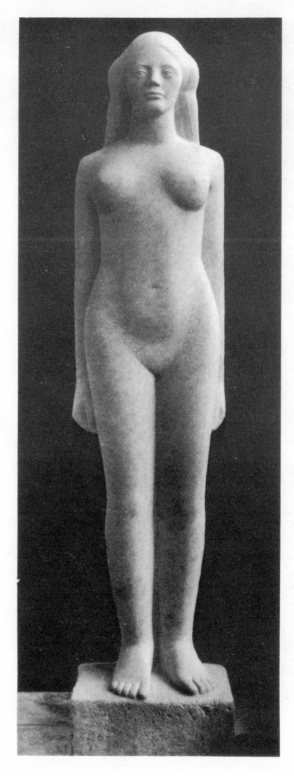

STANDING FIGURE *(Georgia marble)* Erwin Fry

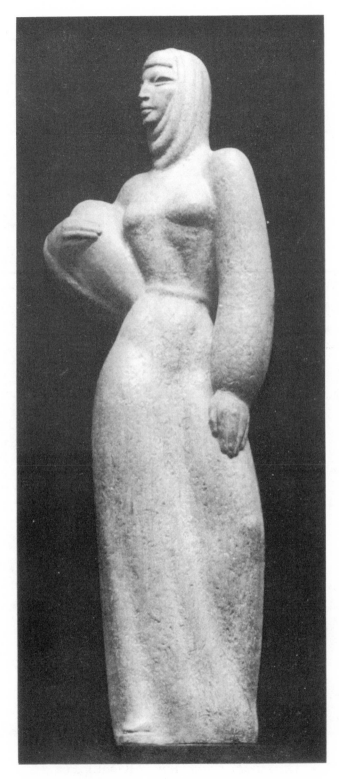

Rebekah *(Terra cotta)* Bernard Frazier

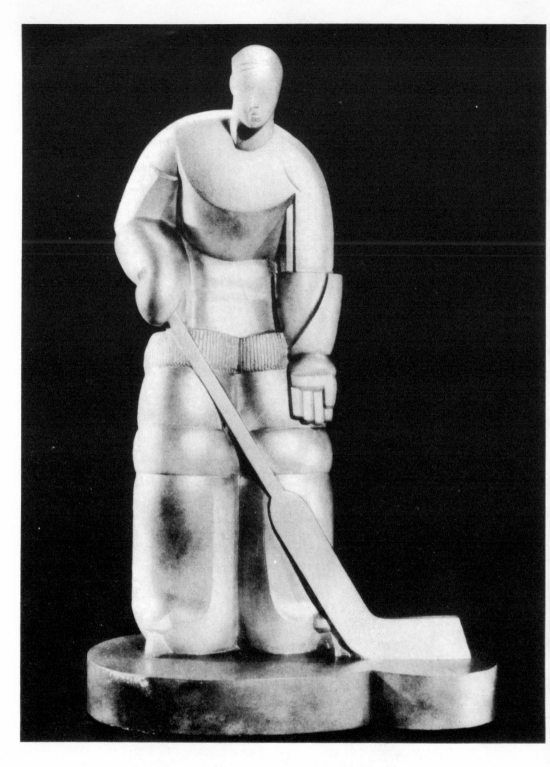

GOALIE *(For aluminum)* Raoul Josset

40

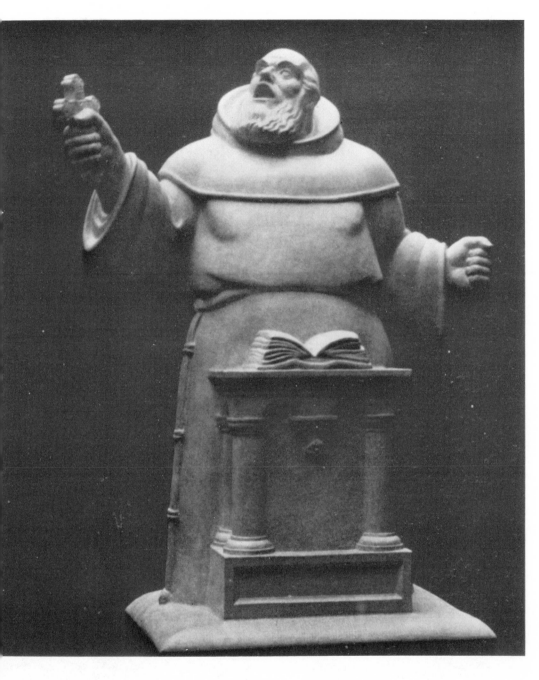

Apage Satana (*Marble*) Elmer Daniels

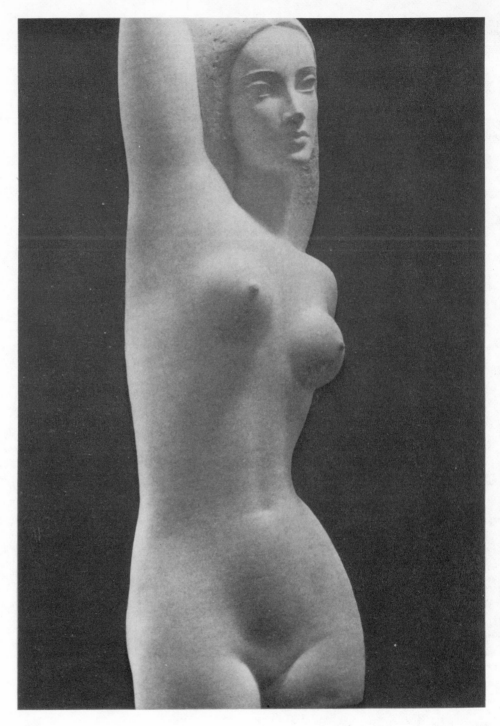

NATASHA *(For marble)* Boris Lovet-Lorski

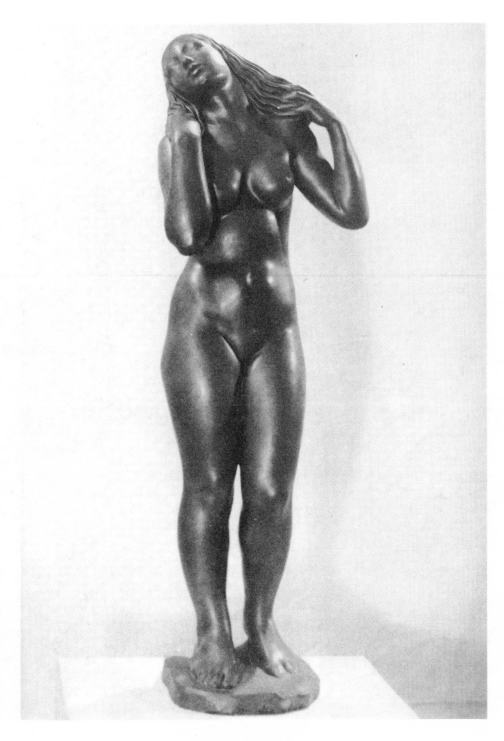

Nude *(Bronze)*　George Aarons

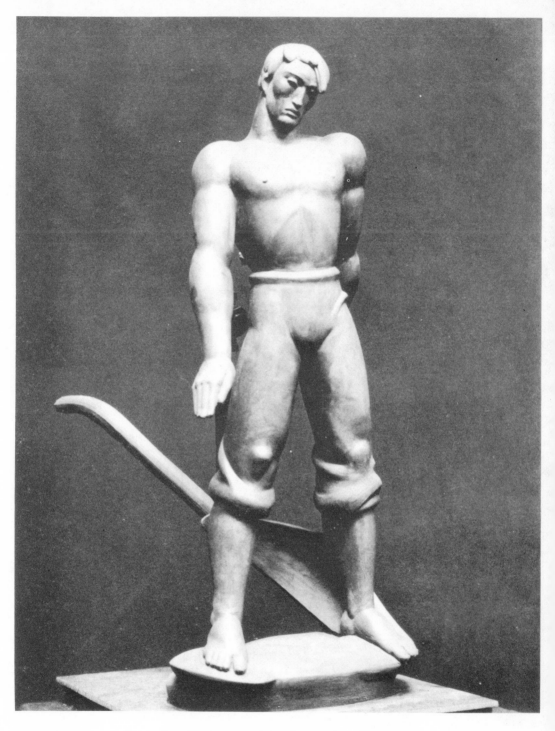

To a God Unknown *(For bronze)* Albert Wein

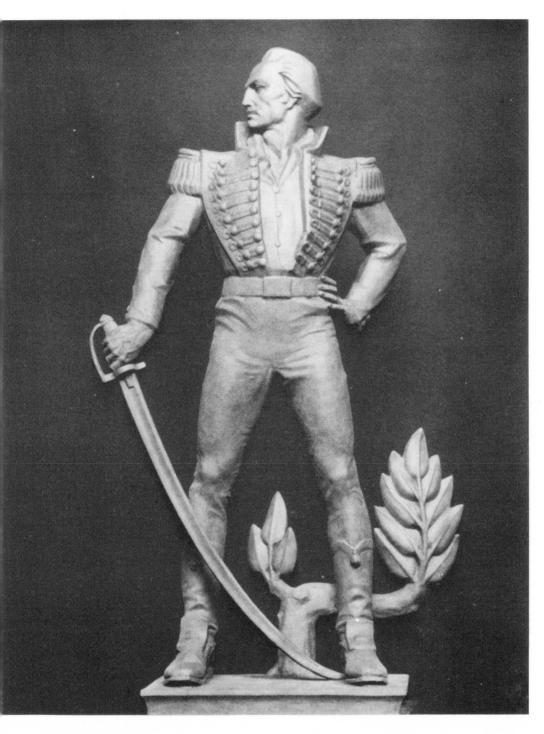

CASIMIR PULASKI *(For bronze)* Sidney Waugh

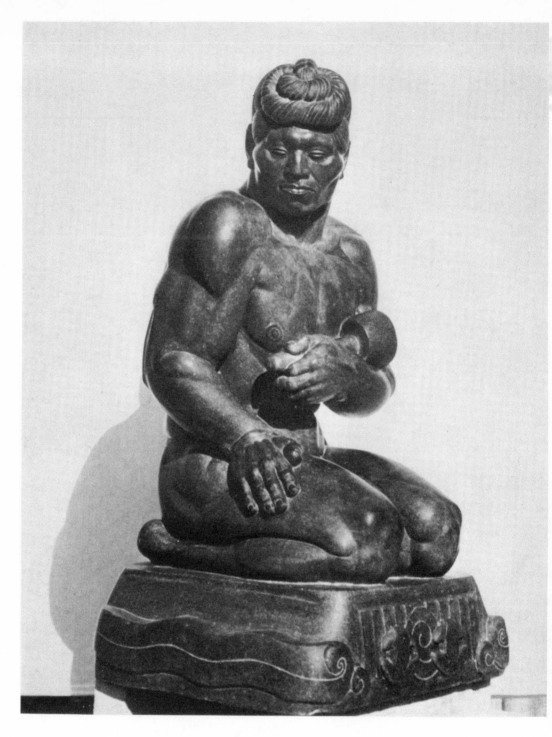

EL COLORADO *(Diorite)* Donal Hord

46

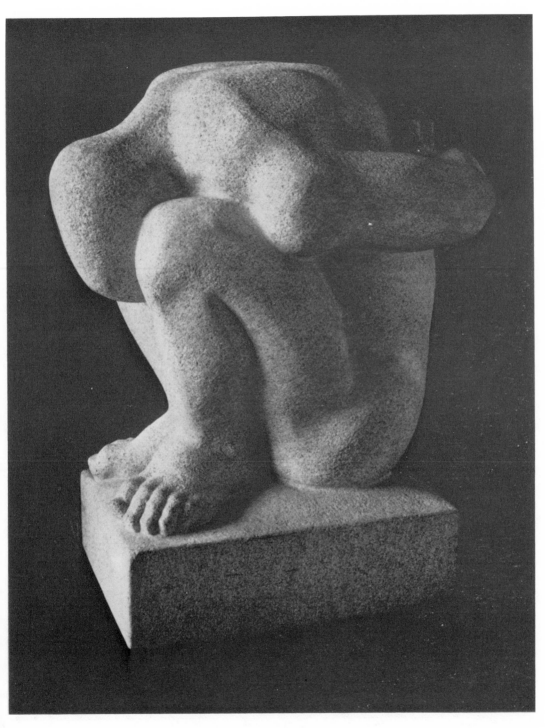

SLAVE *(Granite)* Raymond Puccinelli

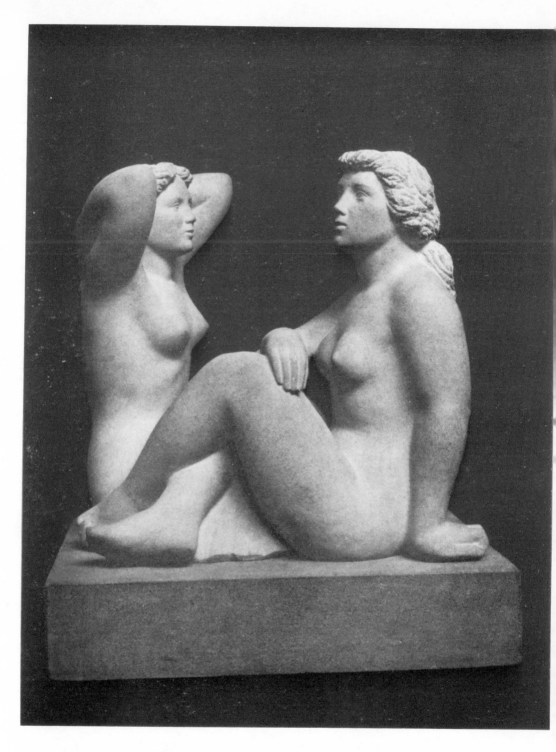

Two Figures *(Stone)* Bruno Mankowski

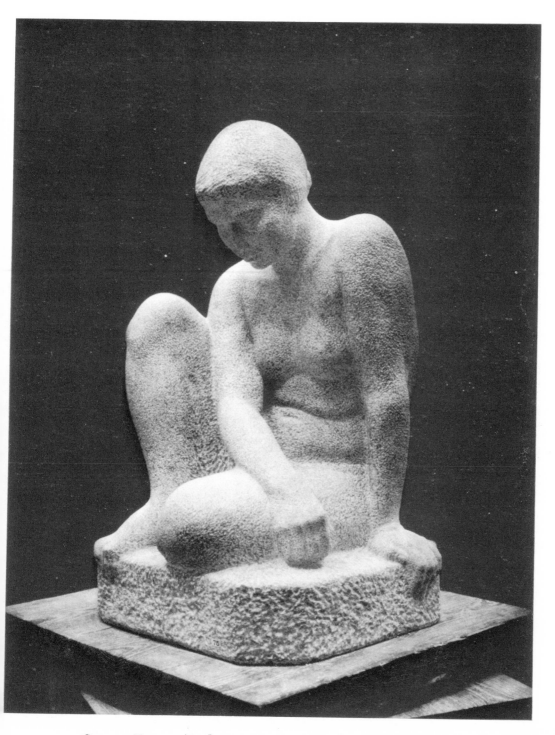

Seated Figure *(Pink Tennessee marble)* Grace Turnbull

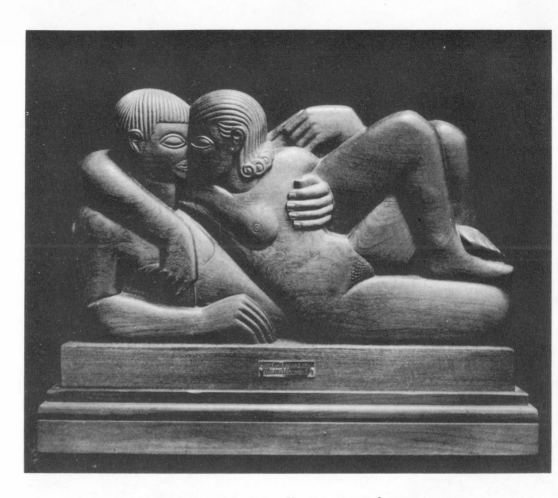

THE KISS *(Teakwood)* Jacques Schnier

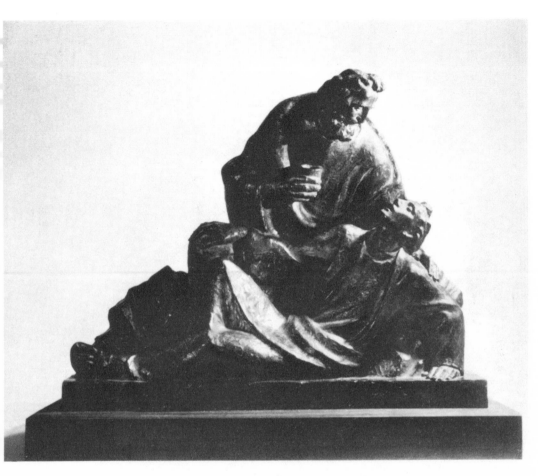

Good Samaritan *(Bronze)* Adlai Hardin

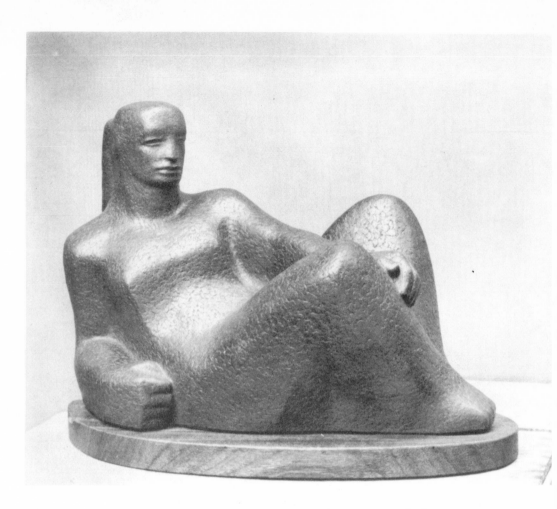

THE MOUNTAIN *(Terra cotta)* Nina Winkel

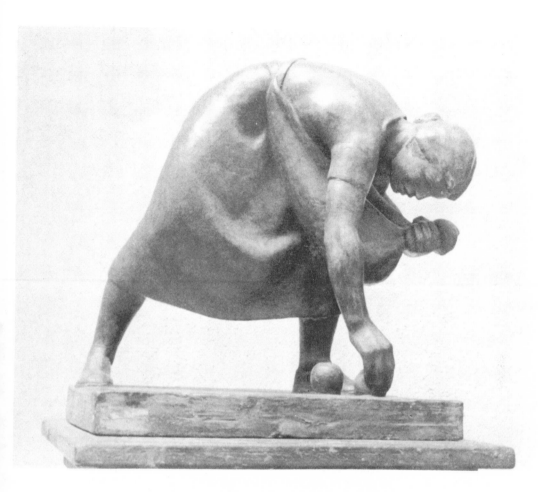

HARVEST *(Bronze)* Cornelia Chapin

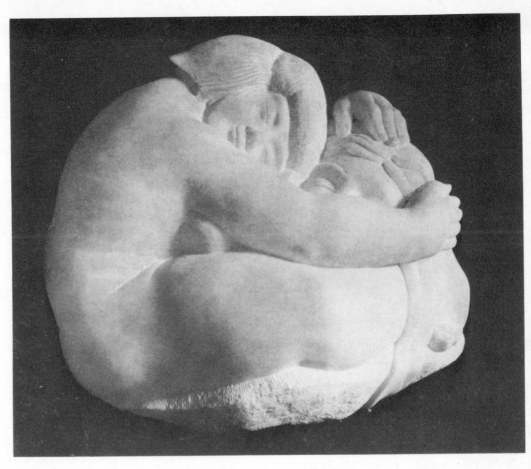

Salome *(Alabaster)* Robert Laurent

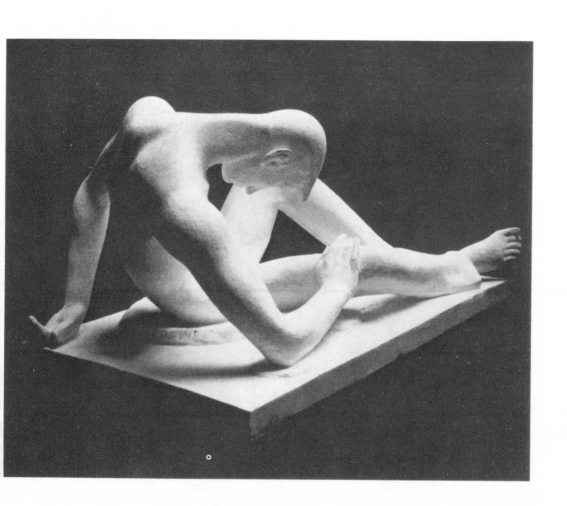

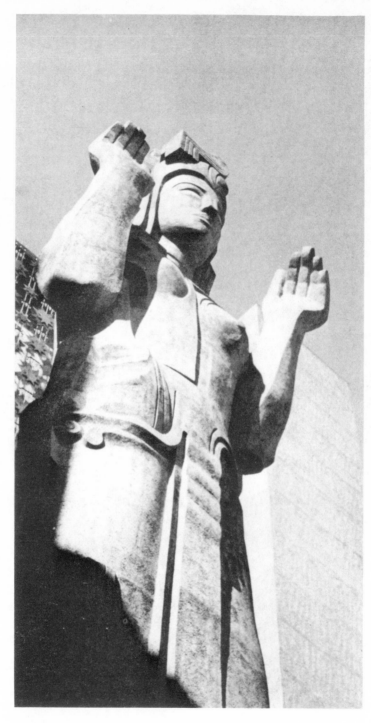

PACIFICA *(Stucco)* Ralph Stackpole

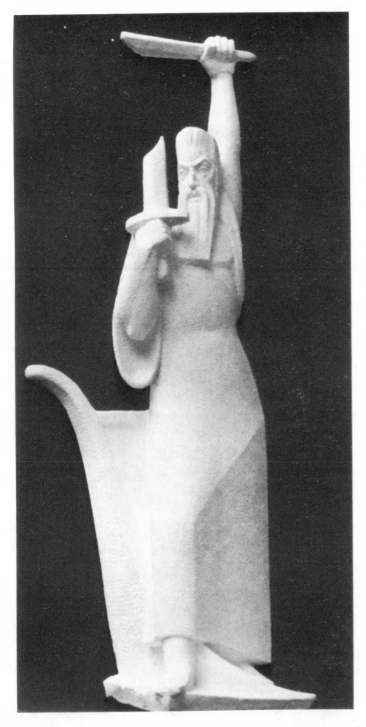

. . . AND THEY SHALL BEAT THEIR SWORDS INTO PLOWSHARES . . . *(Plaster)*
Moissaye Marans

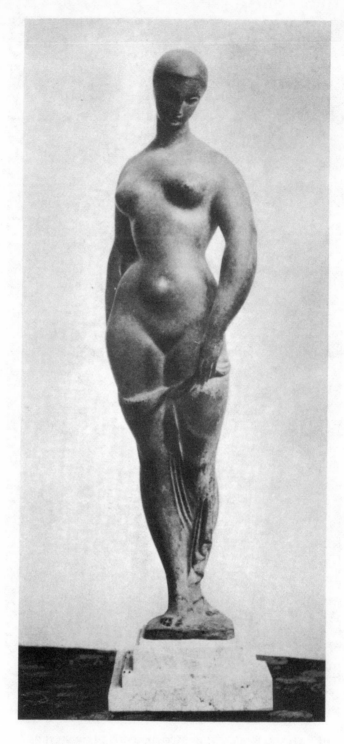

THE FLOWER *(Bronze)* Vincent Glinsky

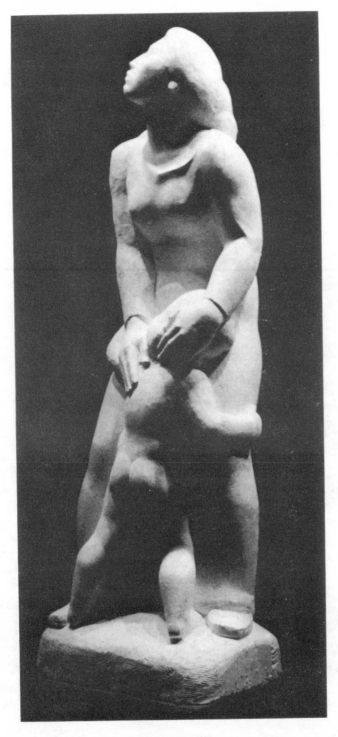

CIVILIANS *(Plaster)* Albert Stewart

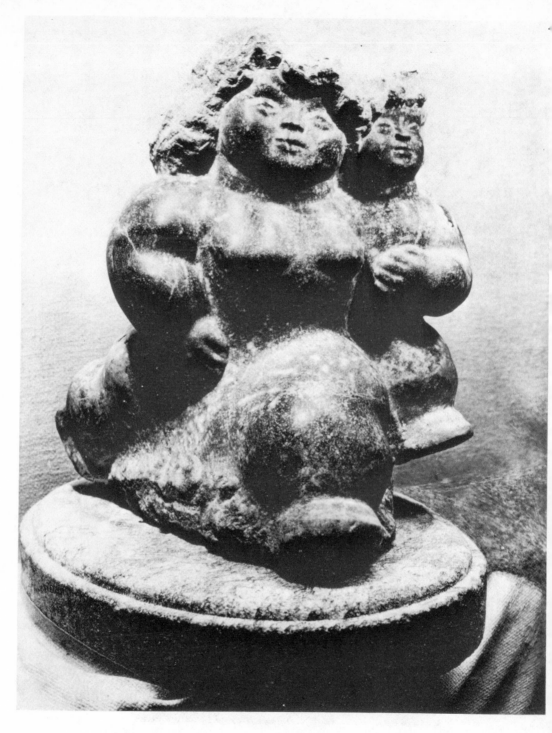

Eternal Mother *(Lithium stone)* Chaim Gross

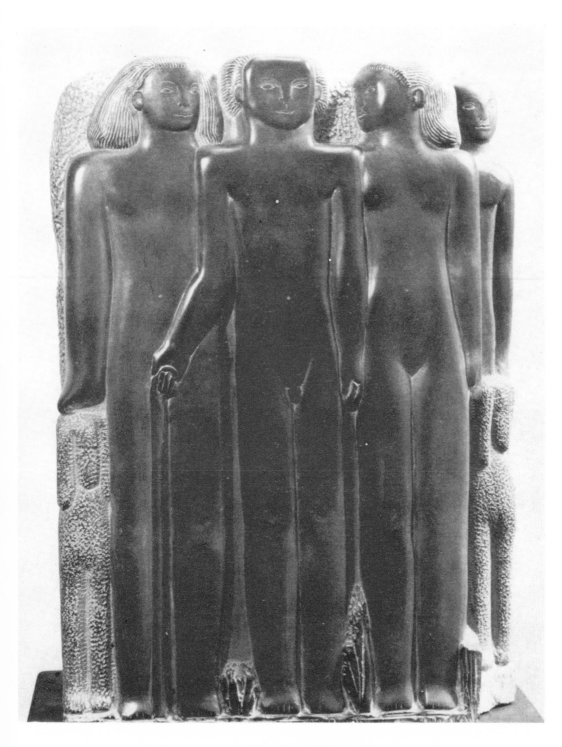

GROUP OF YOUNG PEOPLE *(African wonder stone)* Marion Walton

61

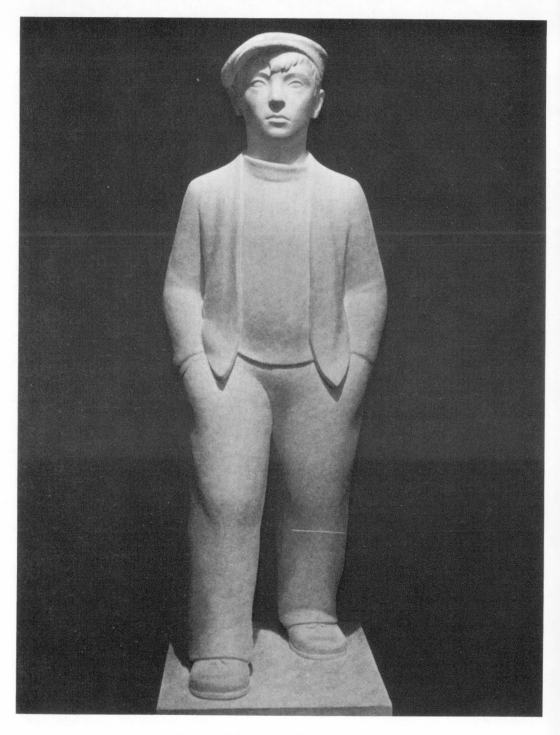

CITY COUSIN *(Plaster)* Thomas Lo Medico

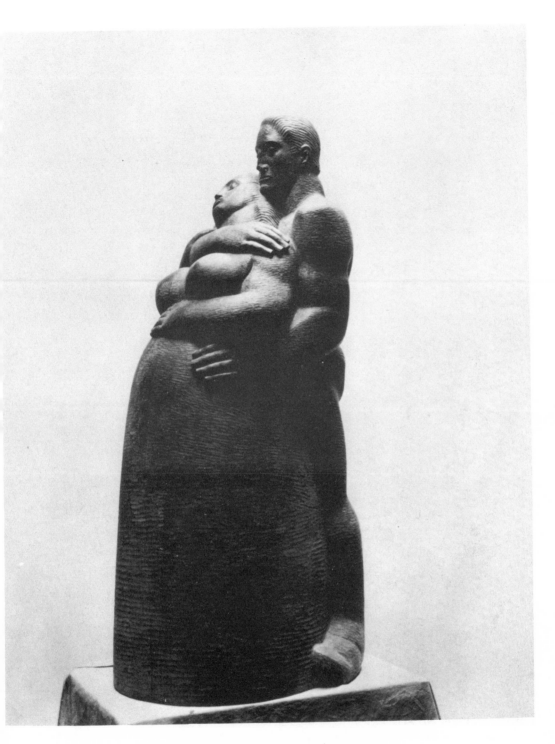

Hope *(Mahogany)* Theodore Barbarossa

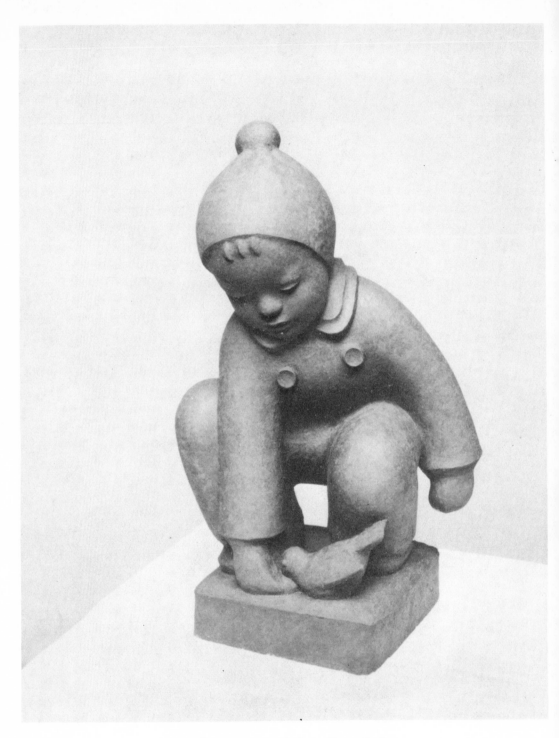

CHILD *(For stone)* Sylvia Shaw Judson

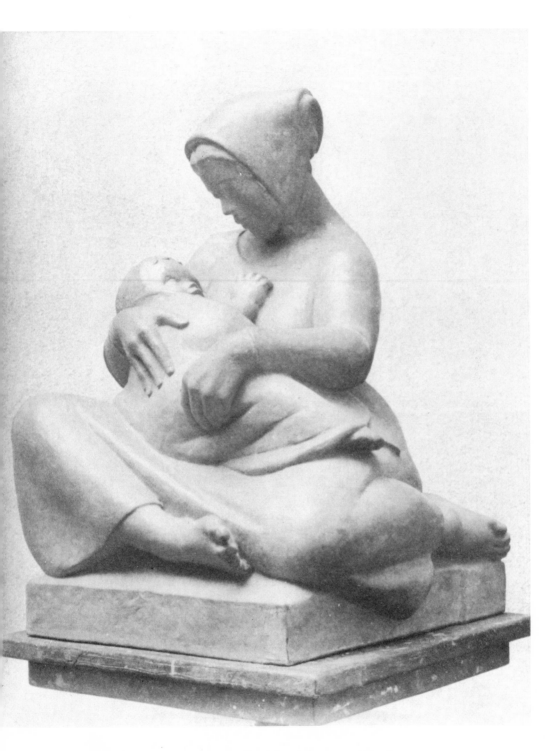

LULLABY *(Cast stone)* Marion Sanford

65

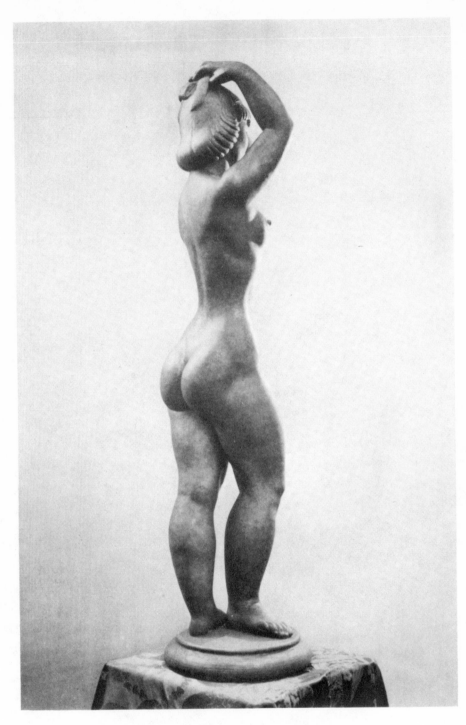

ORIENTALE *(Bronze)* Brenda Putnam

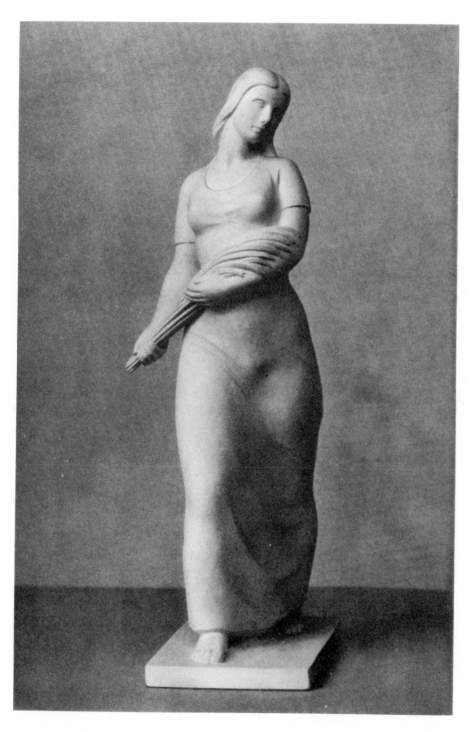

THE REAPER *(Stone)* Betti Richard

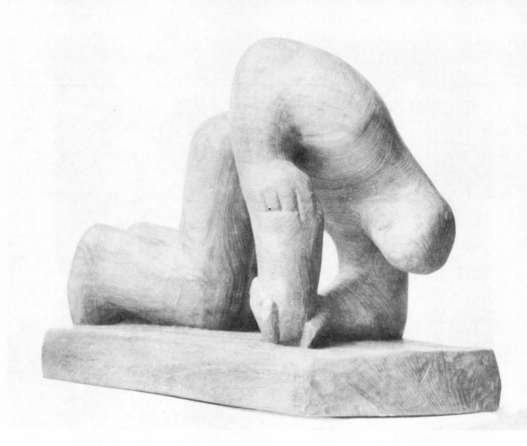

RIVETER *(Wood)* Merle Hoesly

ANIMALS

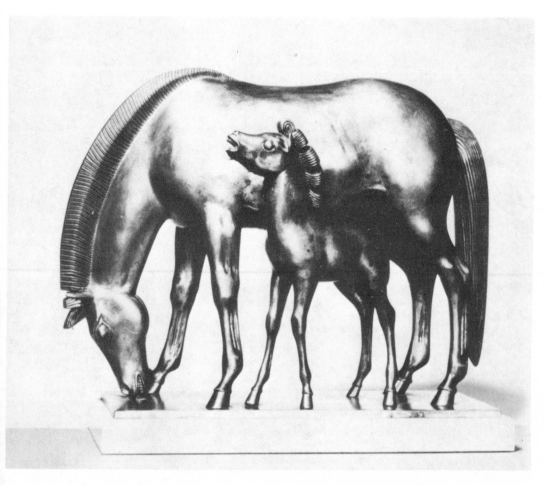

MARE AND FOAL *(Bronze)* Lawrence Tenny Stevens

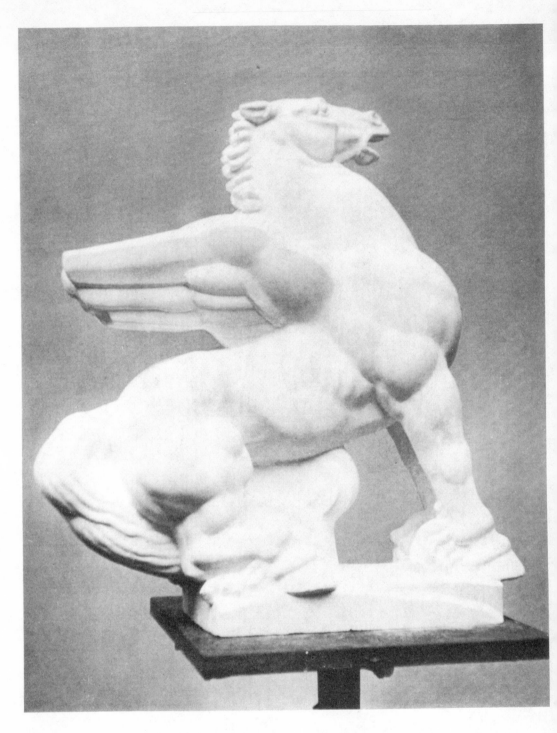

PEGASUS *(For bronze)* Donald De Lue

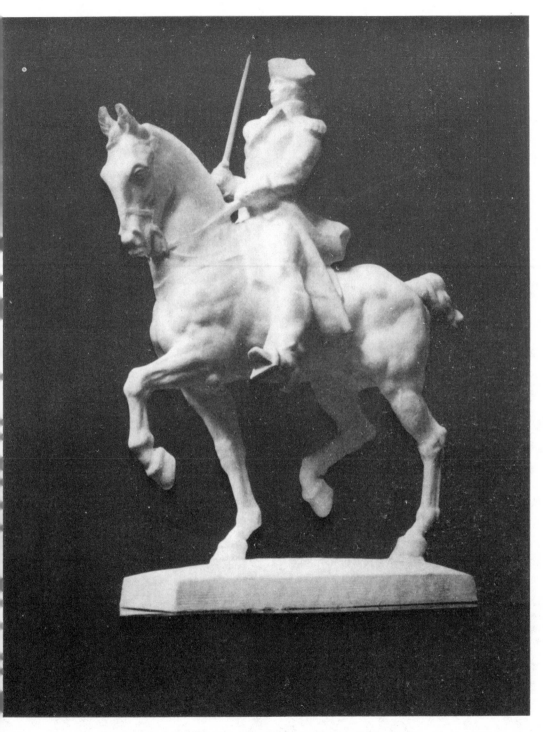

GEORGE WASHINGTON *(For bronze)* Joseph Pollia

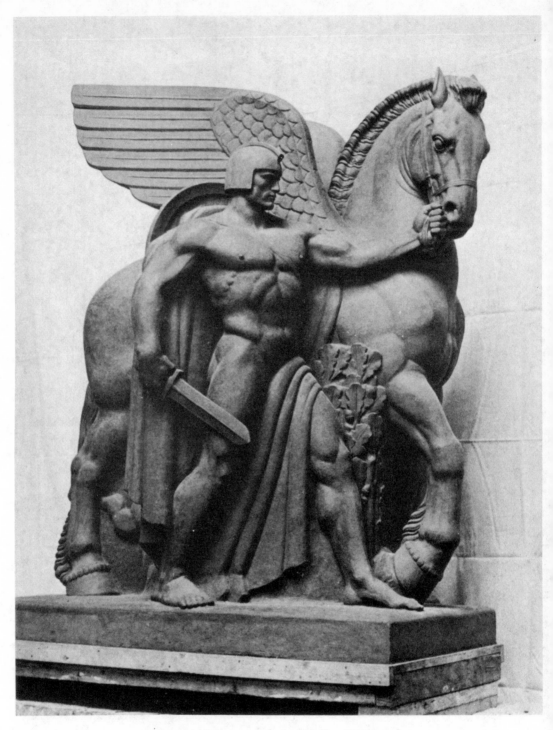

GROUP *(For granite)* Walker Hancock

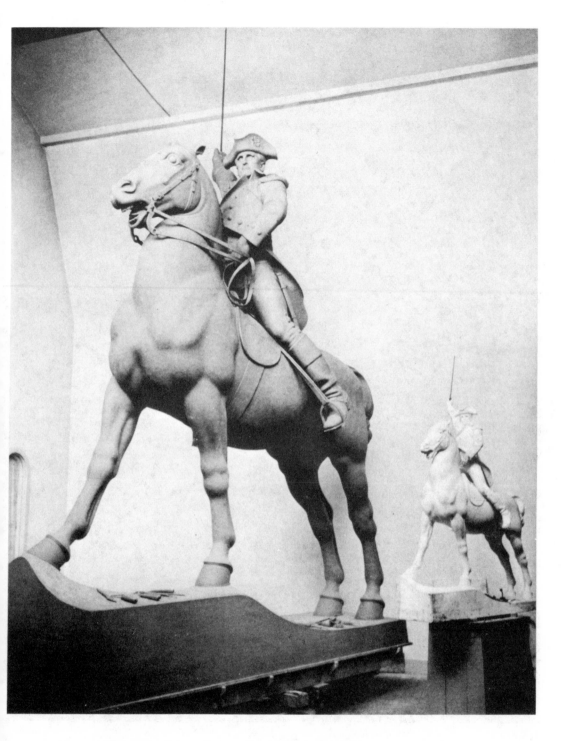

GENERAL JOHN CLARK *(For bronze)* Richard Recchia

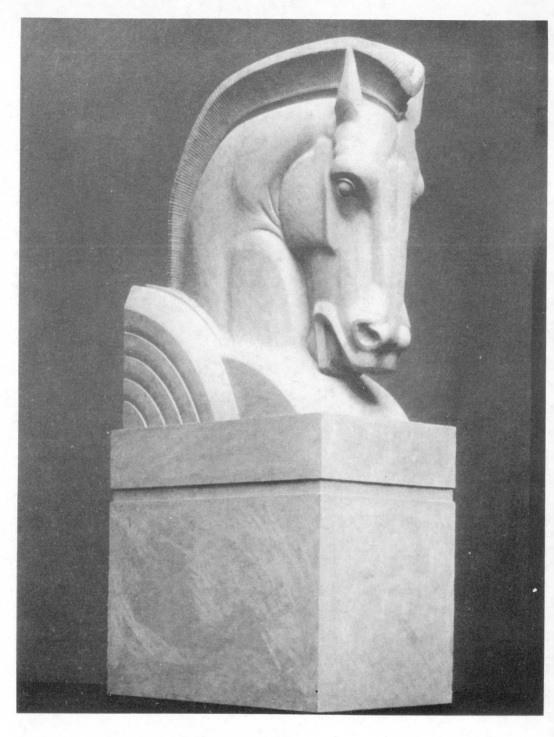

DESIGN FOR A GATE POST *(Plaster)* Joseph Kiselewski

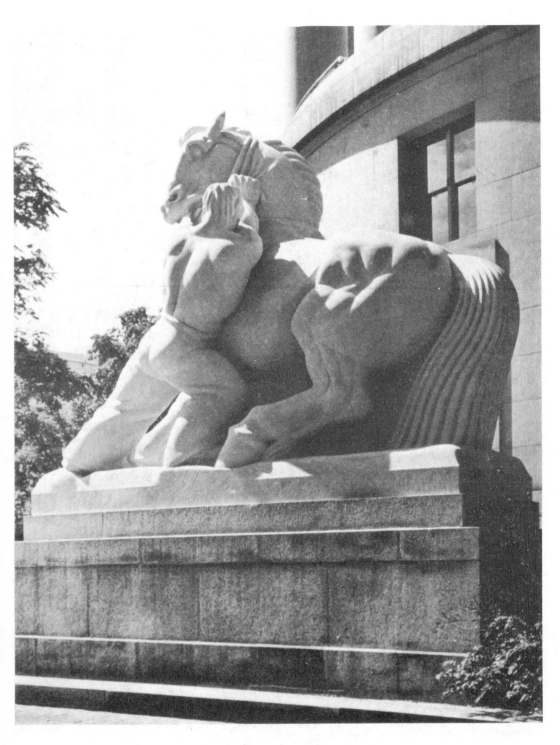

GROUP *(Stone)* Michael Lantz

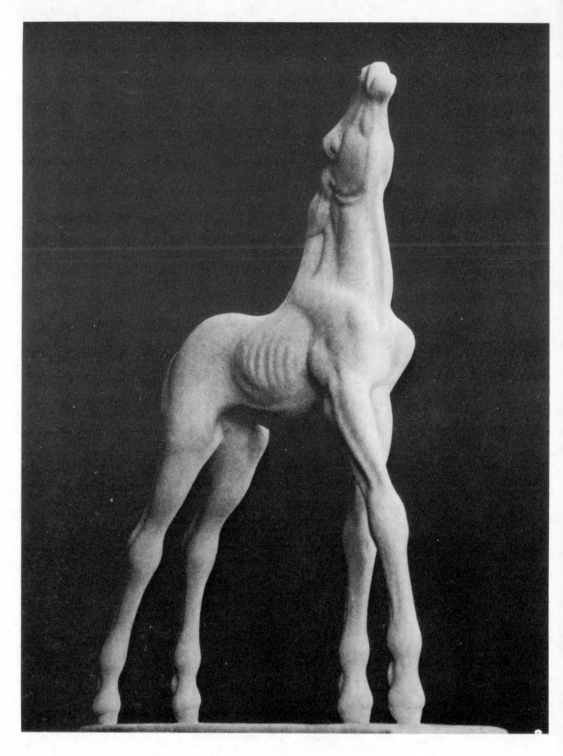

MARE COLT (*Bronze*) Bernard Frazier

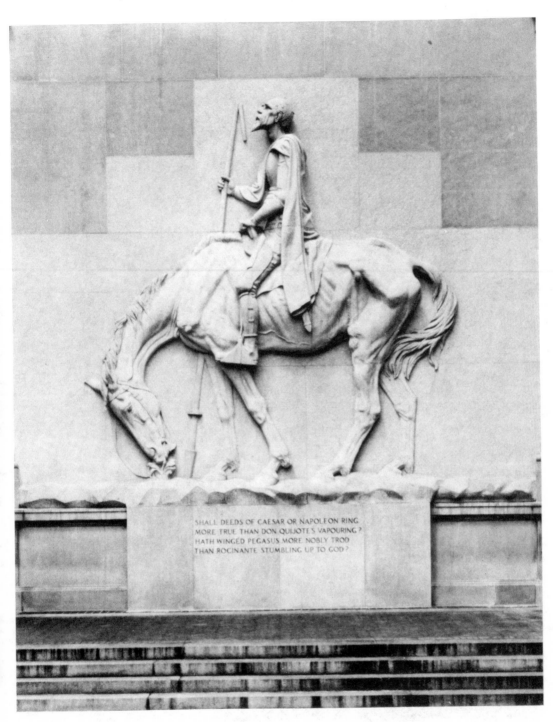

Don Quixote (*Stone*) Anna Hyatt Huntington

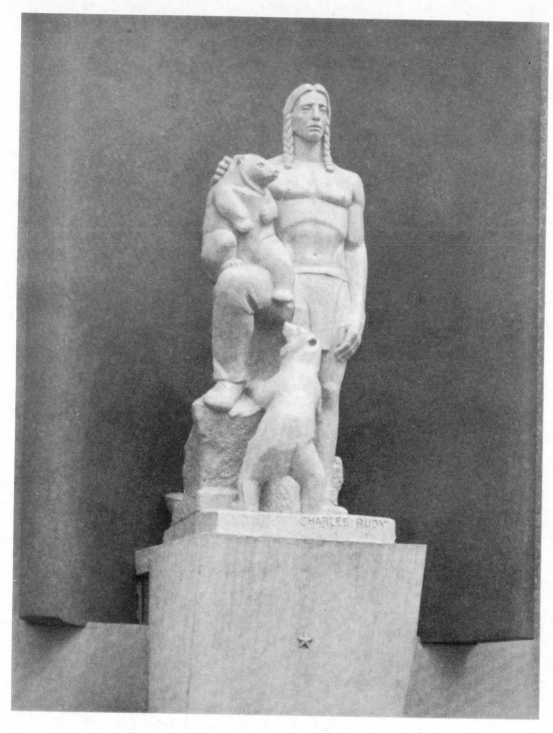

INDIAN AND BEAR CUBS *(For stone)* Charles Rudy

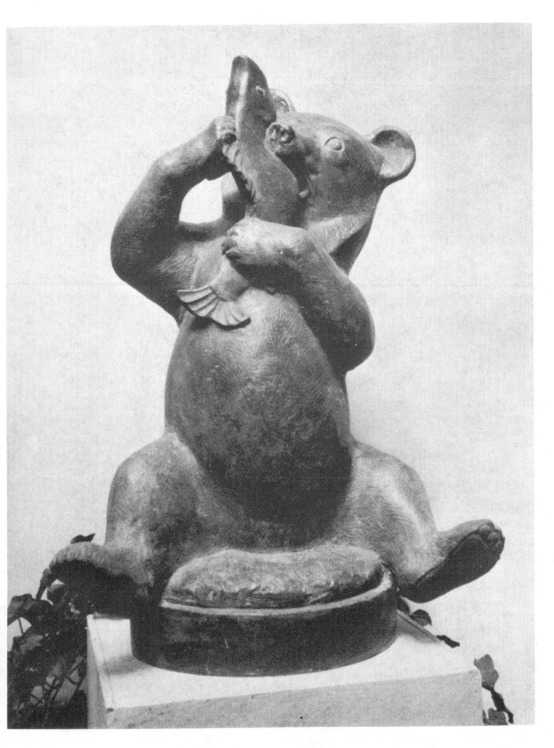

Cᴜʙ Eᴀᴛɪɴɢ Fɪsʜ (*Bronze*) Wheeler Williams

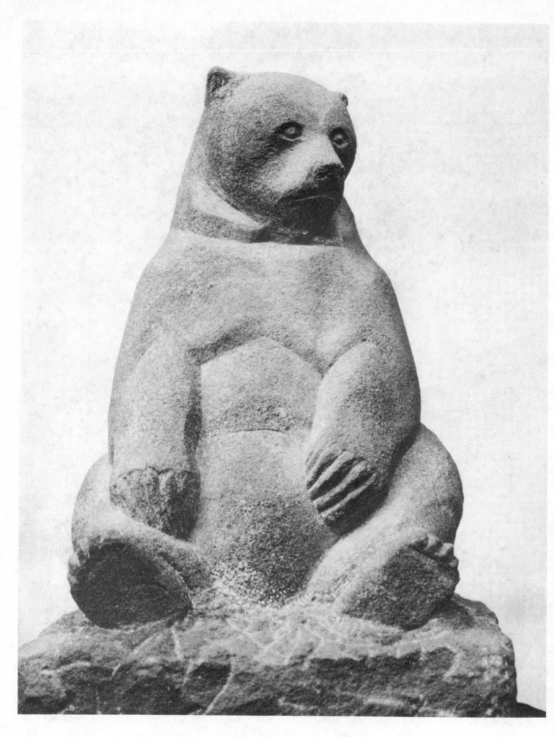

BEAR (*Red sandstone*) Richard Davis

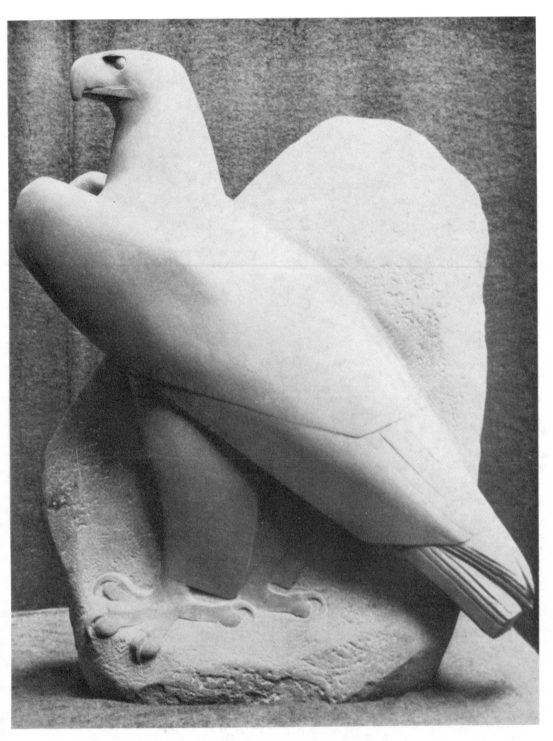

EAGLE (*Blue stone*) Henry Kreis

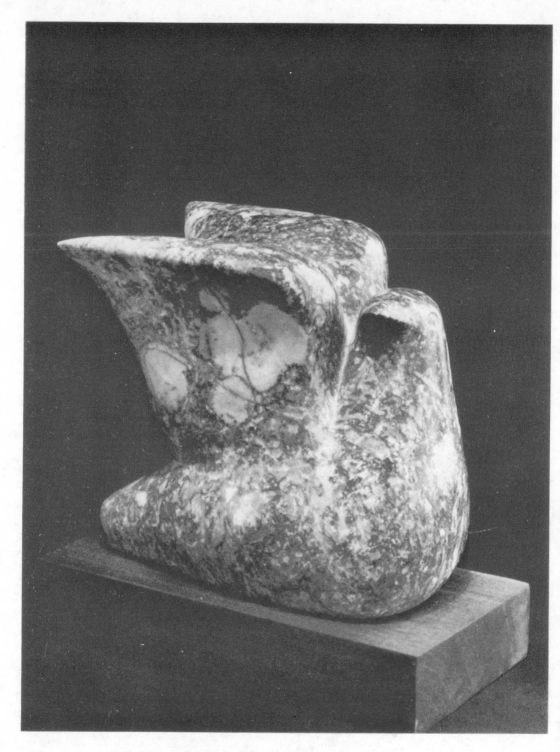

BIRD FORM *(Italian marble)* Cleo Hartwig

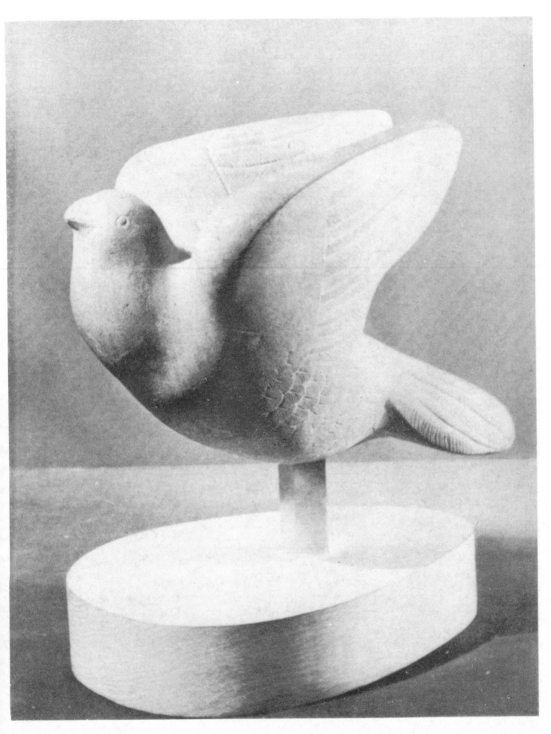

Dove *(Limestone)* Oronzio Maldarelli

83

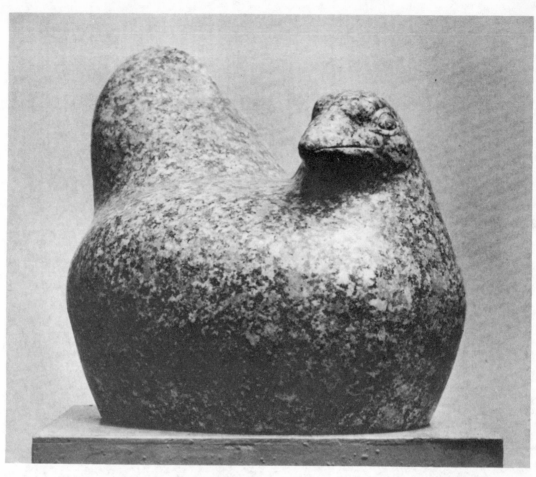

SETTING HEN *(Maine granite)* William Zorach

84

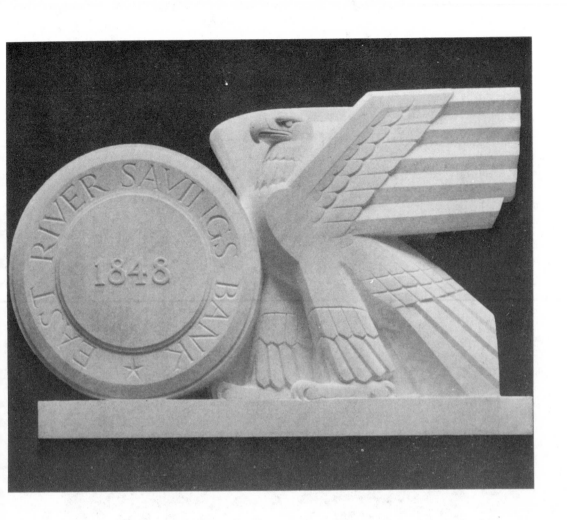

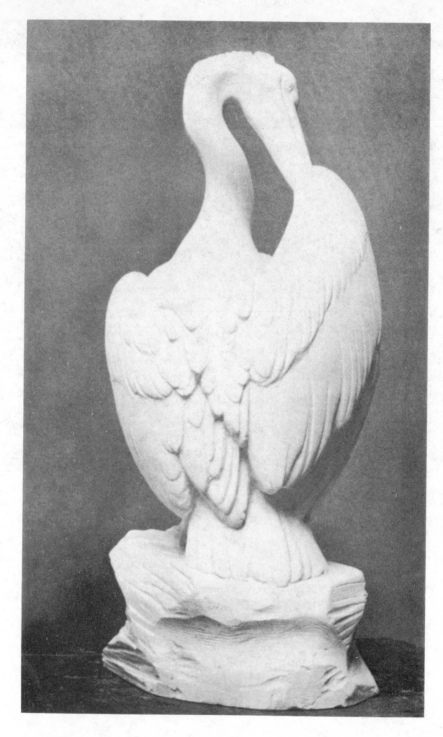

PREENING PELICAN *(For bronze)* Robert Weinman

86

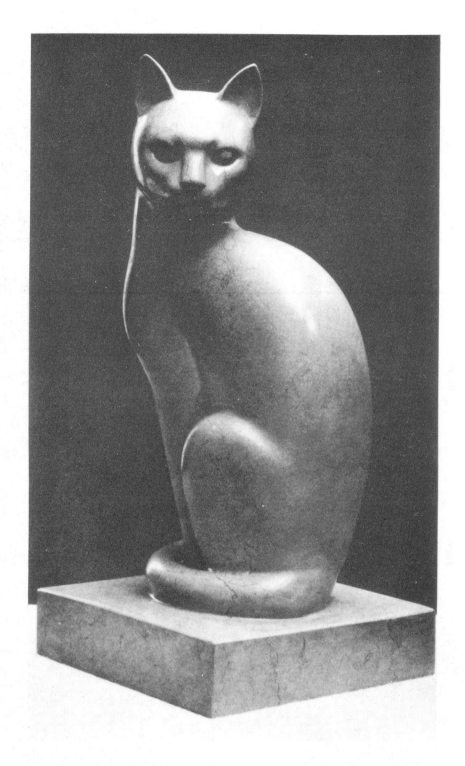

CAT *(Marble)* Heinz Warneke

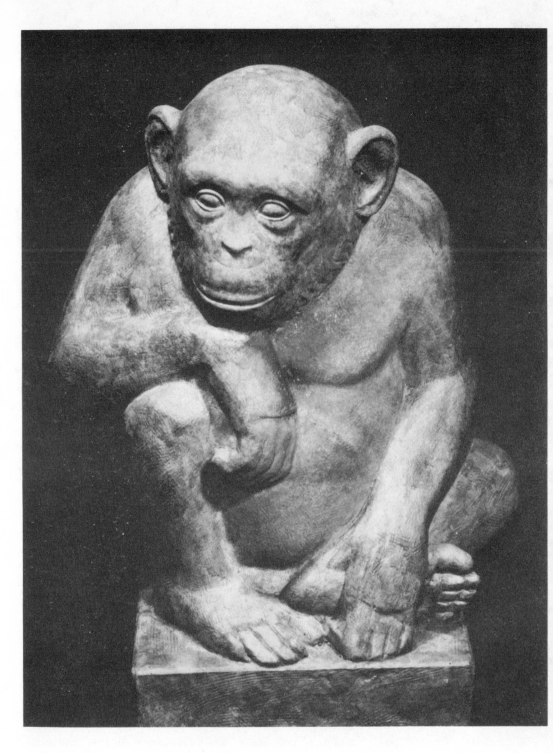

Chimpanzee *(Cast stone)* Hyman Filtzer

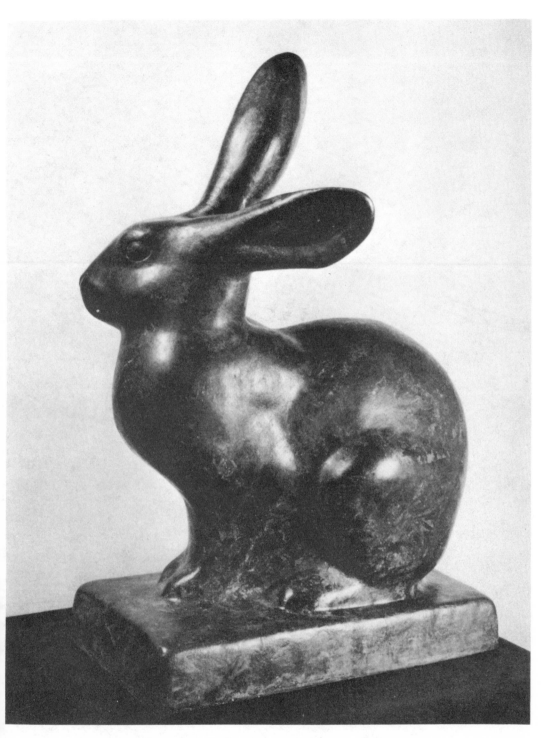

Rabbit Listening *(Bronze)* Eugenie Shonnard

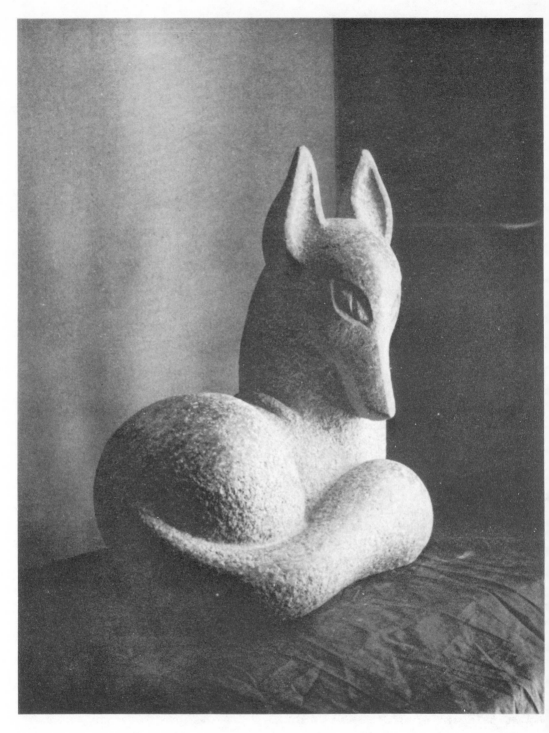

Fox *(Granite)* Sylvia Shaw Judson

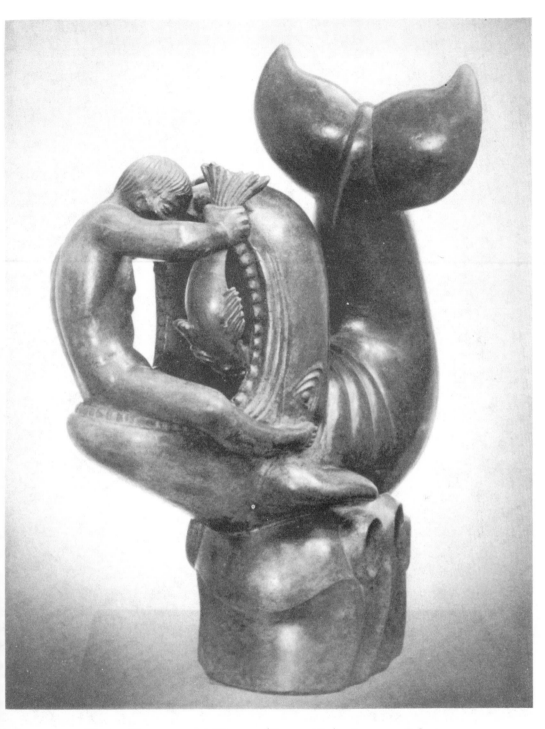

JONAH FEEDING THE WHALE *(Travertite)* Jacques Schnier

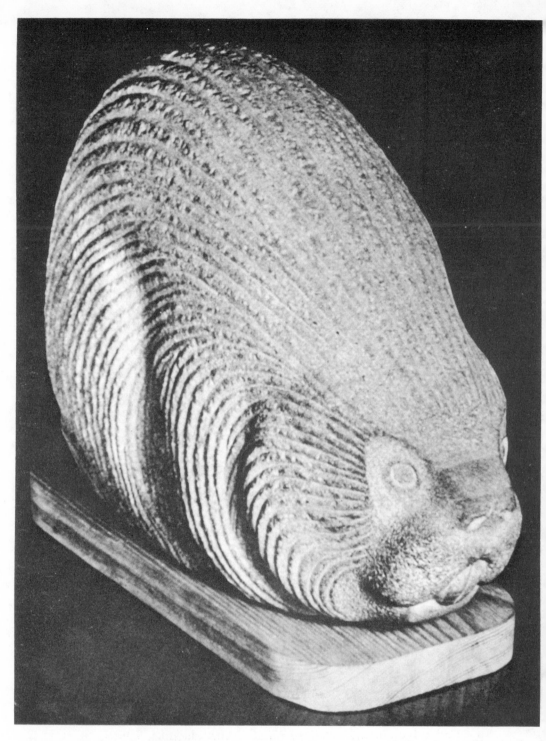

PORCUPINE *(Quartzite)* Richard O'Hanlon

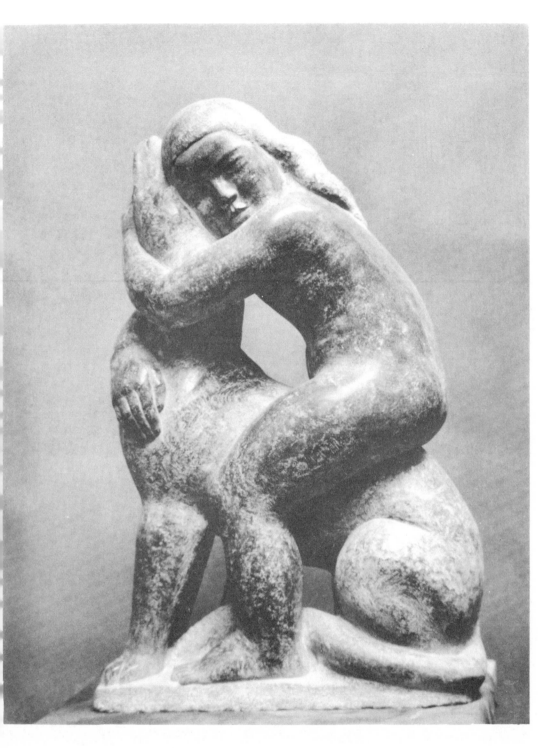

AFFECTION *(York Fossils)* William Zorach

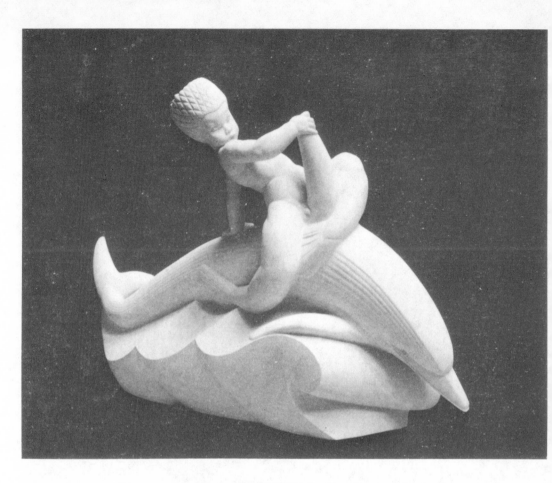

Triton and Dolphin *(Marble)* Benjamin Hawkins

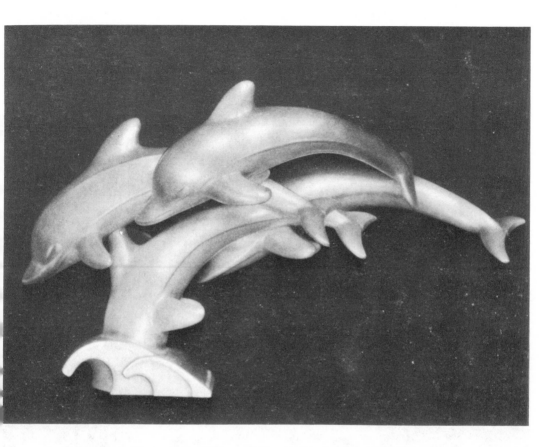

LEAPING DOLPHINS *(Silvered bronze)* Anthony de Francisci

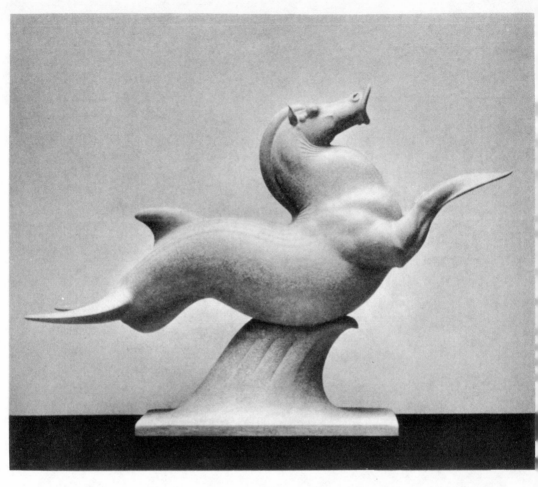

Seahorse *(Bronze)* Joseph Kiselewski

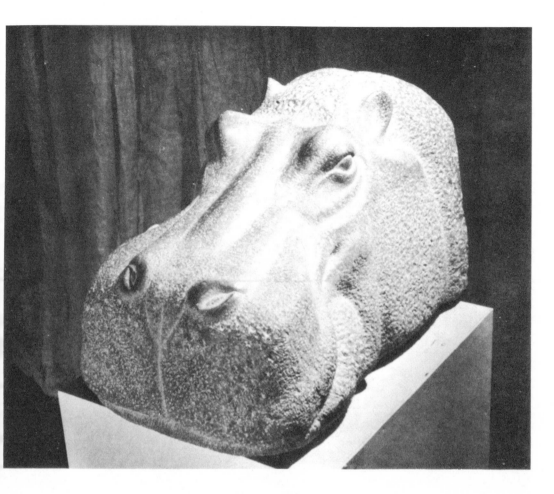

GRACIOUS COUNTENANCE *(Black Belgian marble)* Grace Turnbull

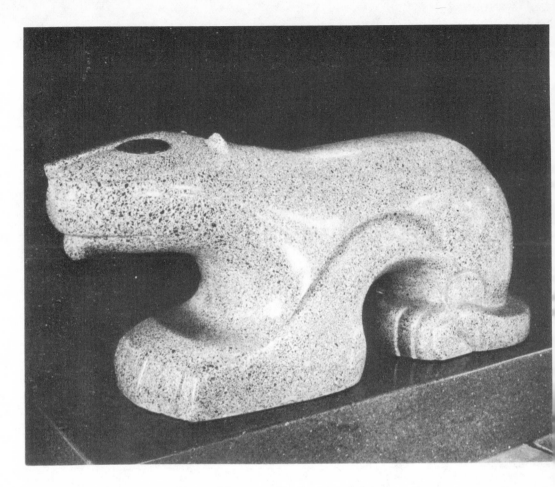

TIGER *(Terrazzo)* Sargent Johnson

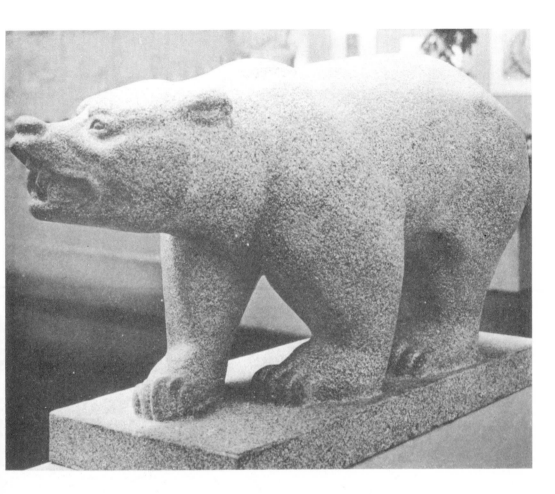

Bear *(Black granite)* Raymond Puccinelli

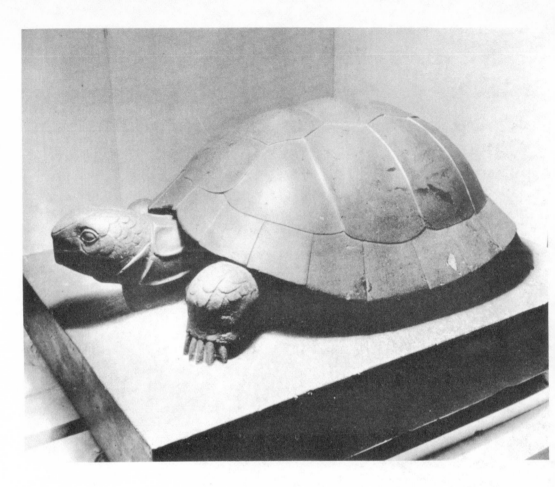

Tortoise *(Volcanic rock)* Cornelia Chapin

RELIEFS

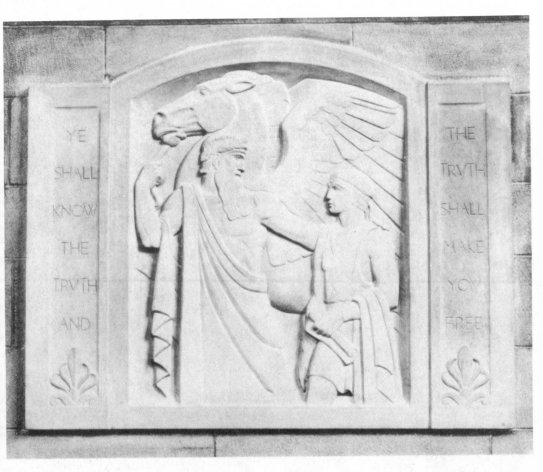

WILLIAM AMORY GARDNER MEMORIAL *(Marble)* Malvina Hoffman

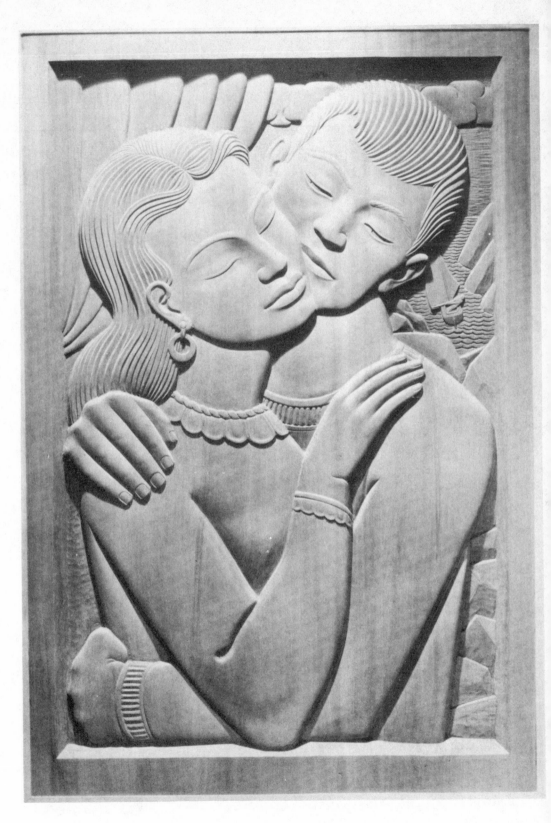

THE CARESS *(Tupelo)* Jacques Schnier

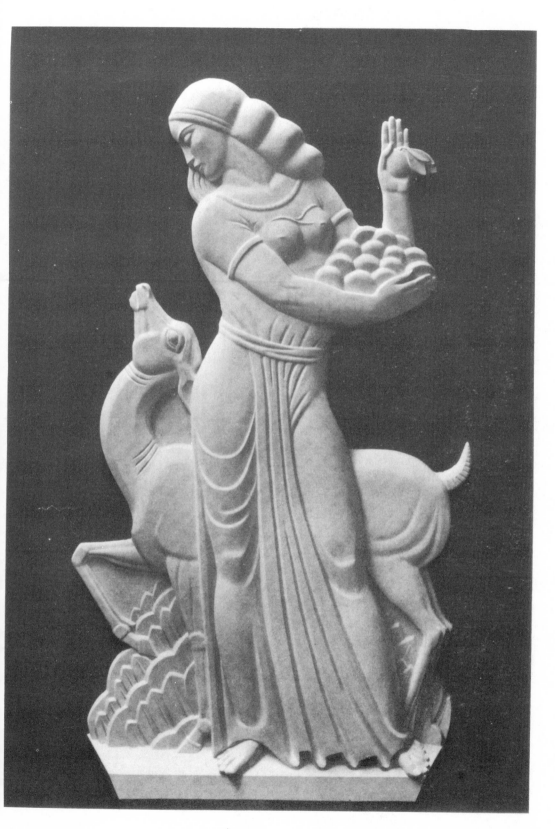

Temptress *(Plaster)* Adolph Block

PLAQUE *(Marble)* Walker Hancock

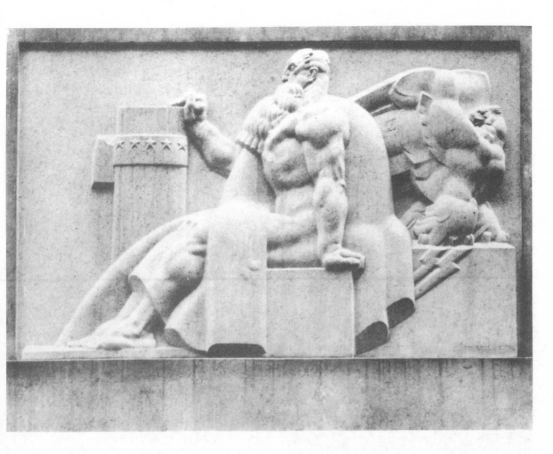

Law *(Granite)* Donald De Lue

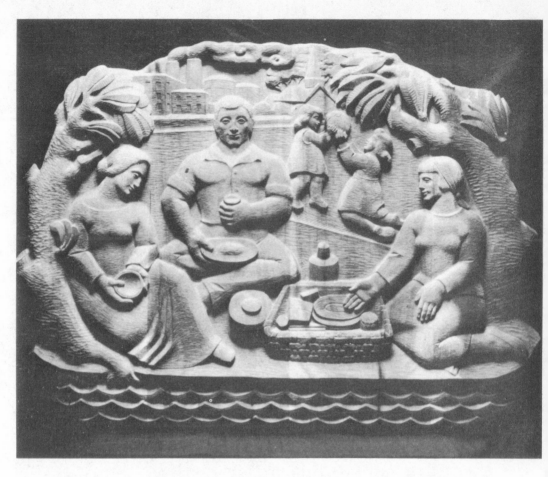

Picnic *(Wood)* Theodore Barbarossa

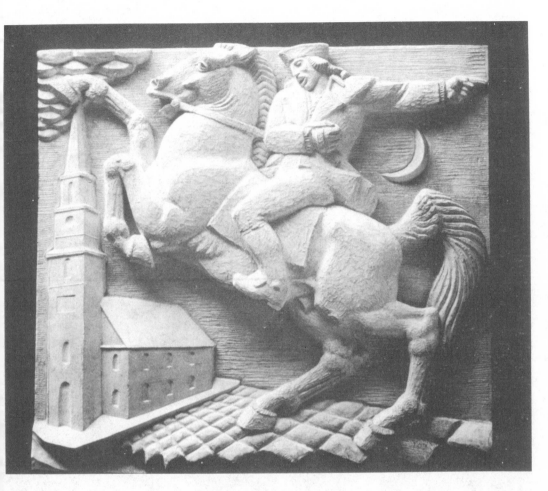

PAUL REVERE *(Plaster)* Theodore Barbarossa

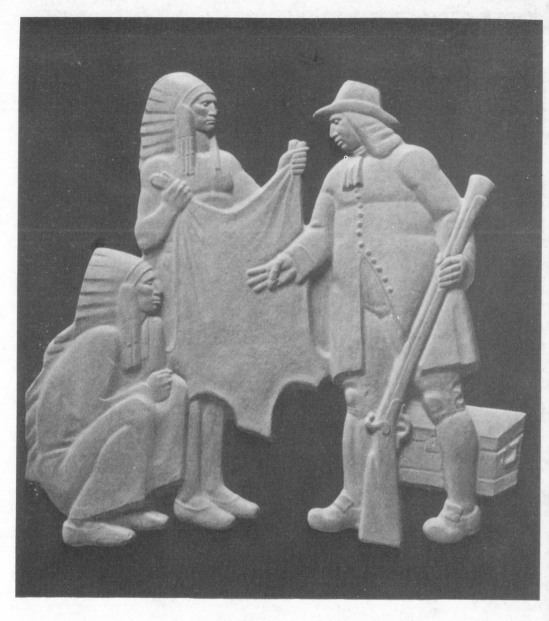

RELIEF (*Limestone*) Benjamin Hawkins

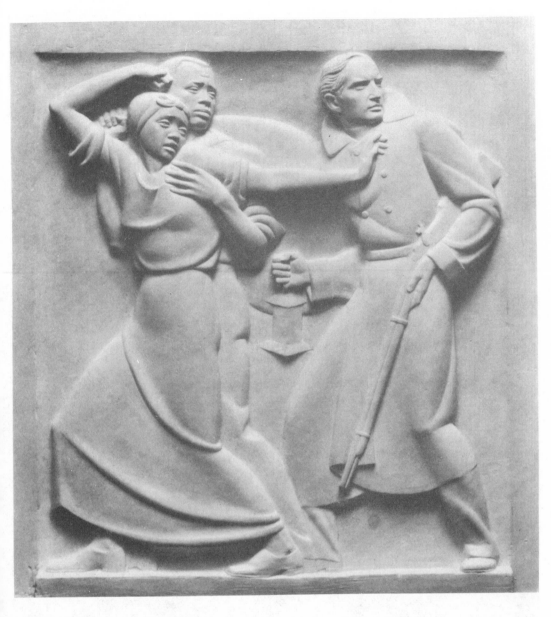

UNDERGROUND RAILWAY *(For marble)* Edmond Amateis

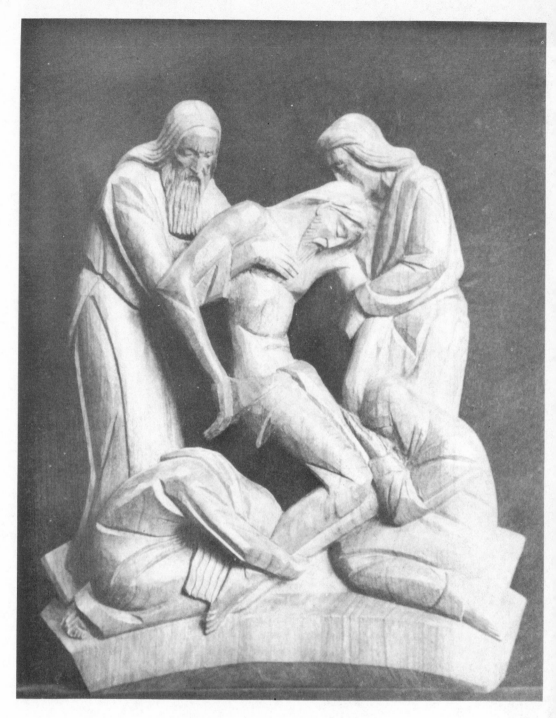

STATION OF THE CROSS *(Wood)* Gleb Derujinsky

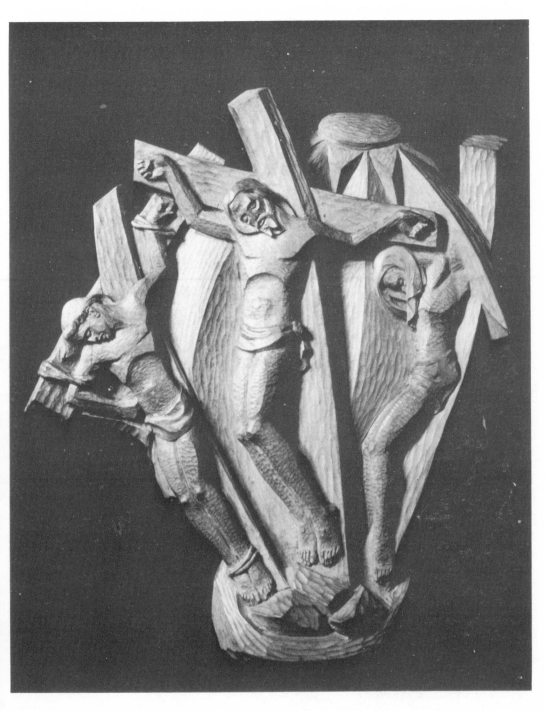

CRUCIFIXION *(Basswood)* Theodore Barbarossa

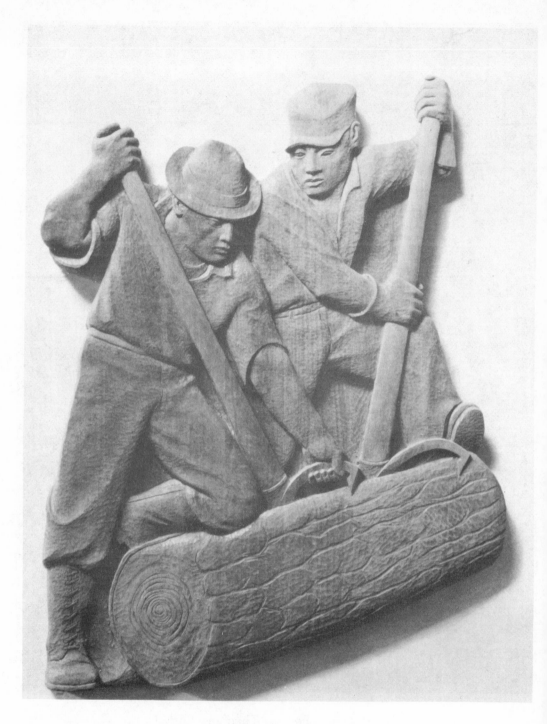

Logging *(Wood)* Peter Dalton

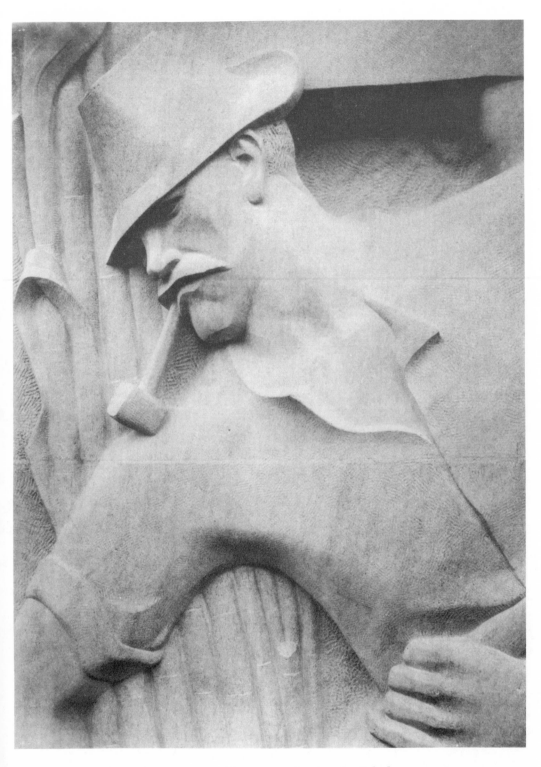

Cane Picker *(Limestone)* Armin Scheler

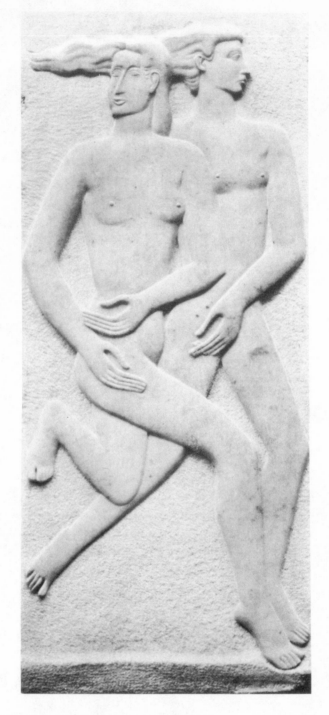

FLIGHT *(White Georgia marble)* Jean de Marco

114

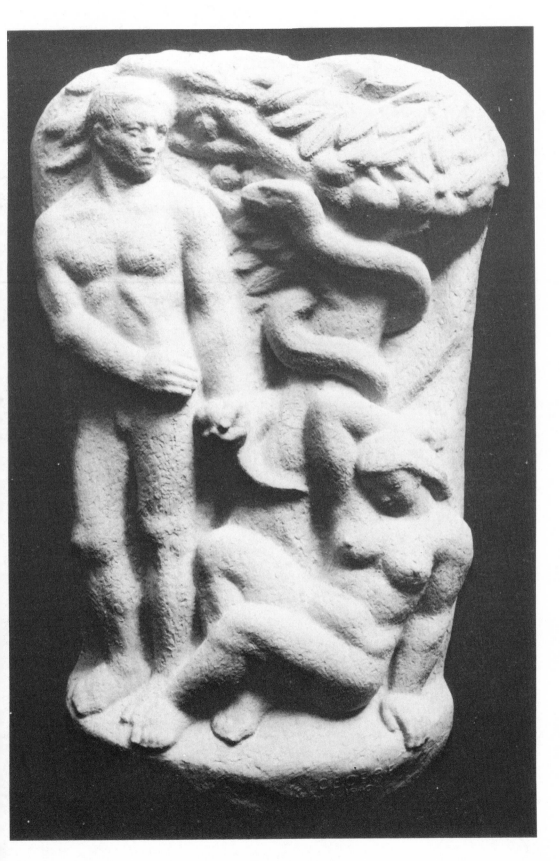

ADAM AND EVE *(Plaster)* Gaetano Cecere

115

CONNECTICUT TERCENTENARY MEDAL *(Bronze)* Henry Kreis

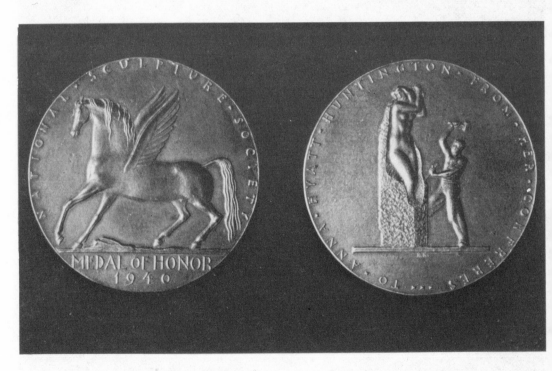

NATIONAL SCULPTURE SOCIETY MEDAL *(Bronze)* Henry Kreis

Society of Medalists, 22d Issue *(For bronze)* Walker Hancock

Society of Medalists, 23d Issue *(For bronze)* Joseph Renier

117

EXPLORATIONS IN FORM

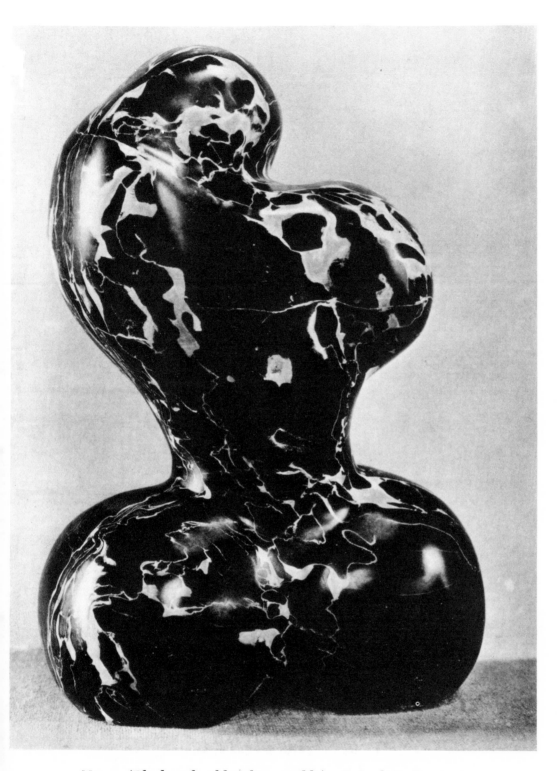

Negra (*Black and gold Italian marble*) C. Ludwig Brummé

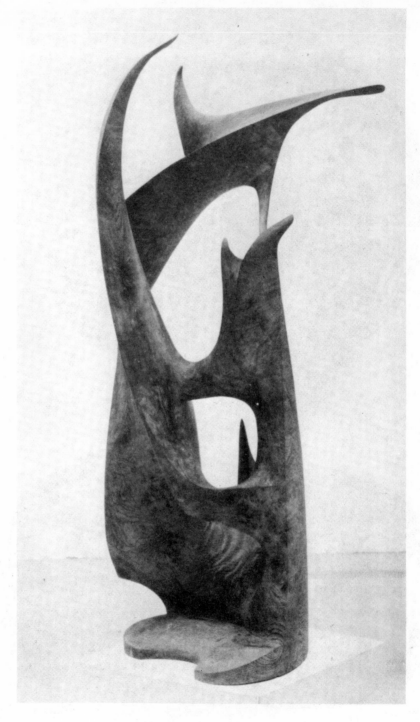

EYRIE *(Redwood)* Robert Howard

119

DARK MOUNTAINS *(Cast stone)* Adaline Kent

SEED POD *(Sienna marble)* Cleo Hartwig

FIGURE *(Plastic)* Alexander Archipenko

ORGANIC FORM *(Limestone)* Claire Falkenstein

123

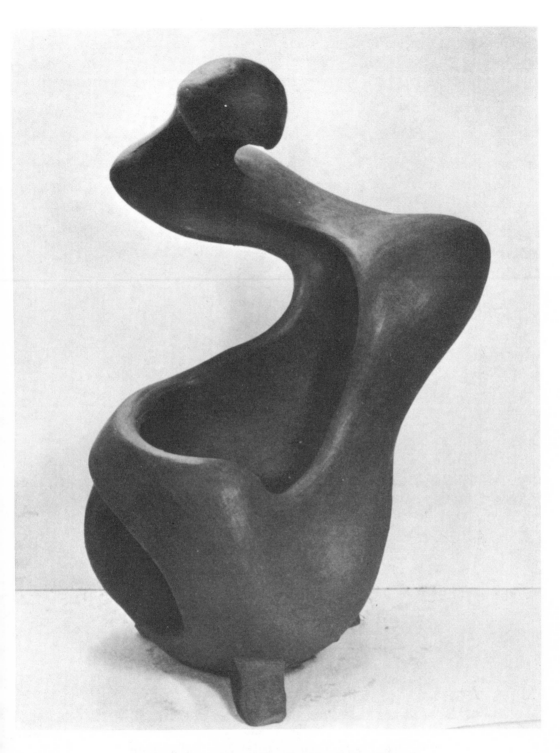

Bone and Muscle (*For lead*) Stefan Novak

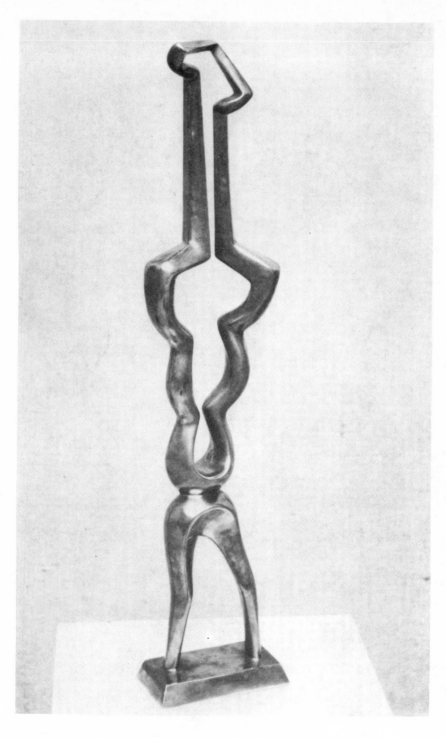

Duo *(Chiseled bronze)* Helen Phillips

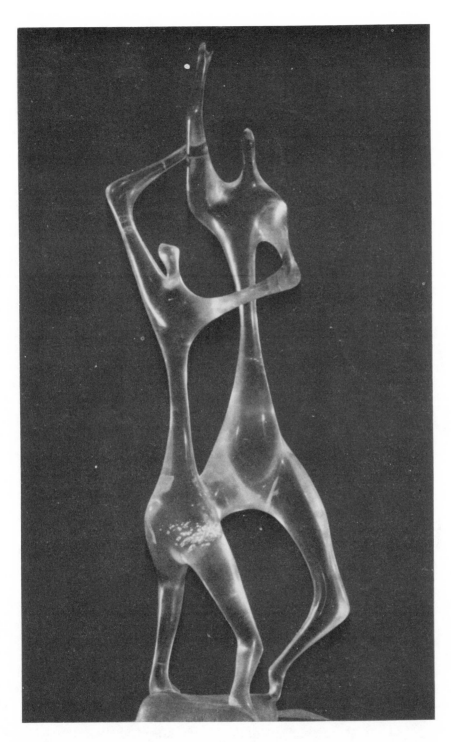

Spring *(Plastic)* Leo Amino

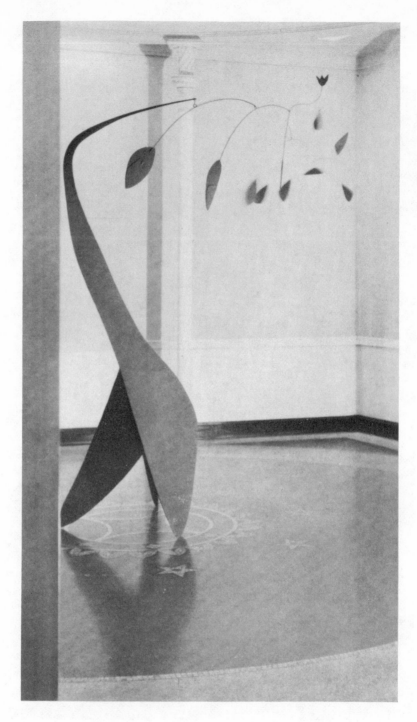

RED PETALS *(Mobile)* Alexander Calder

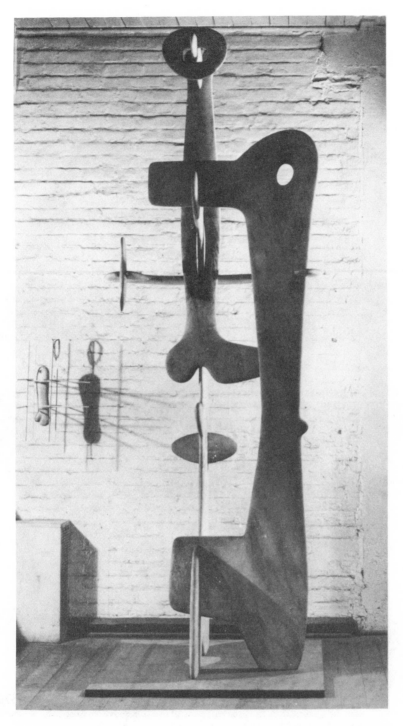

Kouros *(Pink Georgia marble)* Isamu Noguchi

128

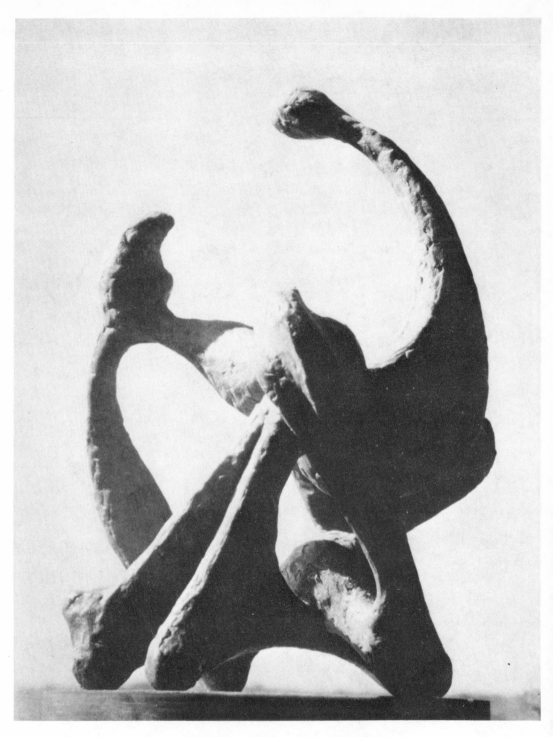

OMINOUS SHADOW *(Bronze)* Herbert Ferber

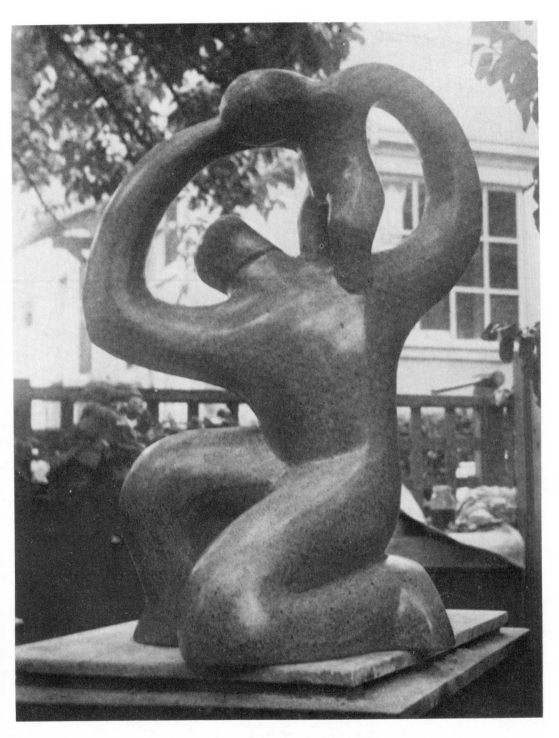

FATHER AND SON *(Terrazzo)* Elah Hale Hays

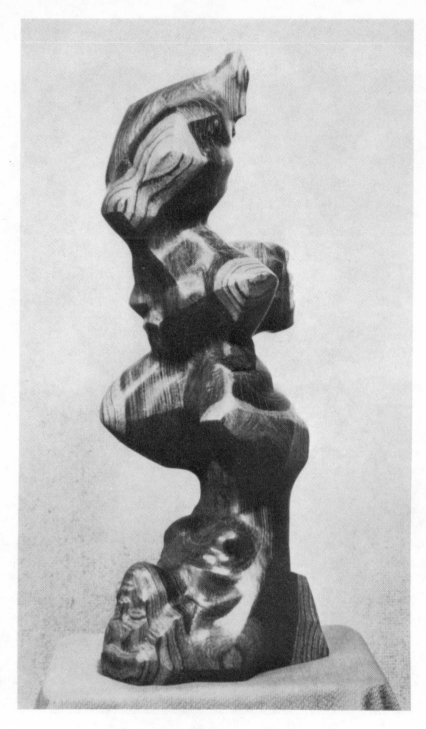

ACROBATS *(Lignum vitae)* Chaim Gross

131

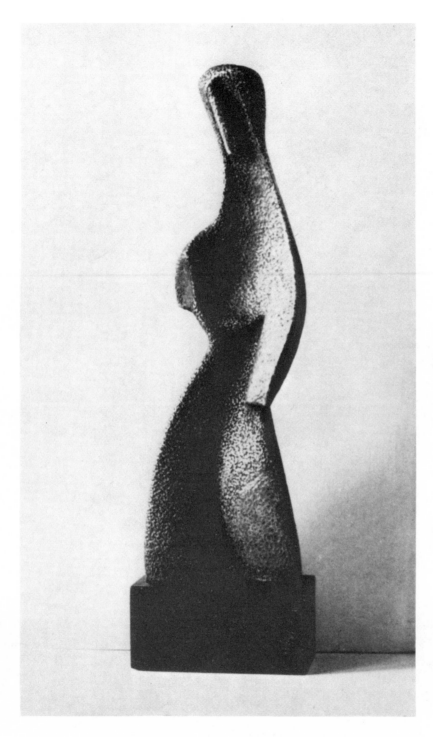

Silhouette *(Silver-plated terra cotta)* Alexander Archipenko

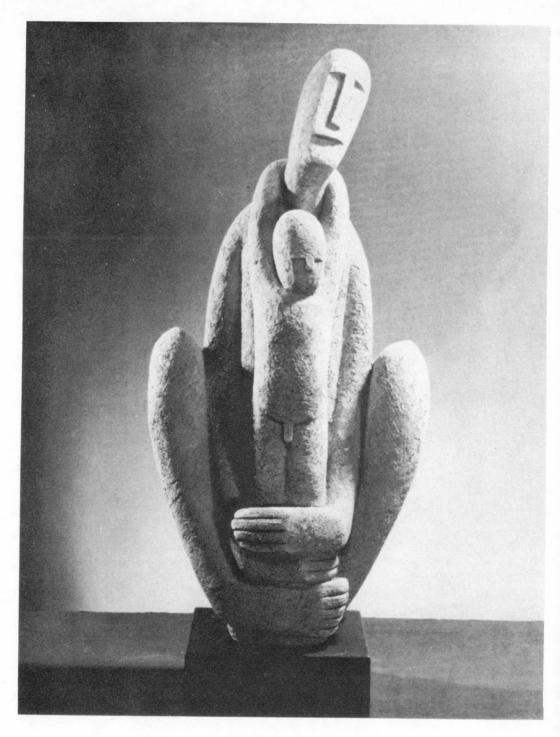

Autochthon *(Terra cotta)* Jean Woodham

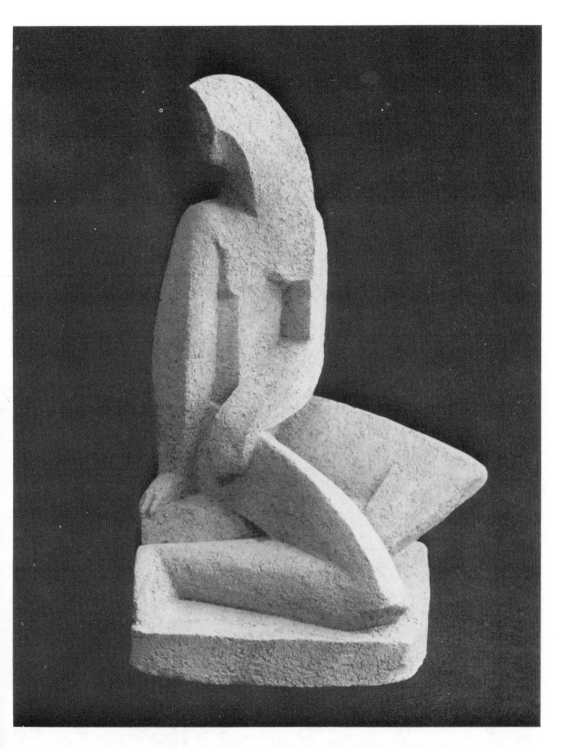

LOT'S WIFE *(Terra cotta)* Robert Howard

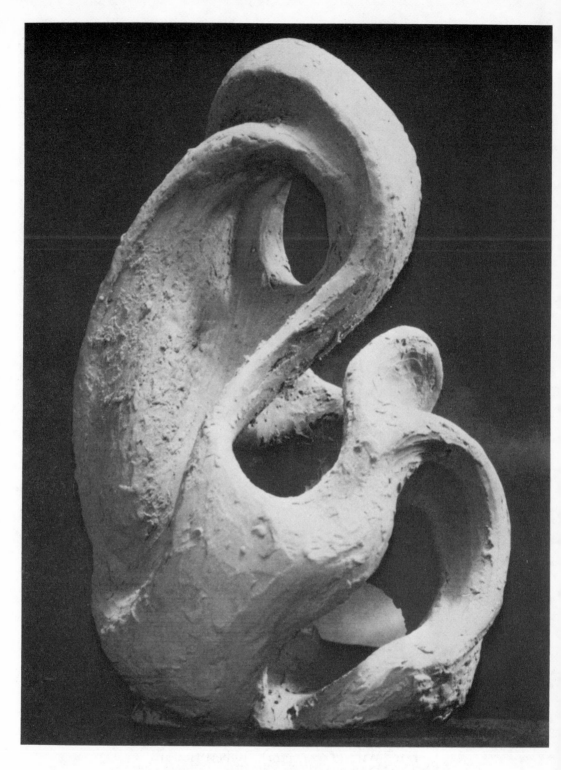

Two Ghosts Jitterbugging *(Plasticum)* John Beckman

135

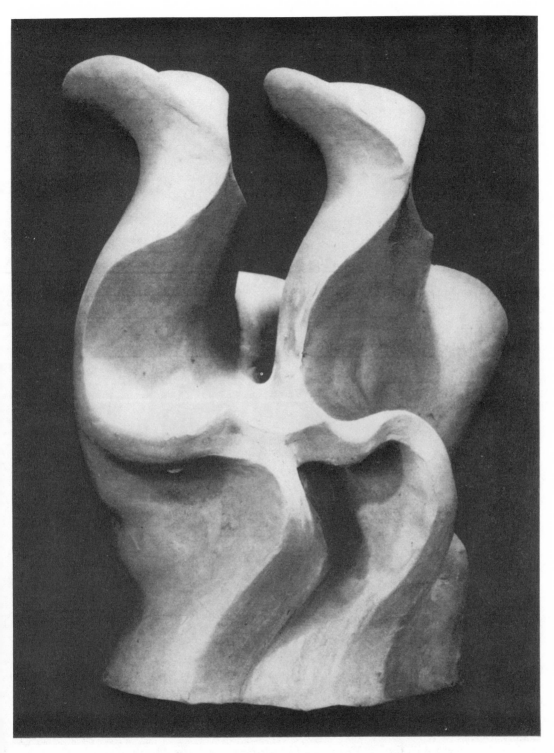

REPETITION OF FORMS *(Plasticum)* William Goss

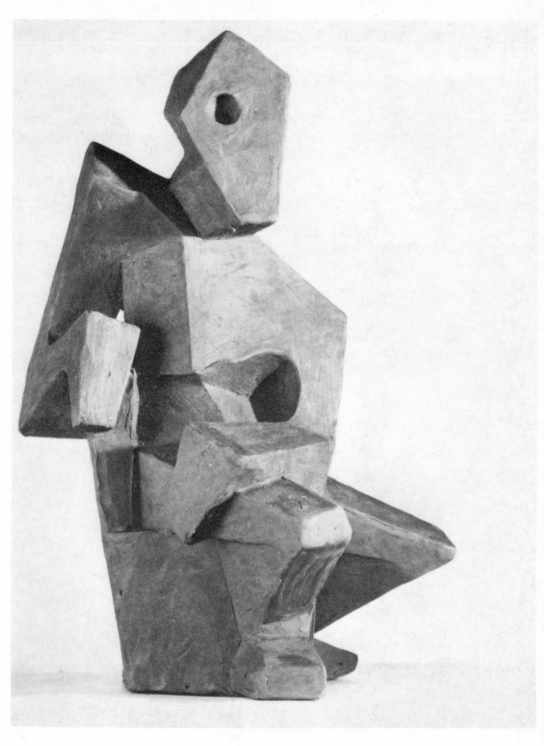

STUDY IN CUBIC VOLUMES *(Plasticum)* Victor Abrahamson

137

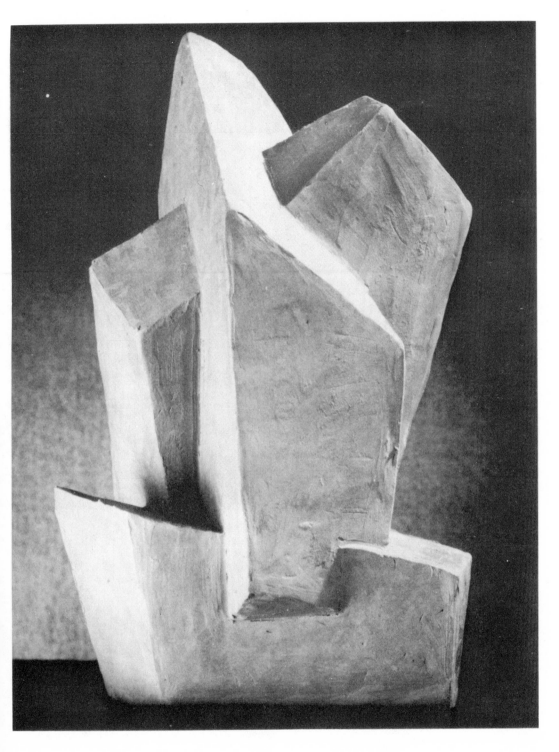

CUBIC FORMS *(Plasticum)* Mel Studer

138

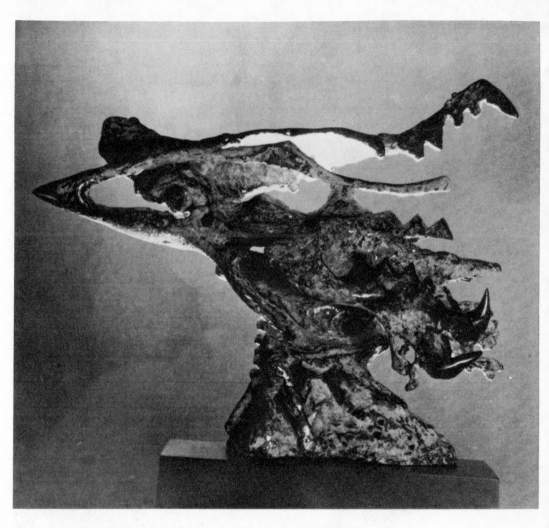

SCAVENGER *(Welded, hammered, and brazed steel)* Theodore Roszak

INDEX TO PLATES

[221]

INDEX TO TEXT